t-shirts from
the underground

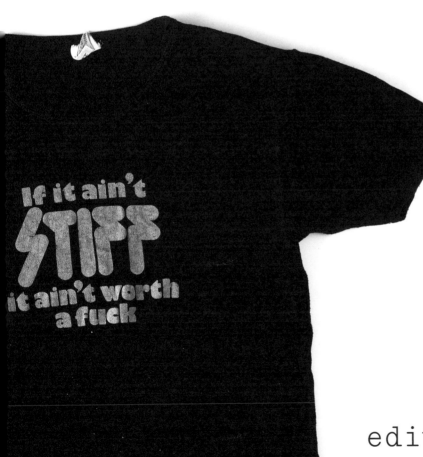

If it ain't
STIFF
it ain't worth
a fuck

edited by
Cesar Padilla

First Published in the United States of America
by Universe Publishing
A Division of Rizzoli International Publications, Inc.
300 Park Avenue South
New York, NY 10010
www.rizzoliusa.com

2010 2011 2012 / 10 9 8 7 6 5 4 3 2 1

ISBN-13: 978-0-7893-2033-9

Photography by Andrea Thompson

Art Direction: Juliette Cezzar / e.a.d.
Design: Andrew Shurtz / e.a.d.

Printed in China

Library of Congress Control Number:
2009935144

A note from the editor:
This collection by no means is meant to represent
an actual visual history of the music I love.
It is meant to represent only what I have found.

Acknowledgments:
Martynka Wawrzyniak, Jacob Lehman, Juliette Cezzar,
Andrew Shurtz, Mat Côté, Radford Brown, Andrea
Thompson, Damian Côté, Cynthia Plastercaster, Keith
Morris, Kari Krome, Kid Congo, Jim Thirlwell, Lydia
Lunch, Richard Kern, Martin Atkins, Pearl Harbour,
Nicole Panter, Jennifer Schwartz, Nina, Betty, Jose,
and Isabel Padilla, Mike Hoffman, Justin Warfield,
Tim Kerr, Roddy Bottum, Marydee Reynolds, Frankie
from My Life with the Thrill Kill Cult, Wax Trax,
Ebay, Stephin Merritt, Susie Lynch, Thurston Moore,
Scott Ewalt, Richard Schuler, Sean Delear, Pauline
Toruan, Charles Miers, Lou Silva, Jack Waterson,
Paul Zone, Steve Anne Irwin, Dean Holdiman, Michael
Schmidt, Tessa Hughes-Freeland, Jodie Bass, Betsey
Johnson, David Pajo, Judy Nylon, Pam Hogue, Brett
Ralph, Wayne Kramer, Margaret Kramer, Bob Gruen,
Mike Watt, Mark Arm, Don Bowles Jr., Pat Fear,
Ariana Speyer, Eleni Mandell, Howie Pyro, Andrea
Kusten, and Joey Yates

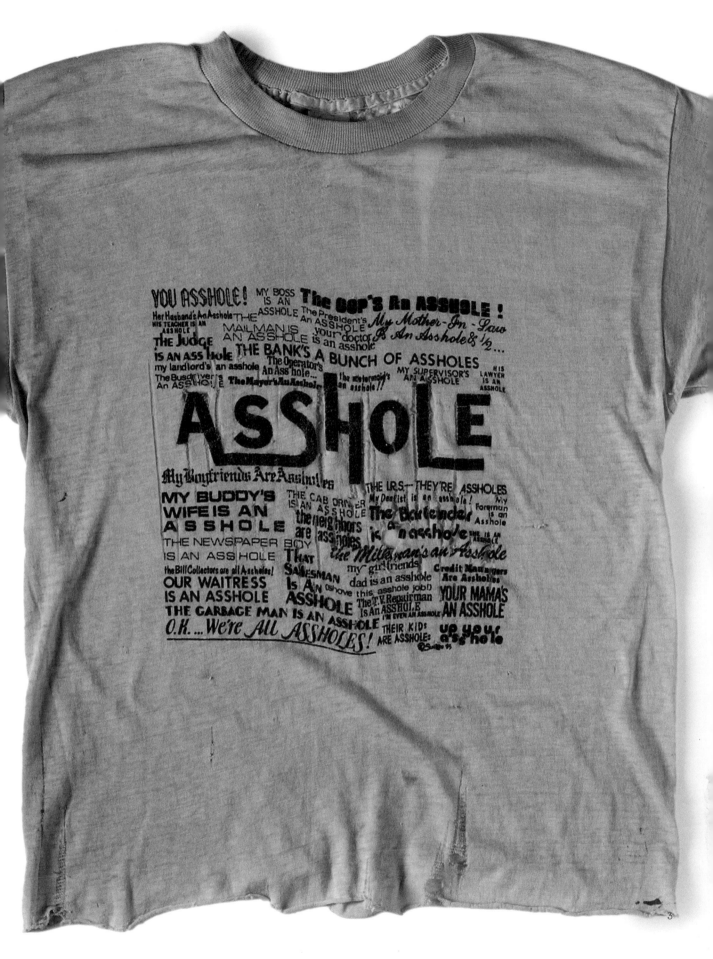

I grew up in Southern California and was raised
by my two sisters. As a consequence I was on the
Sunset Strip at an early age, attending rock shows
and being exposed to many things a ten-year-old
wouldn't normally have been exposed to. In 1988, I
went traveling to South America. When I returned, my
mother had thrown away my rock T-shirt collection,
documenting this misspent California youth. Since
then I have been searching for the Holy Grail.
 This collection is clearly a direct result of
such pillaging.

Cesar Padilla

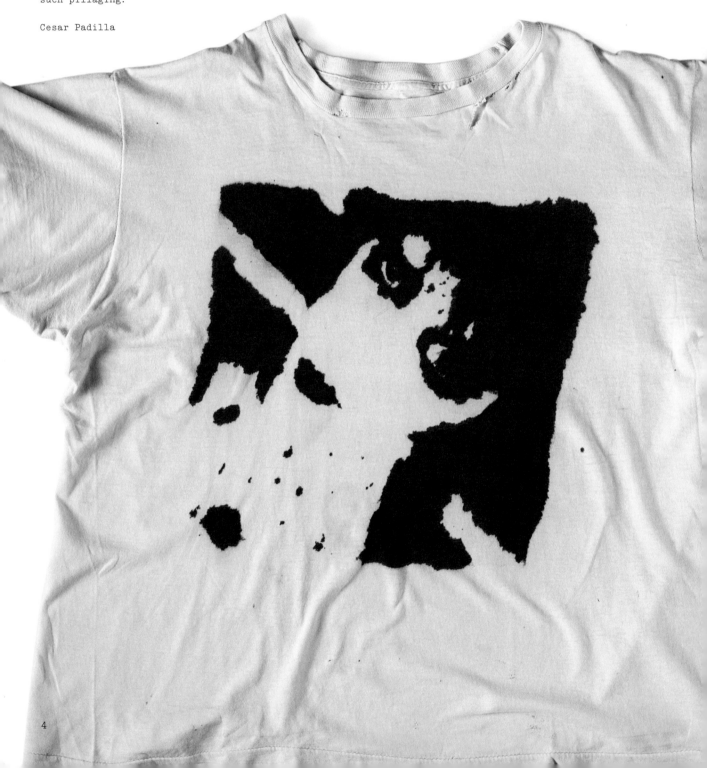

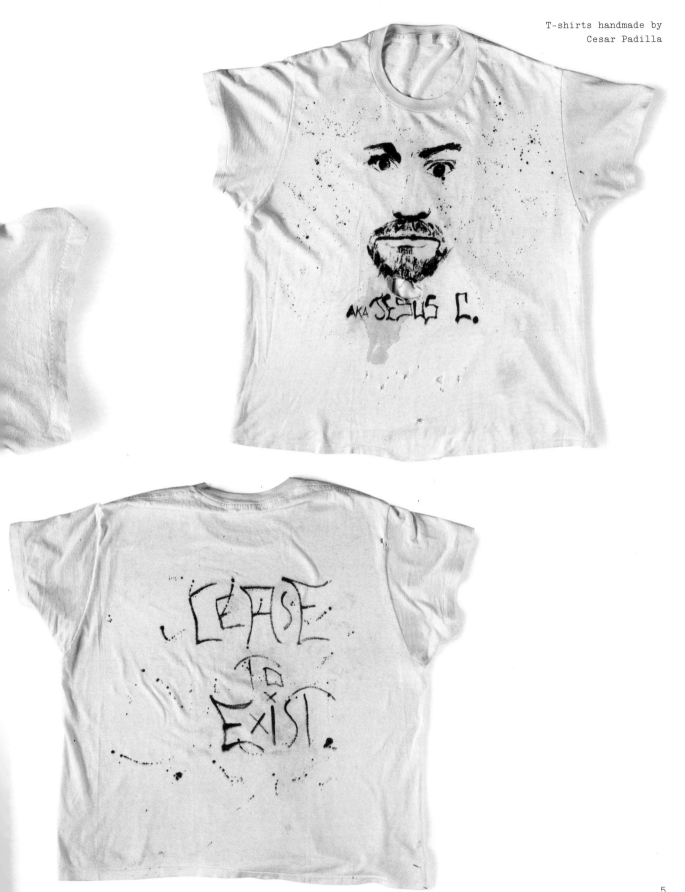

T-shirts have become the daily uniform of every slouch too damn lazy to button up a shirtfront. Their acceptance as fashion accessory is responsible for a universal slobathon that shows no signs of slowing down. Stroll down any street, in any city, in any country on this planet and you will be assaulted by throngs of ill-dressed creatures, their chests riddled with ridiculous slogans, lousy designs, bad graphics, and the grinning mugs of whatever celebutard has sold enough CDs, DVDs, or seats in a sports arena to have become a profitable commodity.

One of the most brilliant marketing cons of the last quarter-century is that alleged global slave-traders like The Gap, Adidas, and Nike were able to convince the average consumer to fork over hard-earned cash for the privilege of playing walking billboard to their oversized, ill-fitting, and horribly ugly pieces of cotton-blend propaganda. "Lifestyle" brands such as the ubiquitous American Apparel may be commendable for encouraging fair trade and resisting sloganeering, but their practice of promoting boring, generic designs further threatens to turn the streets into a ghastly pajama party of ungodly proportions, where every slacker who just rolled out of bed blends anonymously into a crowd of a thousand other wrinkled wastrels.

Blame on it Brando. The original slob. His seething portrayal of the raging Stanley Kowalski in the 1951 film A Streetcar Named Desire oozed sex and violence. Brando's arrogant swagger, while sporting little more than a sweat-stained T-shirt tightly hugging his torso, defined a brute machismo that was both irresistible and slightly repulsive. It transformed the average street-corner working-class zero into a potentially tough-as-fuck superstar sex symbol. Brando may have been the first to proudly parade underwear as outerwear, elevating its status from utilitarian vesture to iconic symbol of defiance and insolence. But a long line of fashion renegades with one eye on the cash machine was soon to follow.

In 1956, James Dean as Jim Stark in Rebel without a Cause painted the definitive portrait of tortured youth. In a role he was born to play, and having died in a violent car crash before the film was even released, Dean embodied the bruising alienation and eternal conflict of a heart forever broken, and its desperate search for love in all the wrong places.

His performance remains an indelible classic of teen angst incarnate, made even more delicious by the backroom gossip-mongering, which painted Dean as a promiscuous bi-boy with a penchant for pain, who enjoyed having cigarettes extinguished on his chest and arms. Gorgeous, rebellious, and a masochist! What a charmer.

With his brooding good looks, dirty pompadour, rolled-up blue jeans, and tight white T-shirt (sales of which soared after the release of the film), James Dean remains the fashion icon of the late 1950s, whose stylistic cool has been endlessly parroted by suburban bikers, rockabilly revivalists, Hollywood actors, and gay men the world over—rarely, however, to such immaculate perfection.

Before presidential elections became the fodder of multimillion-dollar television commercials espousing dime-store rhetoric, the lowly T-shirt was the perfect place for on-the-fly campaign marketing. Beginning demurely in the late 1940s with "Dew it for Dewey" and "I like Ike," and expanding into the 1960s as a psychedelic explosion of political protestations where every hippie, yippie, druggie, and doper promoted the scribbled mantras of "Make Love Not War," "Turn On, Tune In, Drop Out," and "Black is Beautiful"—emblazoned in foot-high letters across the chests of an entire generation—the T-shirt had finally cemented its place in history. The slobification had begun!

The high-drama posturing of Glam Rock and its gurus—T. Rex, Roxy Music, The Sweet, David Bowie, and The New York Dolls—was a direct rebellion against the dirty hippie look of the late 1960s, which stunk of low-slung jeans, unwashed feet, and tie-dyed T-shirts bearing peace symbols and political slogans. Glam meant that no matter how homely you were to begin with, if you'd just slap on enough blue eye shadow, a pair of skinny metallic trousers, and a skin-tight T-shirt two sizes too small, you might not actually look any more glamorous (Slade, Alice Cooper) but at least you'd be making a statement that loudly and proudly proclaimed not only that you were an individual, but that you were secure enough (or silly enough) to accept a backlash of abuse, both verbal and physical, because your very presence was a challenge to the status quo. The personal is political!

But what started off with the sexy promise of androgynous pretty boys dressed in platform shoes, glitter tube tops, and slutty makeup—vamping it up on stage as they tongue-fucked the guitarist's fingertips—quickly degenerated into an open invitation for freaks everywhere to dress up, get down, and play drag queen. Not so pretty after all. Glam died off young, and left a bloated corpse, kicked in the crotch and shuffled into the rubble by its snotty kid brother, Punk Rock.

But back to Brando. Richard Hell was a hunky boho from Lexington, Kentucky, who hit New York City in the early 1970s, hoping to cause a ruckus. Possessing the swagger of a young Brando, the twisted charisma of the ghost of James Dean, and a pocket full of Rimbaud, he sung sexy come-ons like "Love Comes In Spurts," "I Could Live With You In Another World," and what would become an anthem to the next wave of alienated youth, "Blank Generation," which included the opening line, "I was saying let me out of here before I was even born, it's such a gamble when you get a face..." Hell redefined the male mystique with his smudgy bedroom eyes and his full, succulent pout; he often posed shirtless, barefoot, and with jeans provocatively unbuttoned, daring you to stare. Credited with originating the look that would become an enduring punk cliché, Hell was the first rocker to spike his hair, rip his T-shirts, reattach them with safety pins, and scrawl across the front in magic marker—in 1974.

Hell may have initiated the punk aesthetic, but it was the master manipulator and fashion victimizer Malcolm McLaren who exported the idea back to his UK clothing shop, Let It Rock (a.k.a. Too Fast To Live, Too Young To Die, a.k.a. Sex, a.k.a. Seditionairies, a.k.a. World's End.) Together with his partner, the radical fashionista Vivienne Westwood, they conspired to commodify the original concept of Punk and nurture their already subversive fashion into a larger role in the smoldering cultural revolution, which would spontaneously combust in Thatcher's England.

A marketing genius, McLaren was savvy enough to realize that a radical new fashion statement would best be promoted by a complementary soundtrack. He gathered together four juvenile delinquents who had been caught on numerous occasions pilfering over-priced T-shirts from his store (since no real punks could actually afford to shop there), propped them up with musical instruments, shoved a microphone into the snarling mouth of the pimply-faced lead singer, and inspired them to make a hell of a racket.

And thus the Sex Pistols were formed and molded under McLaren's hawkish watch. Coifed, quaffed, and dressed to overkill—replete with FUCK YOU attitude—the music mimicked the image and was wielded as an offensive weapon against apathy, conformity, and all forms of authority—exactly what Westwood's scandalous clothing had been bucking against since the outset. The four young thugs needed little prompting to solicit an outrage, especially when decked out in bondage pants, brothel creepers, and one of Westwood's controversial T-shirt designs—such as the still-shocking DESTROY, the word writ large in vibrating capital letters splashed across the top of a massive Nazi swastika stamped upon an inverted crucifix, on top of which appeared a small portrait of the Queen Mother. The whole glorious mess was a riot of crude graphics, bold colors, and sloppy lettering that would soon become every budding Punk rocker's silk-screened wet dream.

McLaren and Westwood may have been clever enough to capitalize on music as a tool to call attention to their incendiary clothing, but it didn't take long for a movement to begin, triggering a maelstrom engulfing almost an entire generation into a noisy, chaotic, rampaging mass that rebelled against repression, threatened anarchy, and insisted that the revolution would be supported neither by state, church, government, nor corporate sponsors. Punk Rock exploded and created a do-it-yourself aesthetic that proved anyone who wanted to badly enough could beg, borrow, or steal a guitar, think up a cool name, start a band, make some noise, create a logo, print up a box or two of T-shirts, and sell them out of the back of their van to a handful of fans after the gig.

Whether you bought one out of camaraderie, were given one after making out with the lead singer, or went home jacked up by the energy of the gig to custom-make your own tatty design, you were expressing support for fellow members of a loose-knit community of wandering gypsy minstrels, who, like you, valued the music over its sale potential, creativity over commerce, and the individual's sense of self over the group-think of the collective mob's store-bought style. And you can't buy style any more than you can fake a rebellion just by buying a ready-made carbon copy of what a million other clueless fools are wearing this season.

And that brings us to this book. Cesar Padilla—collector, writer, director, musician, entrepreneur, instigator—has assembled within these pages hundreds of classic examples of rare and extremely limited T-shirts, which were created by the very bands who embodied the true essence of the DIY movement. It exists to remind us of a time, not so long ago, when what you actually said and did—the music and art you actually made yourself—and a spirit of real rebellion were far more important than the number of idiots you could connive into coming to the show.

Lydia Lunch

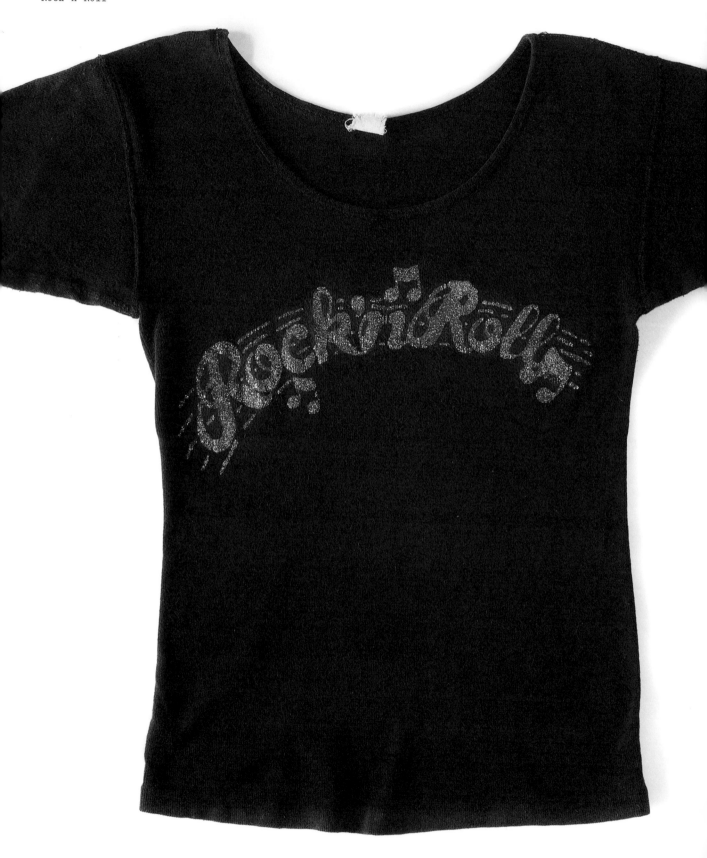

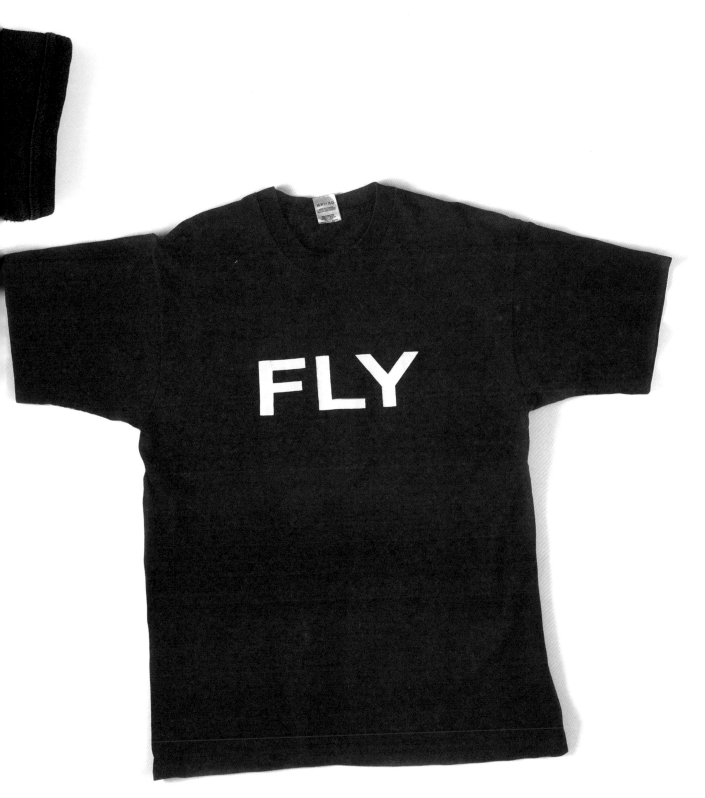

Yoko blew my mind.

Cesar Padilla

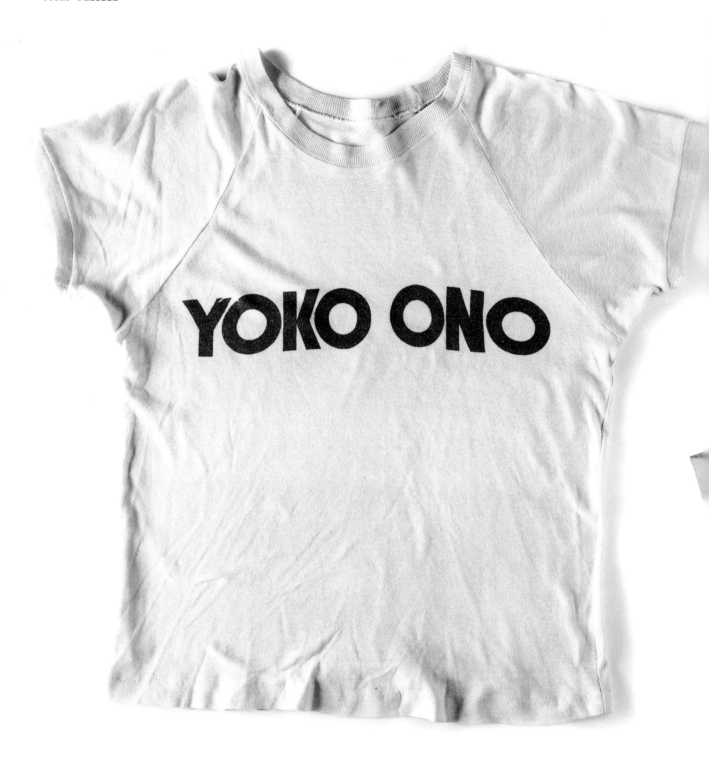

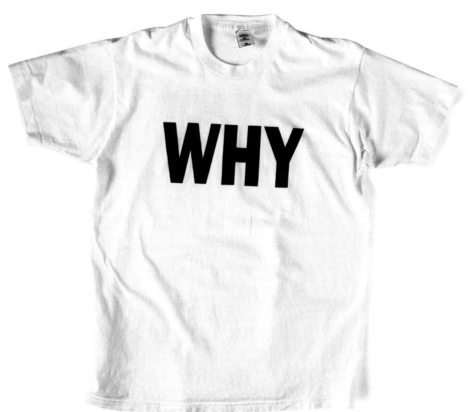

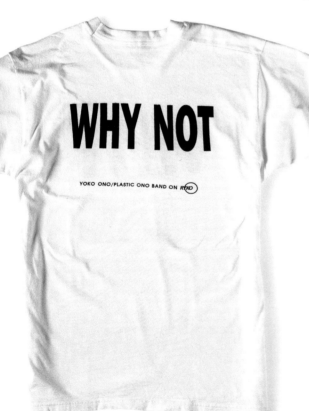

YOKO ONO/PLASTIC ONO BAND ON RYKO

Yoko Ono and John Lennon made shirts that had words
from their art shows. For her show "This is Not
Here," Yoko had shirts made with those words, and
also "You Are Here," which was one of my favorites,
and one I wore often when I wasn't wearing the shirt
that said "New York City."

The "New York City" shirt was homemade by some
guys who sold them on the sidewalk in Times Square
and I usually bought several of them at $5 each
whenever I saw them out. I wore them all the time
and gave some to friends, including John Lennon.
When we were taking photos on his rooftop terrace in
1974, I asked if he still had the shirt I had given
him, and he went and put it on and we took a now
very famous photo of him wearing it.

Bob Gruen

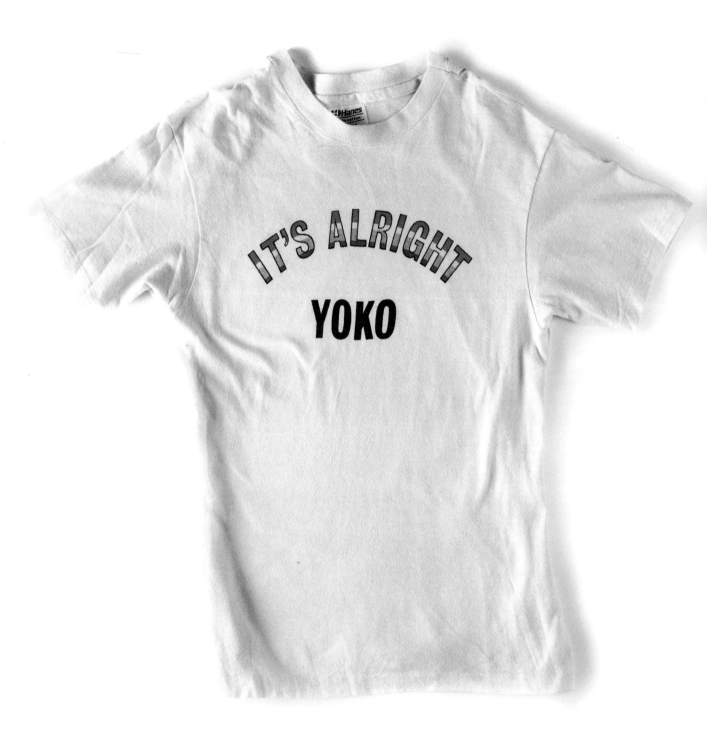

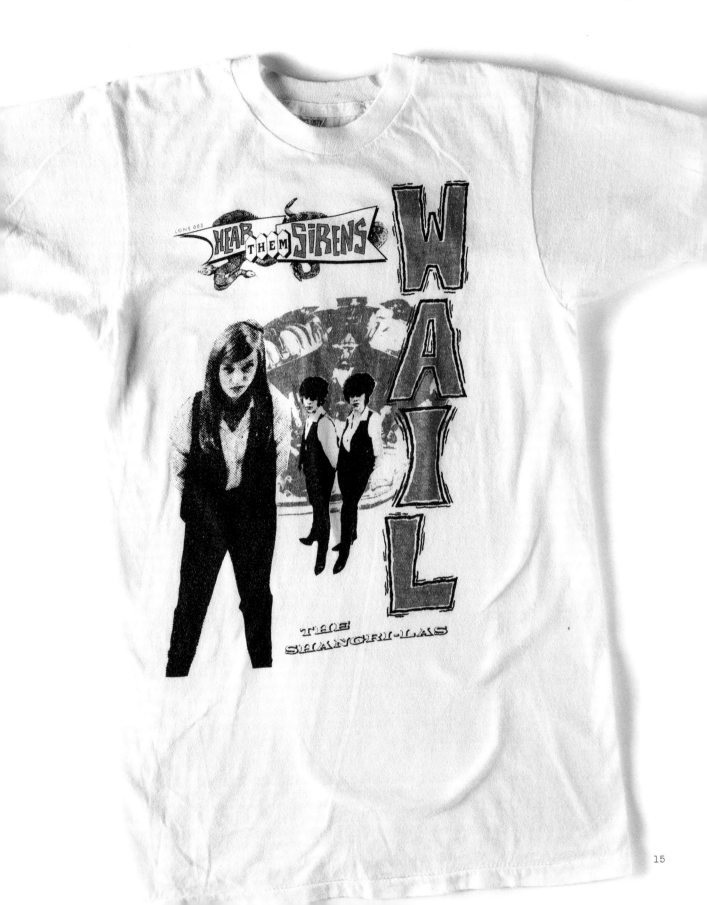

The Who

Love

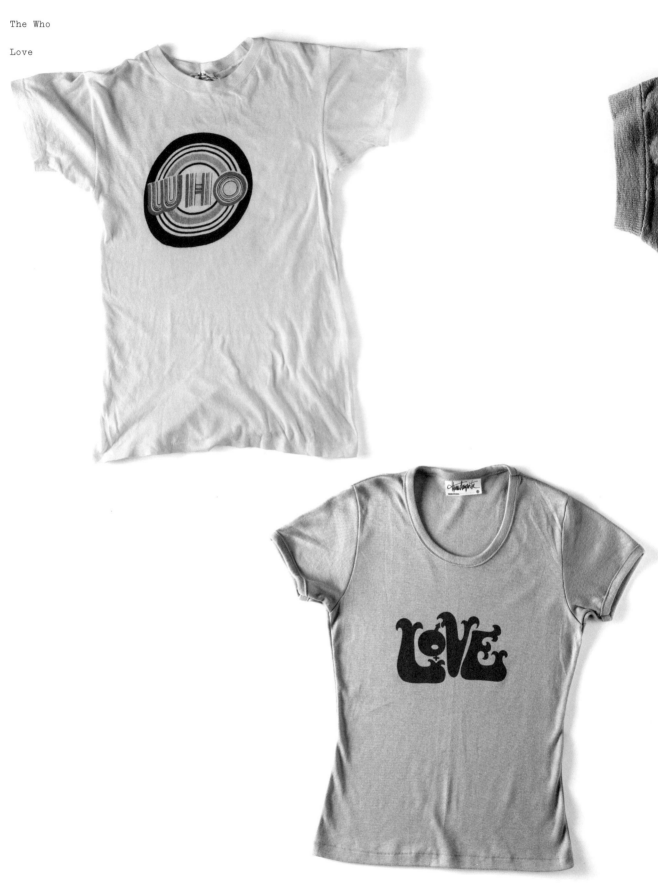

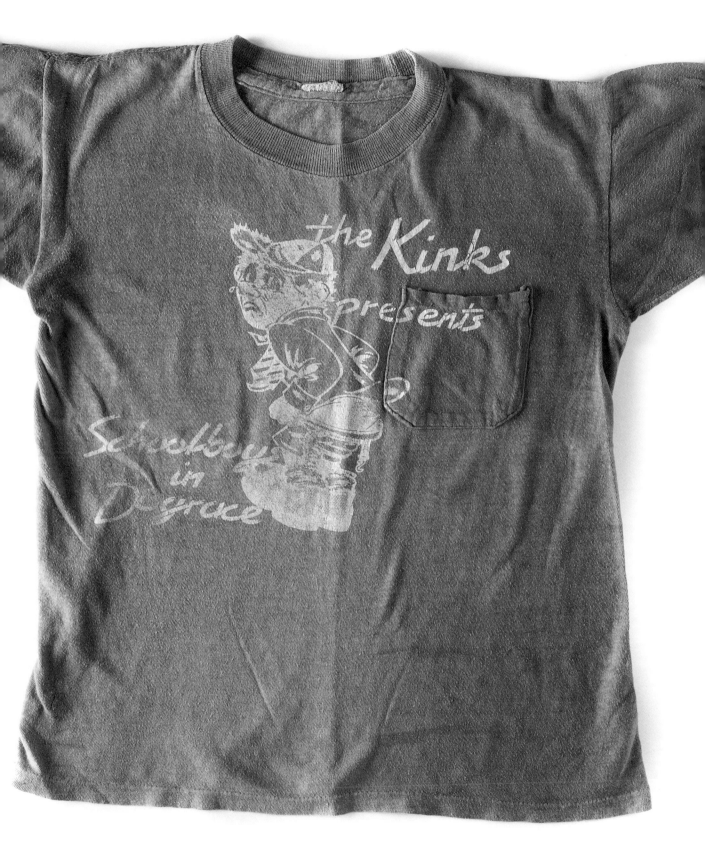

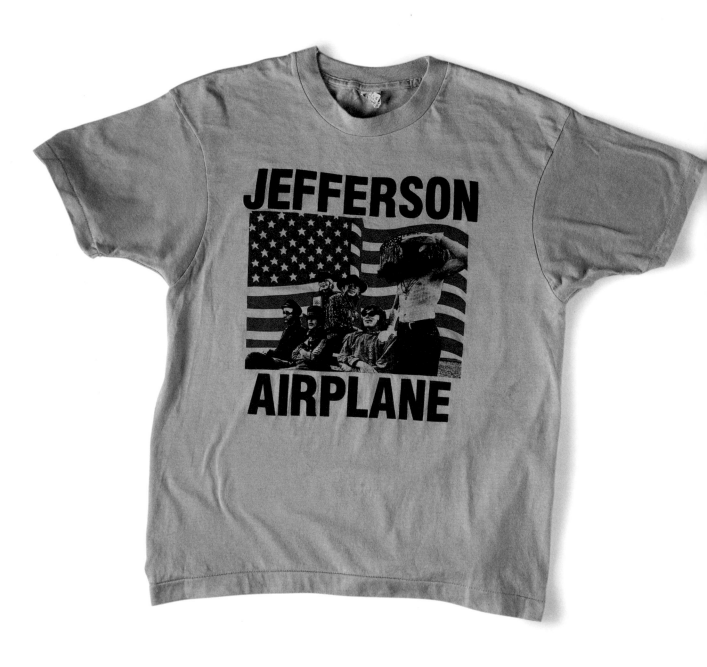

The first T-shirt I remember seeing with words on it was in the late 1960s at the party for the <u>Jefferson Airplane</u>'s new record company, Grunt Records. I couldn't understand why anyone would want to wear a shirt with the word Grunt on it. In those days a T-shirt was underwear, something you wore under your shirt and certainly not in public. At the Newport folk festivals in 1964 and 1965, even people camping out on the beach wore a shirt with a collar, or, if casual, a sweatshirt which might have the name of a college. By the time of the Woodstock festival in 1969, people were wearing T-shirts with words and pictures.

By the early 1970s there were so many record companies and bands putting their name on shirts that my art director friend Dominick Sicillia made a shirt with the words "This Space For Hire," like they used to write on unused billboards. I agreed with him, I didn't understand why someone would advertise for a company without being paid for it. In the 1980s when people started to wear shirts saying "CK'" or "Coca-Cola," I was really confused.

Bob Gruen

The first time I played with The Sun Ra Arkestra in 1967 at the Community Arts Auditorium at Wayne State University in Detroit, they were wearing Afrocentric garb. Dashikis, kufis, Egyptian headdresses and robes. That kind of thing. They looked great to me.

As a result of some powerful LSD, I convinced my fellows in the MC5 that we needed to up the ante on the way we dressed on the gig. Before this point, we had the look of the day, which was British first wave, London/mod style. I had always admired entertainers who wore bright colors, like the sharkskin suits of the great R & B acts. I loved sequins and bright colors. I loved band uniforms. Still do. There was a fabric shop down on Woodward Avenue and we went down there and picked out the most fabulous materials right from the bolts. Beautiful gold, silver, multicolored metallic materials. There was so much to choose from. My vision was that we should look spectacular on stage! I wanted to blind the audience from the reflection of the stage lights off my clothes. We got deep into it, designing all our own outfits. My girlfriend could sew, as could

other women in our camp, and in a short while we had a look that was pretty unique for a bunch of thugs from Detroit. Not that we were all that original. There were a few other bands that seemed to be dressing more flamboyantly, too. Certainly more picked up on it as time went on. Later it was dubbed "Glam." Whatever. Maybe all those other bands took the same acid.

Over the next few times we played with Sun Ra, little by little the dashikis were phased out and a new look came in. They had discovered colored metallic fabrics and sequins, too. And they looked absolutely beautiful, intergalactic. And they still do. Now, I can¹t say for sure, but I would be happy going to my grave thinking that maybe I gave a little sartorial inspiration to one of the greatest bands in history in return for all they gave me.

Incidentally, I never once considered playing in a T-shirt. I don¹t think I ever have and I doubt I ever will.

Wayne Kramer

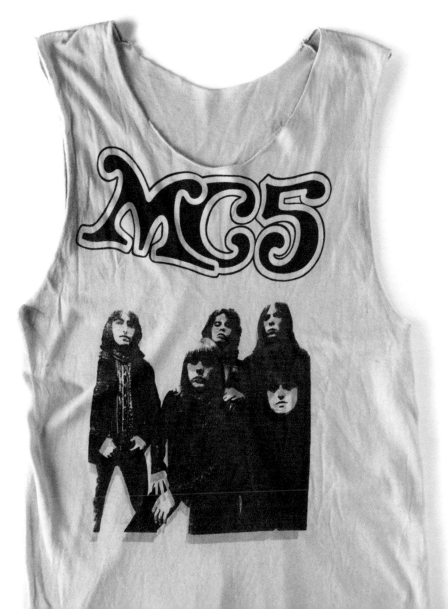

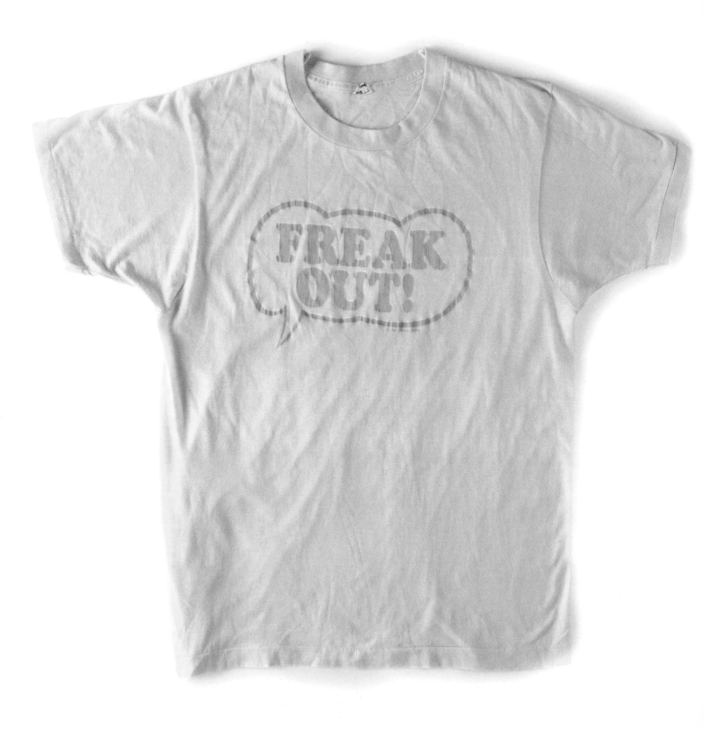

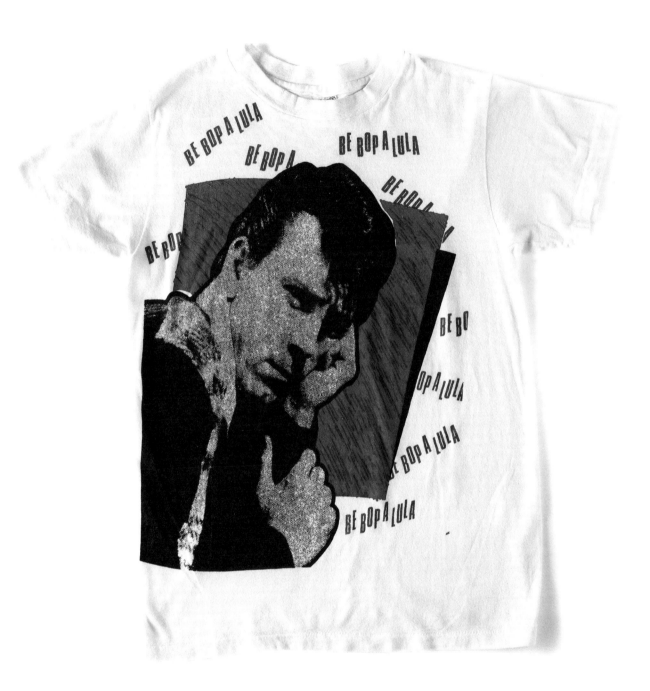

Gene Vincent

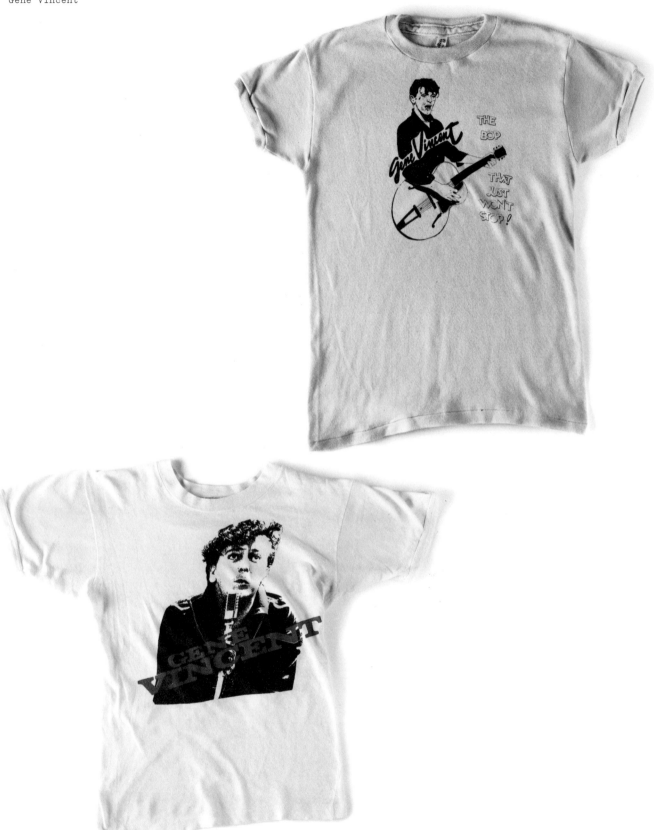

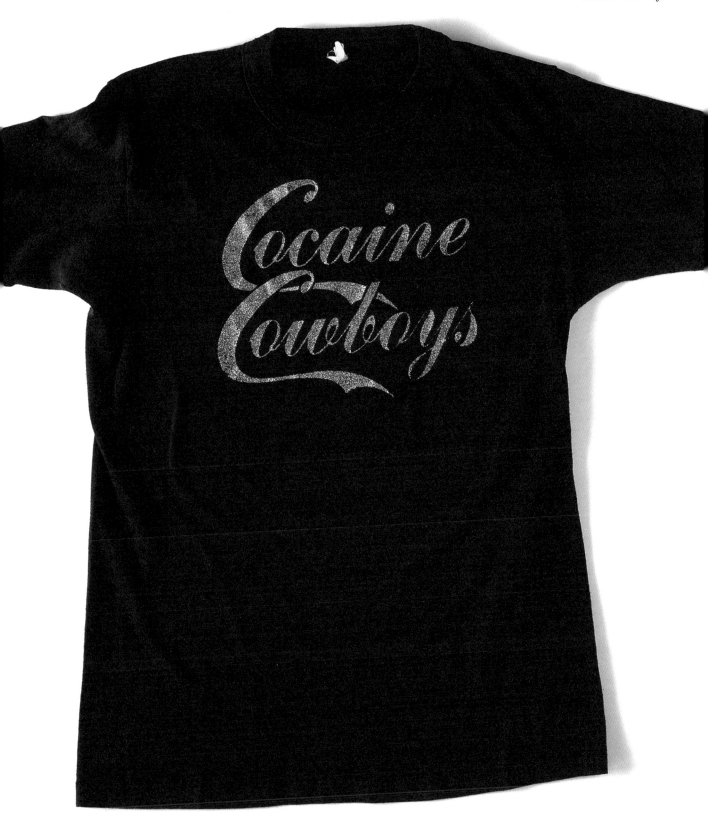

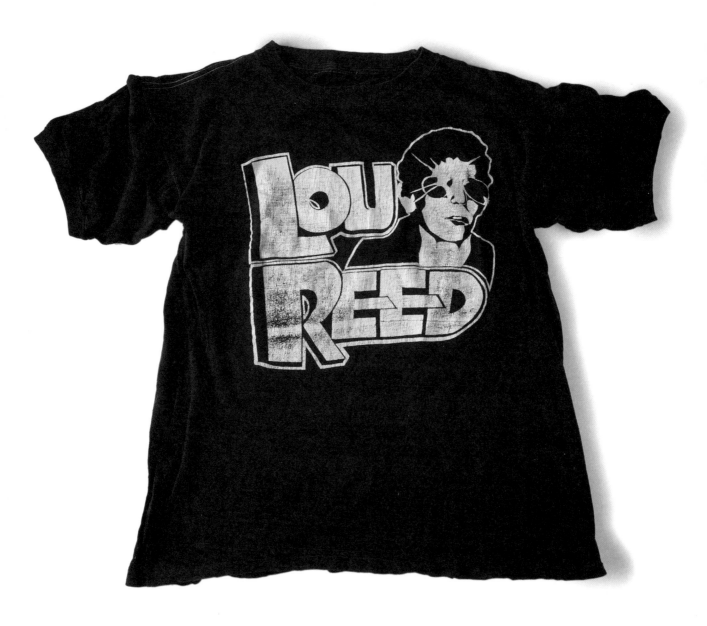

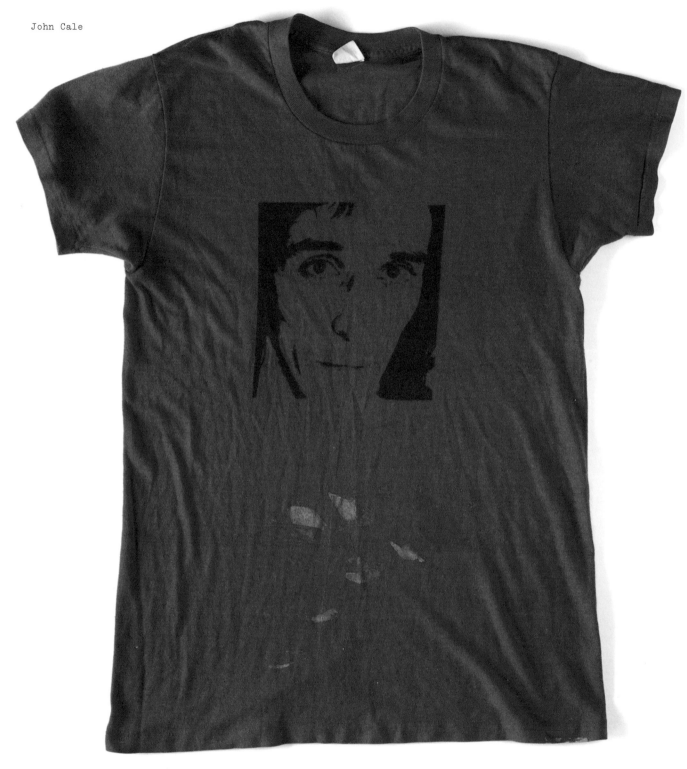

This was my most favorite T-shirt because it's my favorite band, musician, husband, John Cale from the Velvet Underground. It's a great black image of John's face on a scarlet-red normal T. Super-thin and soft, since it's almost forty-five years old, I gave it to Cesar—and I wish I still had it.

Betsey Johnson

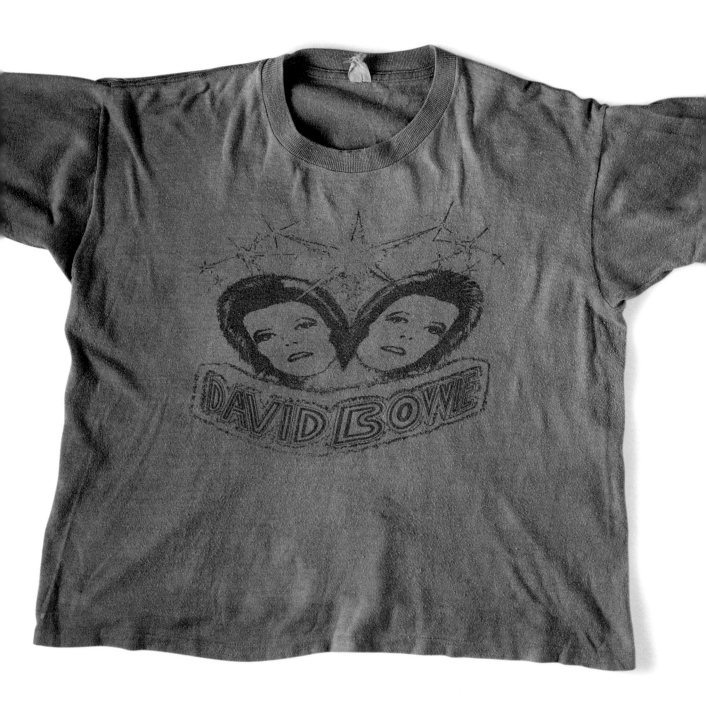

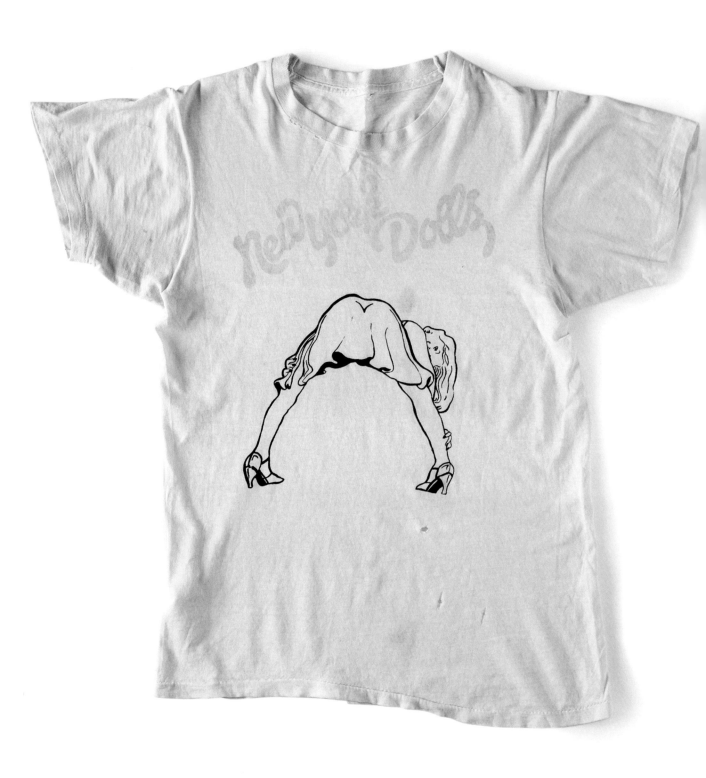

In Doll days we bought kids' T-shirts from the bins on 14th Street so they were tight tight tight. We made the armholes and necks bigger and wore them with a "pussycat bow" at the neck made out of two layers of wispy nylon scarves that were meant for granny's bouffant. If you layered, say, pink and black, the scarves would pulse with a moiré pattern. A poor girl's iridescence. This was going on above toreador stretch pants with tights, not knickers, underneath. The Doll crowd came gift-wrapped; pull the bow and peel.

Judy Nylon

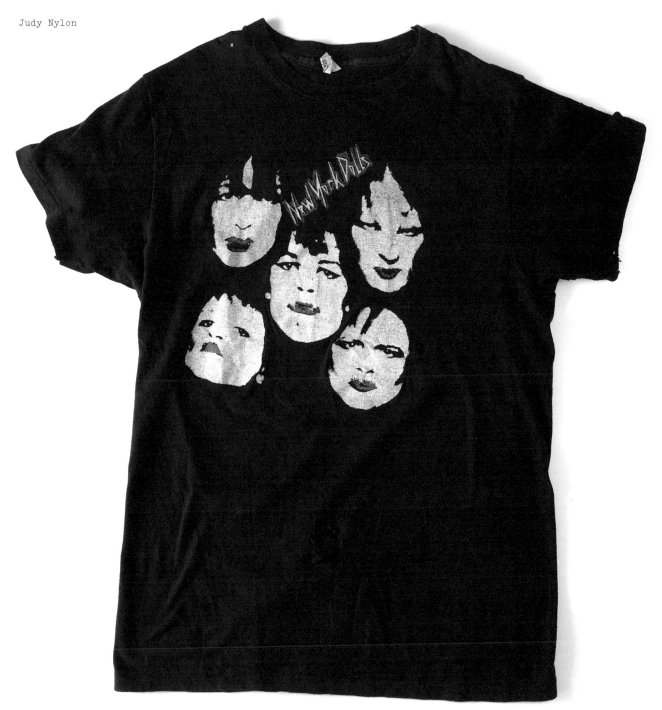

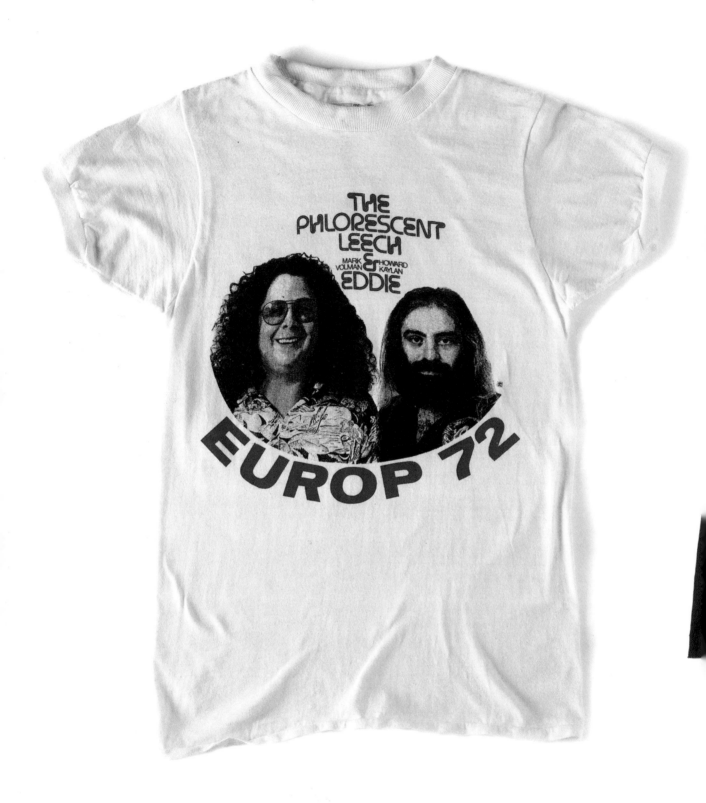

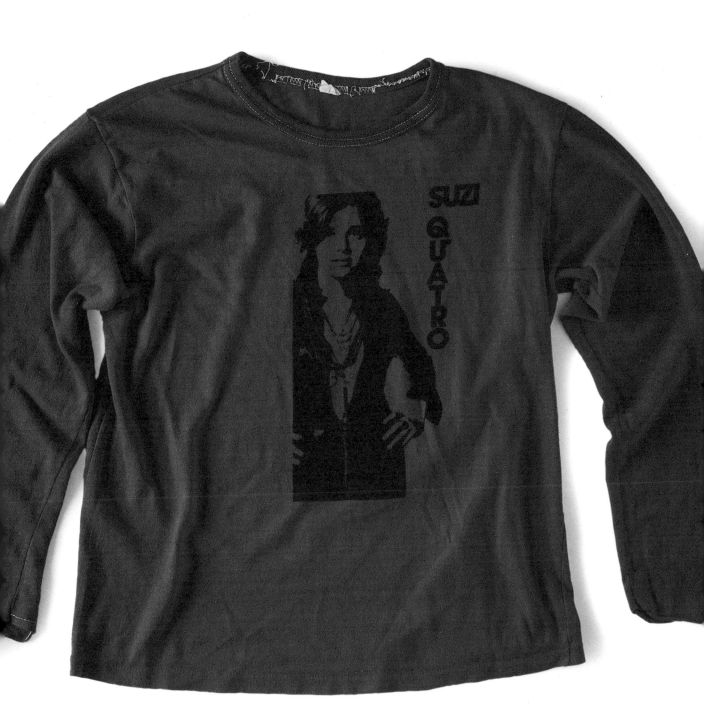

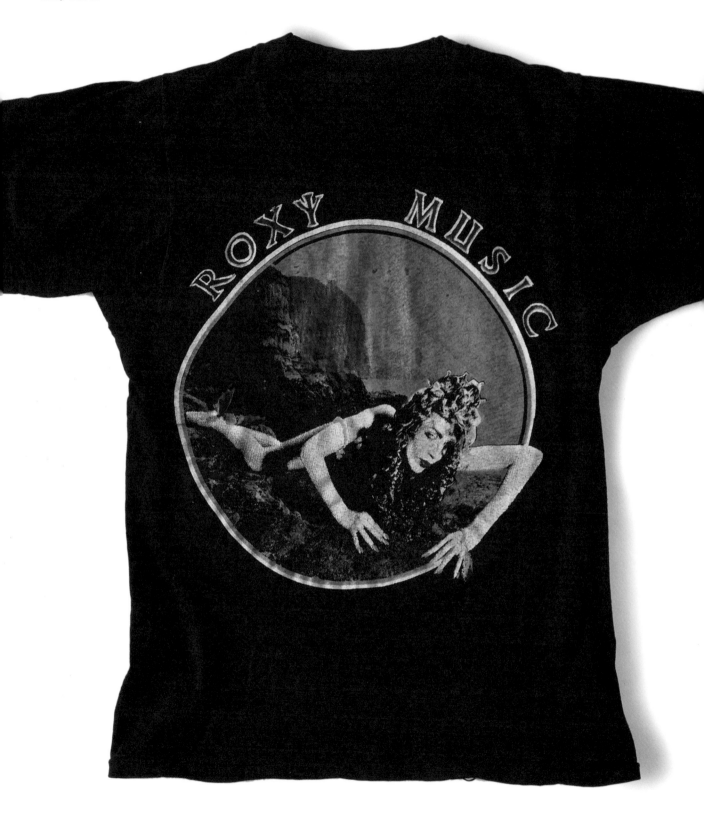

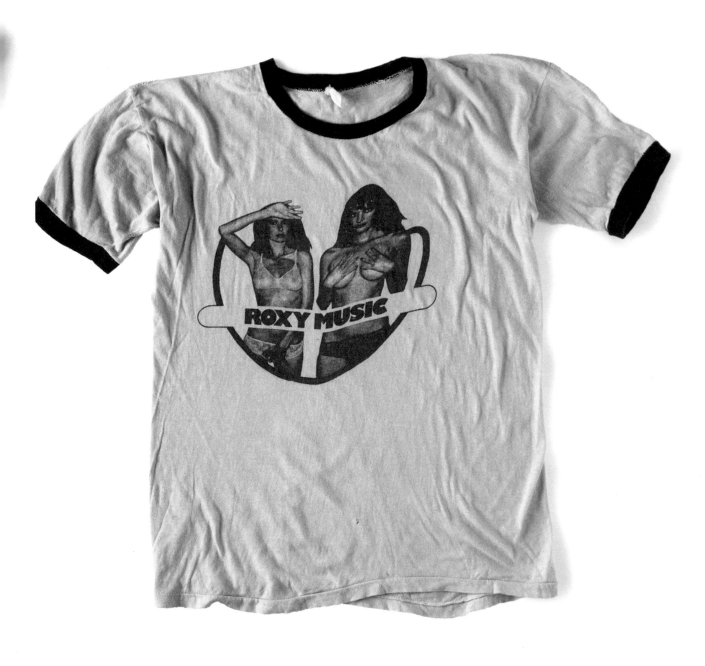

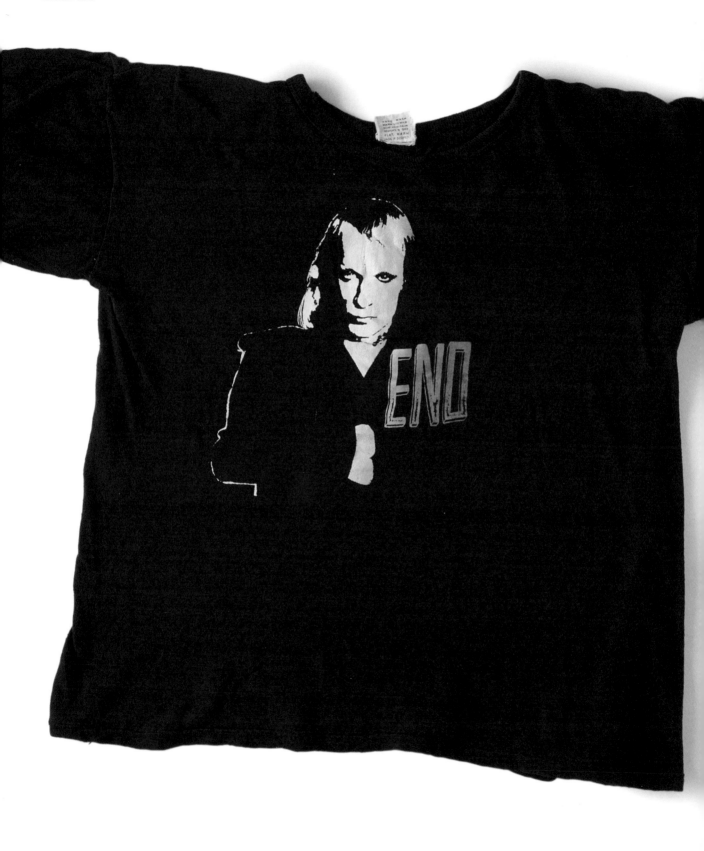

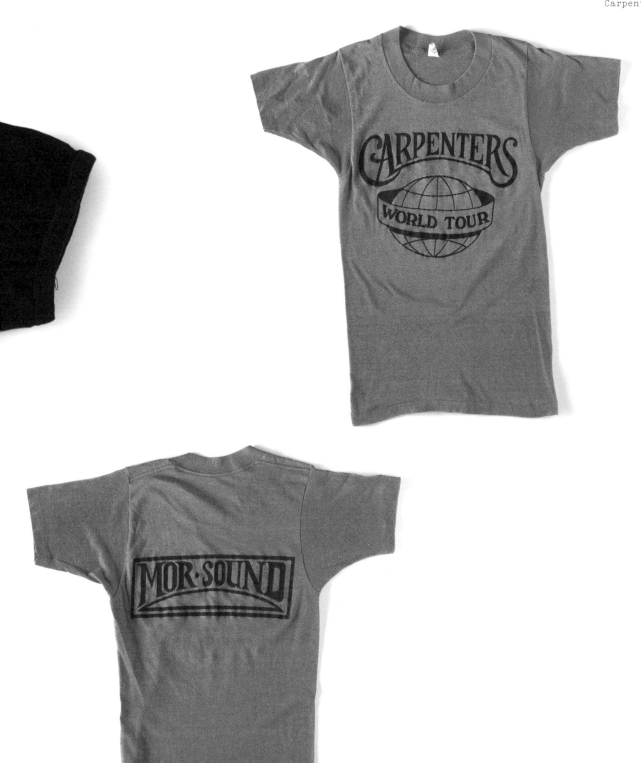

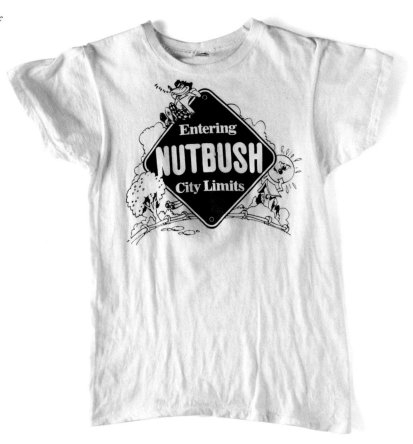

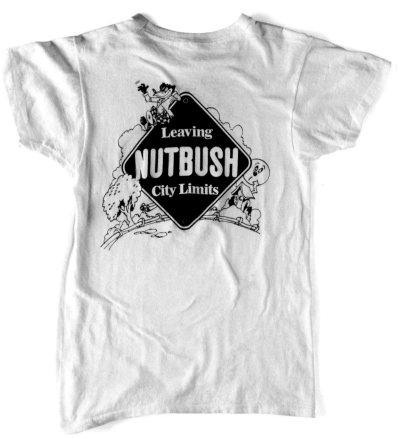

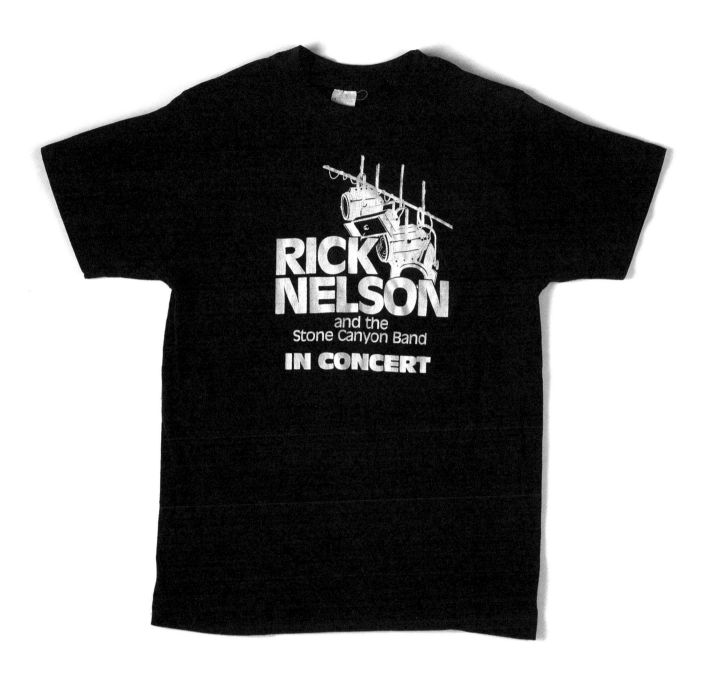

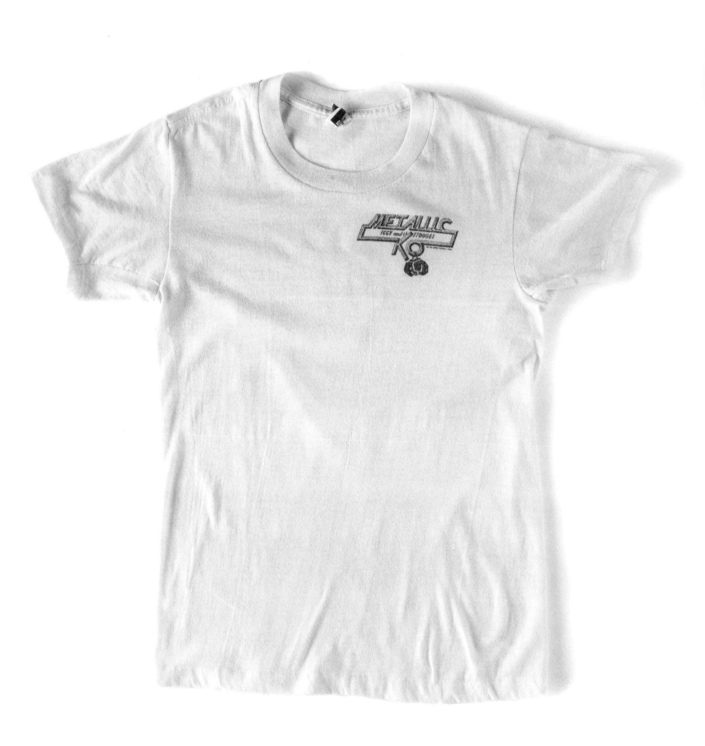

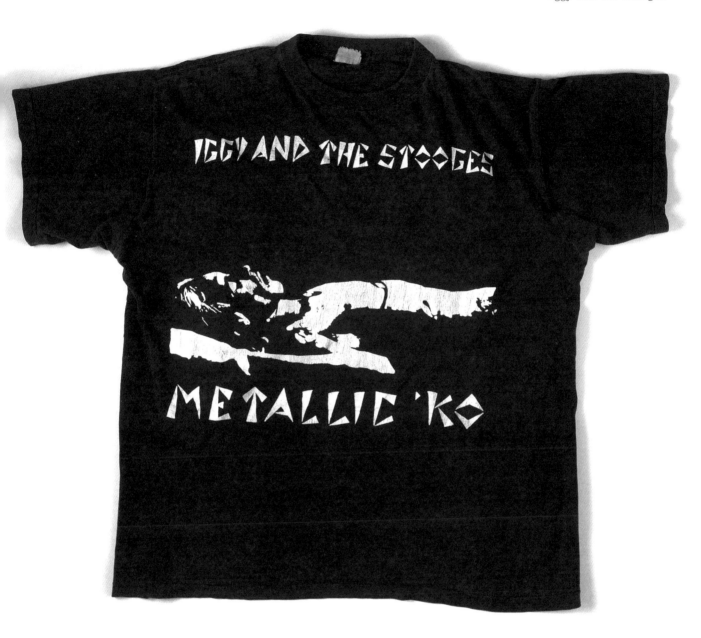

Five and a half years I got to spend some time in the Stooges classroom, learning from the most interesting of gentlemen: Ig was culture, Ronnie was history, Scotty was nature, and Steve was politics. Fucking amazing cats... and the music they made—oh my god... How much stuff do you get second, third, fourth-hand, and here I was, right at the fucking source! I knew D. Boon was laughing his head off, telling me, "You know you owe these guys your best notes." I totally did, and worked my hardest... I was there to learn. The biggest mindblow of my fucking life.

Mike Watt

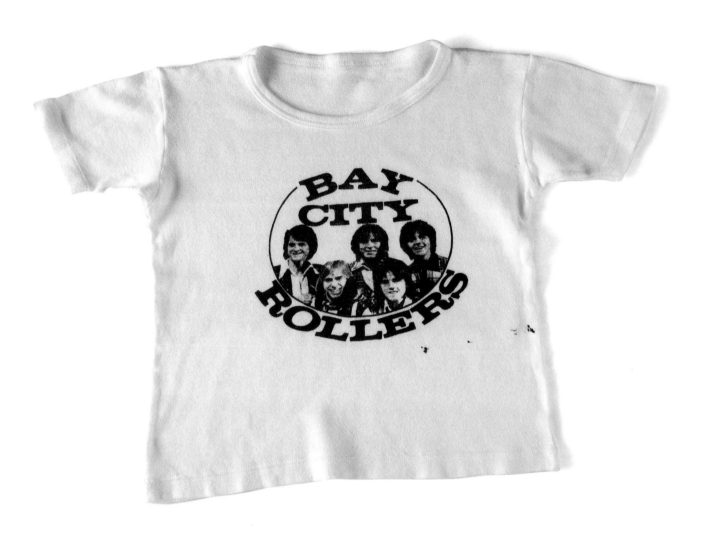

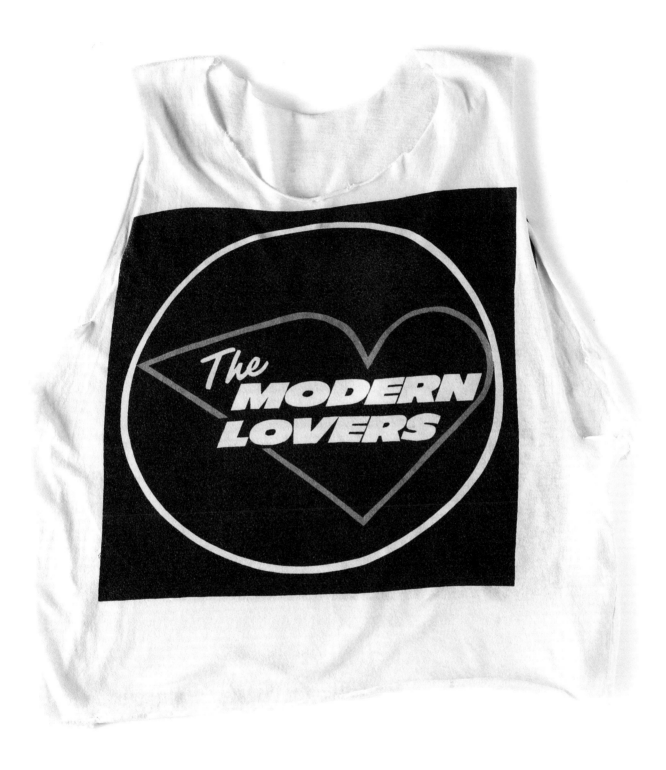

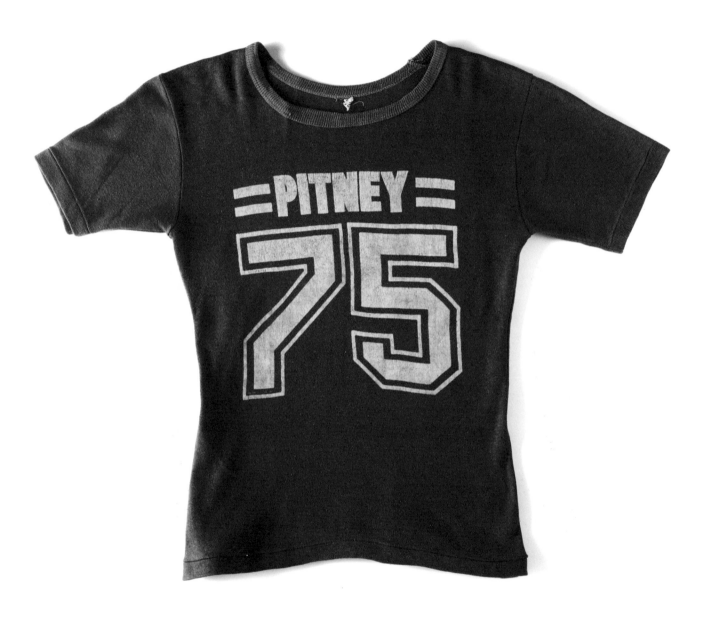

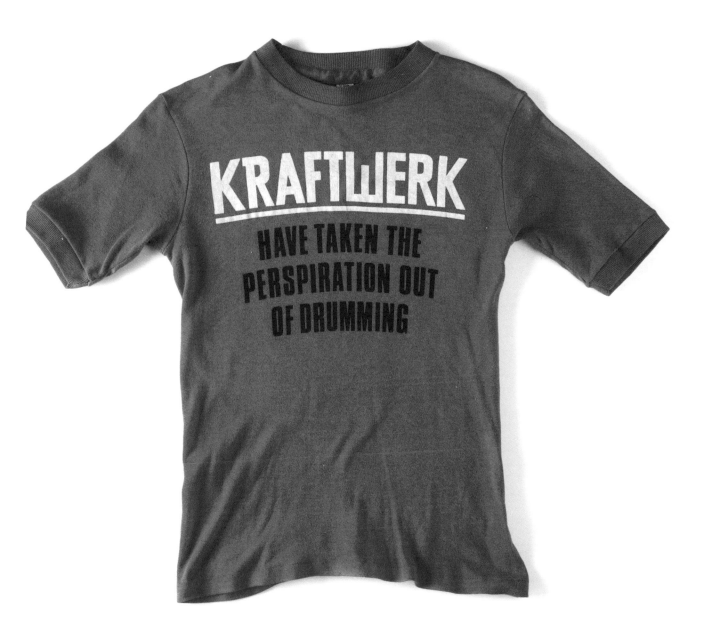

Blondie

Ramones

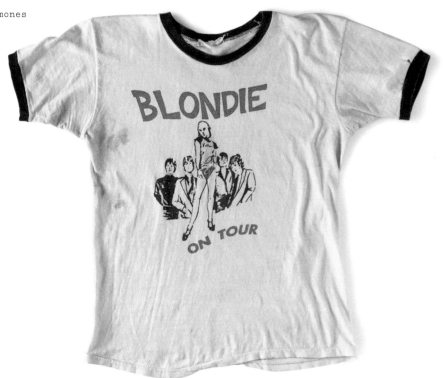

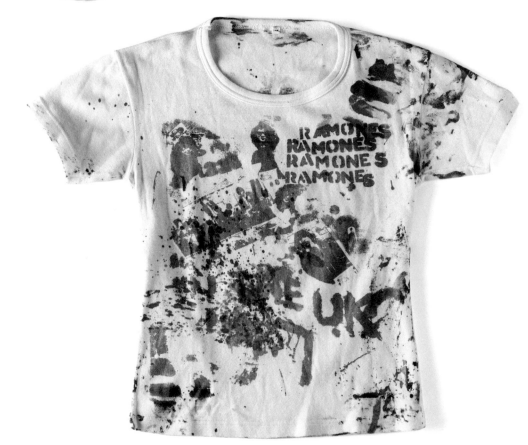

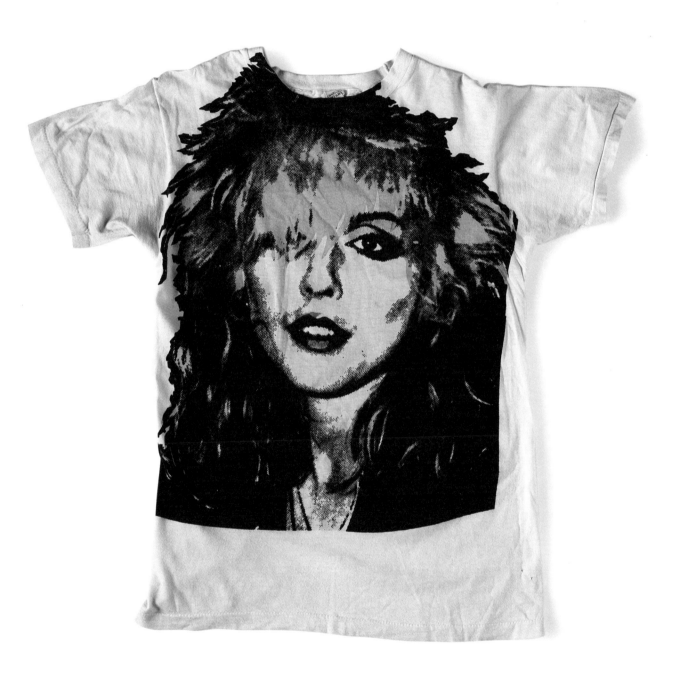

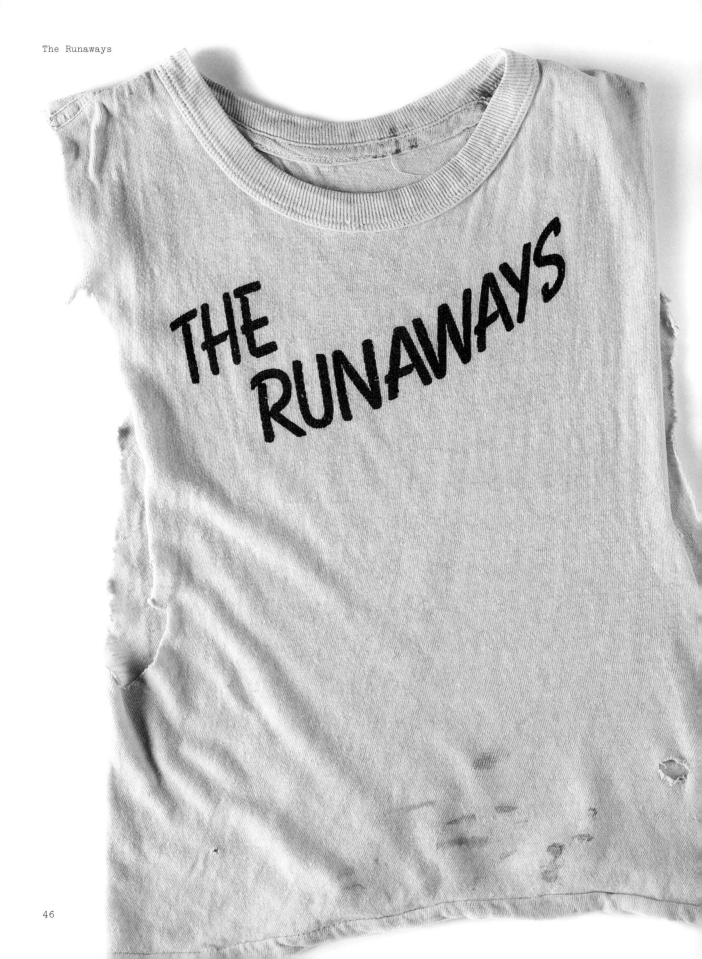

In the 1970s, the vacuum sound that Tucson, AZ, made was audible. You could hike up nearby mountains, turn, and see the horizons of all your opportunities. Everyone you knew and everywhere you went was visible. Beyond the scope of the city there was open desert. Uninterrupted south to Mexico, west to California.

We hoped and waited and created things to do. Drinking age then was a rough-and-tumble nineteen years old—fresh out of high school and into the bars. Fake IDs everywhere. How hard is it to pull off the mature stance of someone nineteen years old?

The outside world was a distant one. Our interest in new music could only be fueled a few ways. Rock journalism was at its peak—that sweet pipeline to the desert. One of the bands we discovered in the pages of Rolling Stone was the Runaways. Sure I remembered Suzi Quattro, but this was different. I had found the records and although it came off like boogie rock you could not help but be both impressed and curious. Tough as nails, the impression was that you could get close but one of them might burn you with a cigarette. I was always attracted to girls with a criminal background... Mall shoplifting challenge, doing drugs in the cemetery—you know, all the fun stuff of youth.

As refreshing as the desert rains of late summer, occasionally musical relief would come. The local rock bar the Night Train had announced an appearance by the Runaways. Usually only the most hateful of cover bands would play the Night Train and we would go and heckle them. Like hunting dodos, most of these acts had no ability to fight off our attacks. We would hold them to task. Shouts of "Play something original!" and the occasional "You suck!" would come from our table. After all, there was a reputation at stake. Another band opened but nobody gave a shit then or now. I'm sure we scolded them. Besides the employees, there were maybe four other people in attendance. After all, a flame can't burn in a vacuum.

That was not the case when the Runaways played. Cherrie Currie was gone. I was always saddened by the loss of the original lineup with any band, and I was prepared for perhaps a little less "jailbait." They came out dressed in all-black leather. Commanding Marshall stacks they faced that empty house and rocked fucking out. They played with such authority and power you were crushed in your seat. Joan Jett sang and I could fucking care less about Cherrie. Shock spread through the building. There weren't any women taking such a stand in rock and roll at that time. Although they were embraced by the open-minded punk audience, clearly there were stadium aspirations here. Professional and competent in every way. All twenty eyes in the building were fixated on these girls from California. They seemed a little taken back when we actually proved we were familiar with their material, yelling and applauding from our table when a song was introduced. It must have been strange for them to actually be there. They carefully slaughtered everyone at the Night Train. I wanted to thank them, smell the leather as it was. But I was afraid one of them might try to burn me with a cigarette.

Jack Waterson

I am a T-shirt whore. I covet the humble item the way gold-diggers want diamonds. At my age, wearing one is not quite as attractive as it used to be, and I lean toward a tailored button-up. Nonetheless, I can't stay away from them. I count at least four hundred in my personal collection and I'm always trolling for new ones. Thrift stores, vintage stores, yard sales, even the god-awful tourist haunts have at least one beauty of superior design to gaze upon. I have even been known to dumpster-dive and dig shamelessly through other people's garbage with the slightest hint of a T-shirt peeking out. I have been yelled at, dissed, dismissed, and chased off with brooms by angry Ukrainian ladies, but nothing can dissuade me from my relentless quest for the ultimate prize.

As a teenager I pined over the catalogues in the back pages of Creem, Rock Scene, and Circus magazines. I was too young and economically challenged to afford outrageous platforms from Fred Slatten or satin suits from Granny Takes a Trip. The T-shirt stated my allegiances without making too much of a dent in my magazine allowance. Rock Star T-shirts boasted the best of the Glam bands. Years later in the '90s, I found an old Bowie T from the same company, an electric-blue mirror "Rorschach" image of David's mug surrounded by stars on a red shirt. The combination of blue and red vibrated. My eyeballs shivered. I was so excited I felt dizzy. I think I may have peed myself a little.

A Los Angeles record store considered the Beatles to be their highest priority. As a result, a backroom refrigerator box filled with B- and C-list bands was all but forgotten, and the staff clueless as to their pricing. I casually concealed my excitement and bared my fangs at anyone who so much as looked in my direction. This was serious business—I had limited cash with me and wouldn't dream of leaving my rightful rock ancestry behind in the feeble hands of such yokels. I prepared for battle and pounced on a ribbed Slade shirt with a dorky cartoon of the band, and another baseball jersey with the Slade logo emblazoned on a fist and knuckles. "Rock On with David Essex" screeched out in bright red on a canary yellow shirt, the lettering so awful it broke my heart with low-fi joy. Roxy Music, Hawkwind, and an Alice Cooper Muscle of Love promo with a nautical sailor motif, and a Billion Dollar Babies tour as well. A lurid Stones "World's Greatest Rock and Roll Band," with a hand-drawn tongue dripping out of the mouth, leered out at me. I grabbed them all, and more. I even bought a scary old Uriah Heep, just to be an asshole.

I strove for a well-rounded rock vocabulary. I peacocked around town in my latest acquisitions and was received with admiration and envy by my peers. My treasures remain with me, the collection ever growing, under tight lock and key. In a world of uncertain changes and impending disasters, it's always good to go in with a smart T-shirt on your back.

Kari Krome

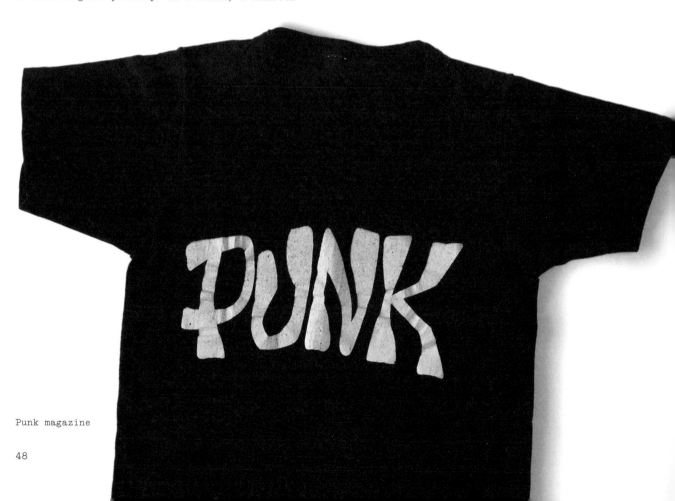

Punk magazine

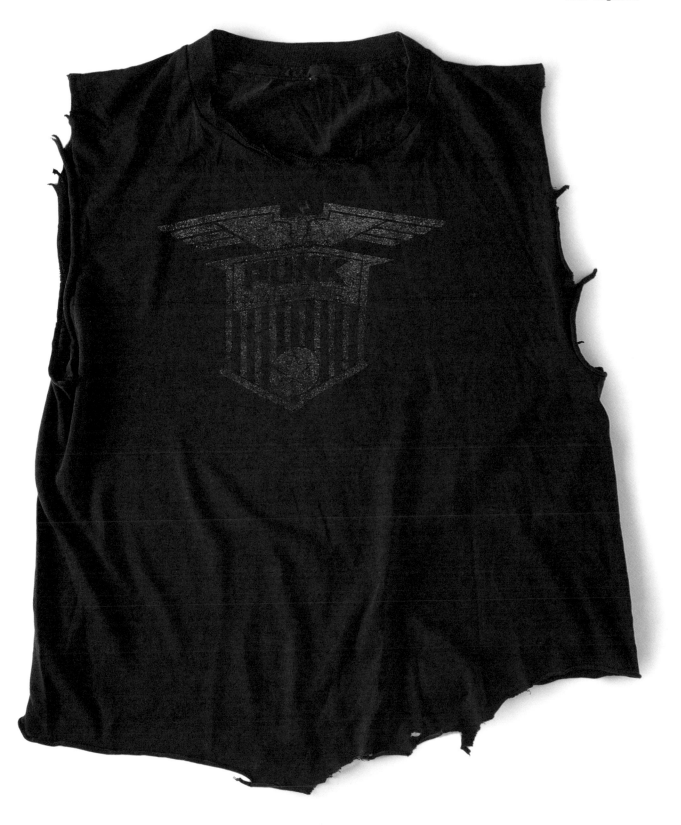

Sex Pistols

The Damned

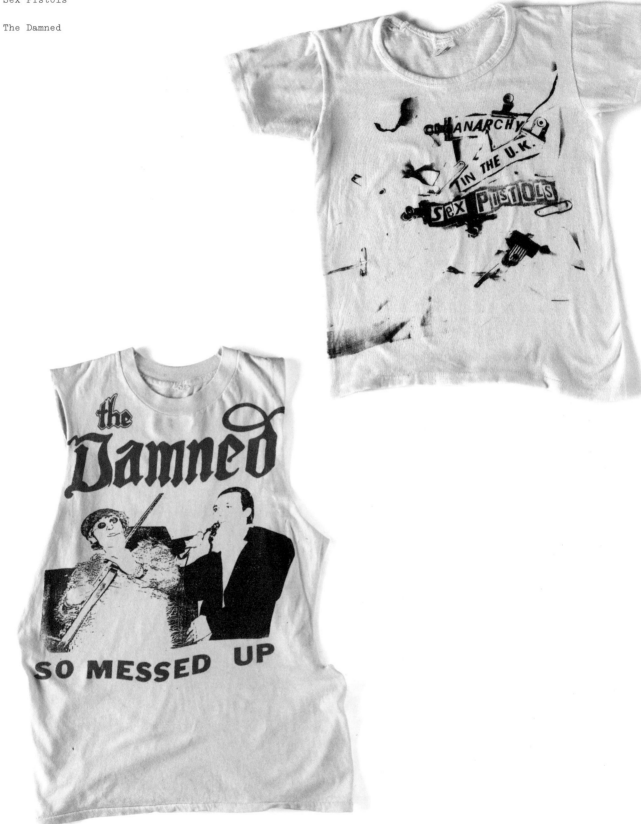

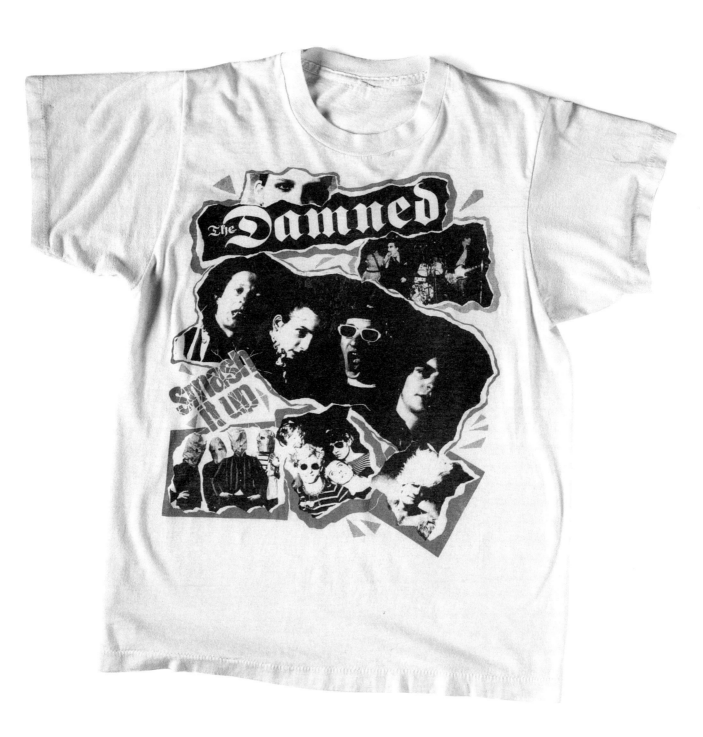

Johnny Rotten

Sex Pistols

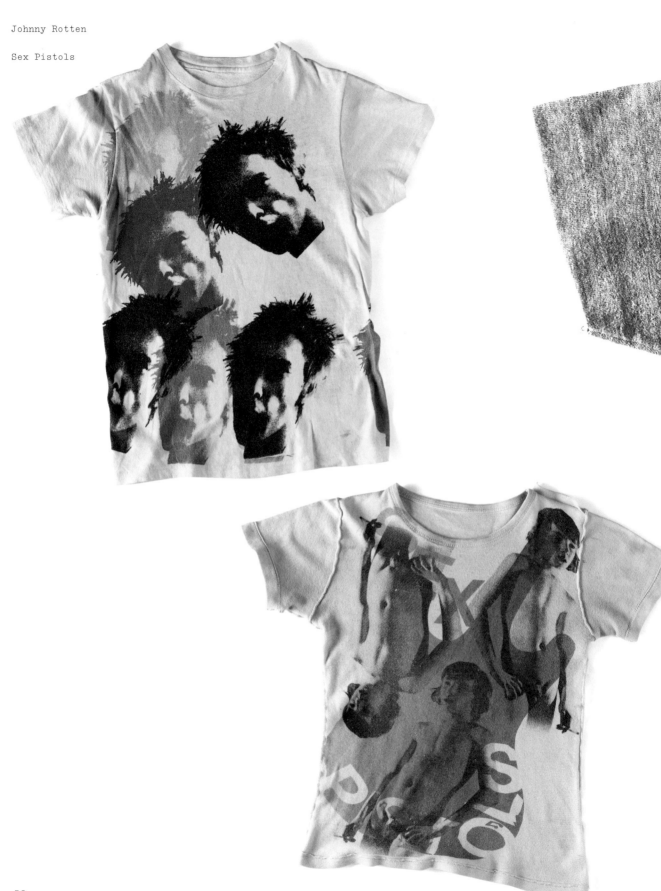

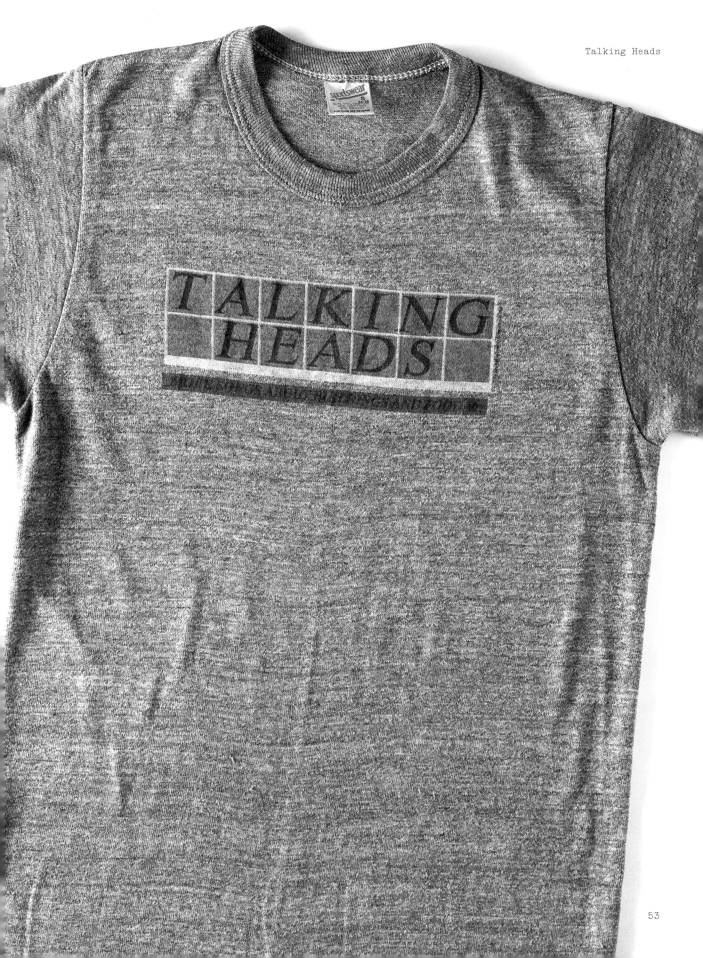

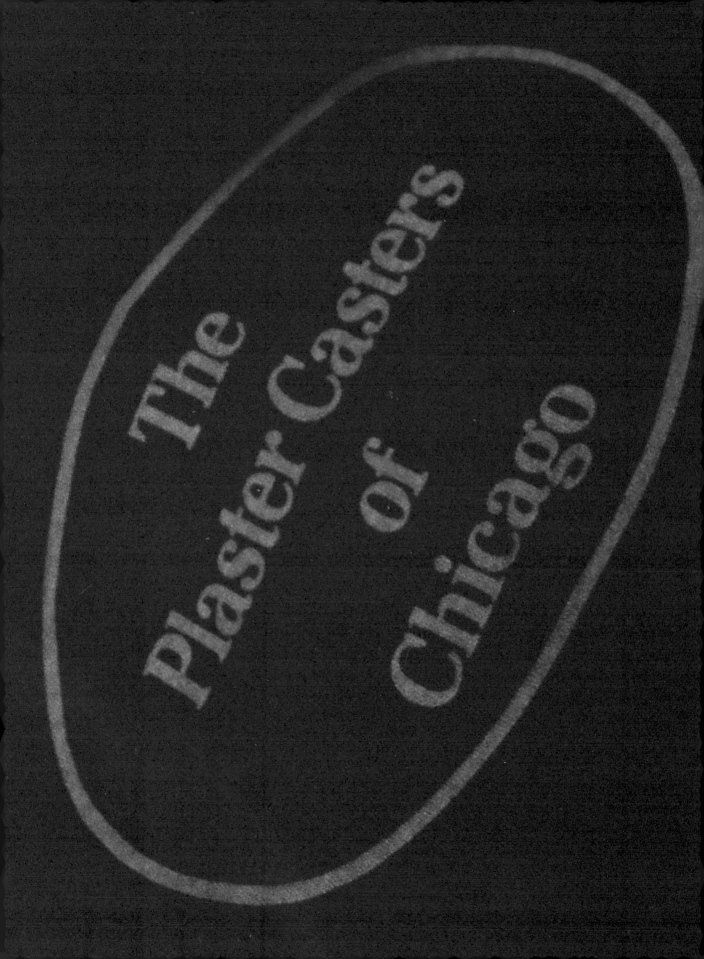

The History of the Plaster Caster T-shirt

In the mid-1960s, the combined forces of the British rock invasion, the sexual revolution, and teenage hormones hit one Chicago high-schooler like a ton of bricks.

After I became aware of the Beatles in 1963, my mundane life took on a whole new meaning. I lived and breathed all things George Harrison. And I wanted to learn more about that new acceptable form of recreation: sex without marriage. While the Beatles went on to conquer the world, a slew of other British bands bombarded the music charts and played concert halls in America. More and more reason for me to research this sex thang.

Thousands of other girls had the same lusty feelings for all these cute boys strutting their tight-trousered stuff on the Ed Sullivan Show. Some of us couldn't just turn the TV off and leave it at that. We wanted to take it further. Fall in love with and meet the band members—or the other way around. But easier said than done. With all that annoying competition, how was I ever to meet one of these gorgeous mop-tops?

My best friend Pest and I needed to figure out a way to stand out from the frenzied hordes of girls outside the bands' hotels. A few times we managed to get close enough to a few horny band members to make awkward conversation about hand-jobs in cockney rhyming slang. Then while I was an art major at college, I got a homework assignment that gave my life another whole new meaning.

One weekend in 1969, just as I was on my way out the classroom door to meet up with Pest and head for the hotel where Paul Revere and the Raiders were staying, my teacher told the class to make a plaster cast of something solid. I halted dead in my tracks. I had heard that men's crotches got solid—sometimes. By the time I met up with Pest, the light bulb flickering over my head was a raging six-alarm fire.

Pest and I asked the Raiders if they would be interested in helping with my homework assignment. They were.

Well, no penises were cast, but a lot more important stuff happened. I lost my virginity to the lead singer—just for bringing up this goofy plaster idea in conversation. Pest and I had stolen the thunder from all the other girls at the hotel, and became the talk of the tour bus after it left town. That weekend the Plaster Casters of Chicago were officially born. As for the homework assignment—I turned in a plaster cast of a carrot on Monday.

Out of earshot from our nosy parents, Pest and I plotted over the phone how to carry out what would be our new groupie schtick. We would target a chosen rock star, then ask if he would like to donate his penis to science. In those days, donors were not hard to find. We also needed to figure out a suitable material to dip a dick into, other than the sand and water my teacher had recommended. We packed a suitcase full of different substances that might be used for a mold. Armed with our kit, we showed up at hotels and introduced ourselves to the bands, just like traveling saleswomen. To maintain a professional appearance, an industrial, elliptical logo enclosing the words "The Plaster Casters of Chicago" was glued onto our suitcase. We also ordered calling cards that said "The Plaster Casters of Chicago—Lifelike models of Hampton Wicks."

Rather than don expensive business suits, there was a better way to complete the look. We would wear Plaster Caster T-shirts. In the mid-1960s, T-shirts with band logos were becoming big-time fashion items. They were cheap, cool ways to display one's musical leanings, and they were flattering to svelte figures like ours.

I couldn't afford to have my T-shirts screen-printed by a manufacturer, so I just made them myself. First I threw a couple of men's white undershirts and some RIT dye into a washing machine not intended for dying purposes. Then I cut out a negative paper stencil of the Plaster Caster logo, the same way I used to make snowflakes in grade school. I Scotch-taped some newspaper onto a wall and taped a T-shirt over the newspaper. The stencil was carefully positioned and taped over the chest region of the shirt. Matte black aerosol paint was then sprayed over the stencil, which was removed a few minutes later. Voilà! One hot Plaster Caster T-shirt, ready to rock!

Pest retired from the Groupie Force, but her replacement Dianne and I made a big splash when we showed up in our Plaster regalia at the Monkees' hotel. We were spotted outside with the rest of the fans by one of the entourage, and were escorted like visiting royalty up to the party room. A few months later, the Rolling Stone photographer Baron Wolman flew to Chicago to shoot us wearing our T-shirts for the upcoming "Groupies" issue in 1969. As the legend of the Plaster Casters was building up momentum in the rock and roll world, our collection grew.

Initially, I made one red shirt for myself and one blue one for Dianne. Later, it made sense to get that logo seen on other chests besides our own. I stenciled a couple more shirts in various colors for a chosen few: first castee/college buddy Joel Coplon; Frank Zappa; Gary Brooker of Procol Harum; and Noel Redding. Noel wore his pink Plaster Pride when he performed with the Jimi Hendrix Experience on the LuLu TV Show in 1969.

Over the years, several different versions of the Plaster Caster T-shirt have been designed and sold. The most popular one remains the basic one-sided style with the logo on the front. Though I no longer work with a full-time Plaster partner, I still make casts of dicks (as well as tits) whenever I encounter a talented and willing subject—and I still wear that T-shirt.

Cynthia Plaster Caster

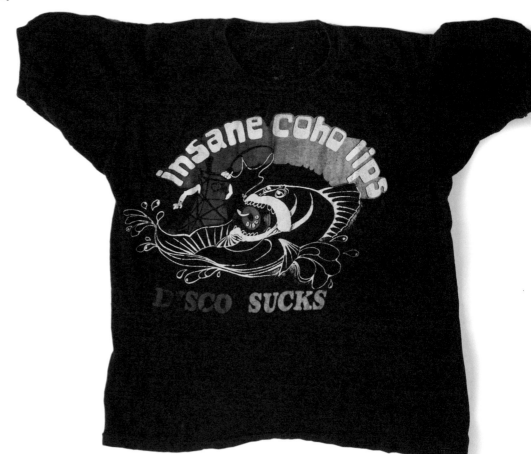

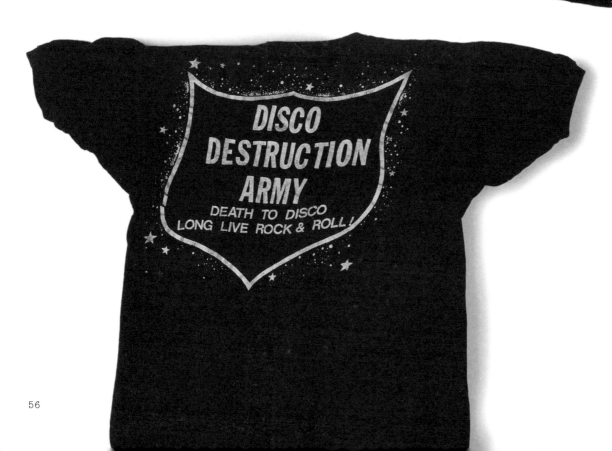

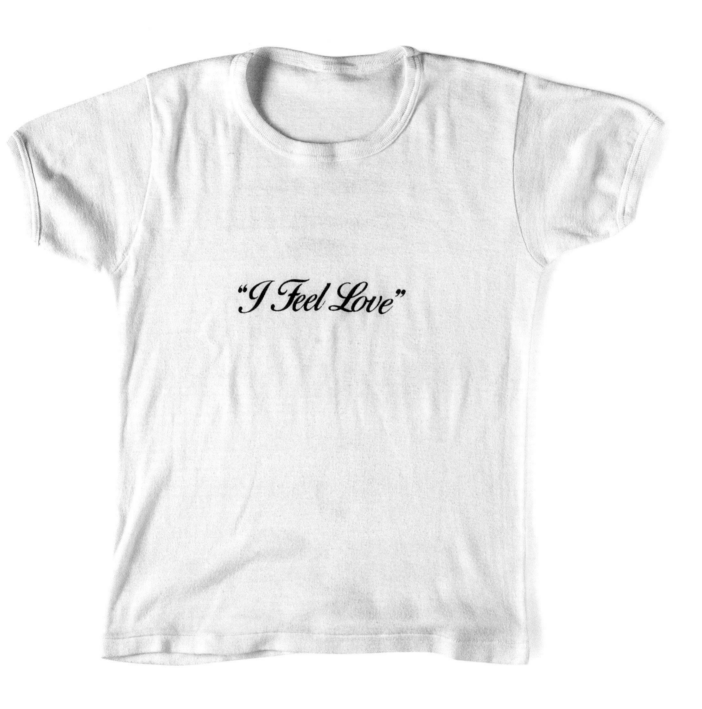

Chic

Sylvester

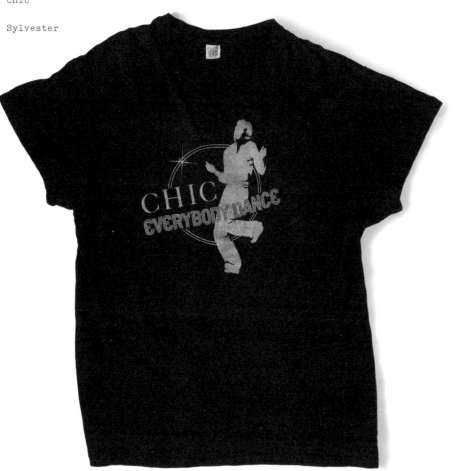

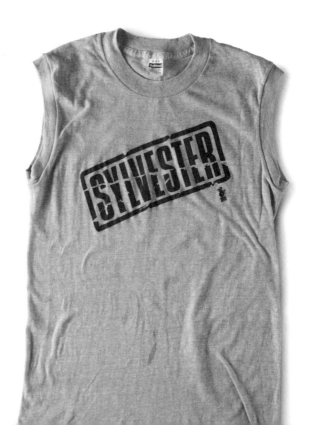

SISTER SLEDGE
WE ARE FAMILY

CERRONE IV
THE GOLDEN TOUCH

Cale is one of the few guys in the music world, like Duke Ellington and Johnny Cash, who will always be remembered as a "cinematic male lead." Production value's in the eyes... all starless and Bible-black like that night in "Under Milkwood." In his early sober days of frenzied shopping, he bought some orange clothes. Nothing I remember in Garnant, Wales, was ever orange except the sunset. I understood the orange clobber as having been chosen to fill a void left by lost Wales and absent drugs (or vice versa). Cale's sartorial style subliminally reflected choirs, soldiers, shadows, things poetic rather than things fashionable. Nevertheless, only a dandy could navigate the field of designers he worked, even with dollars and dreams.

Judy Nylon

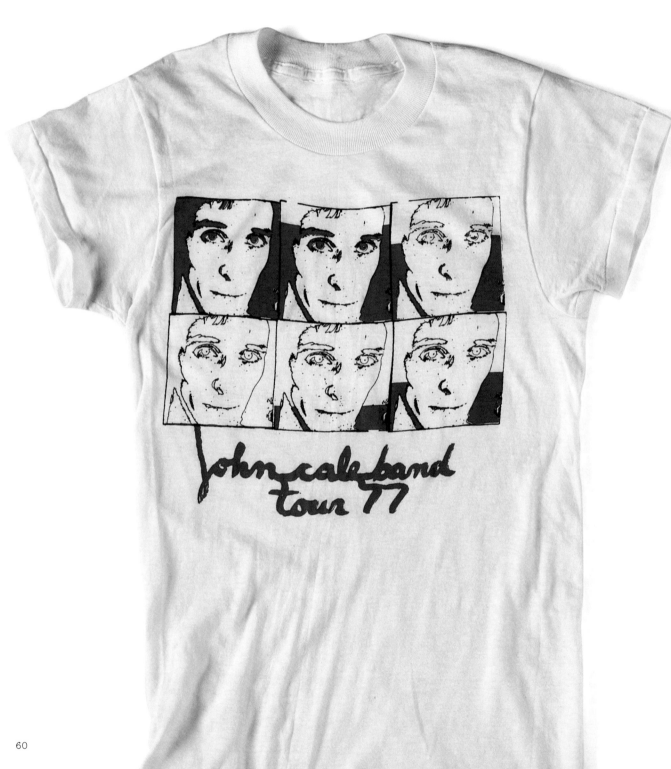

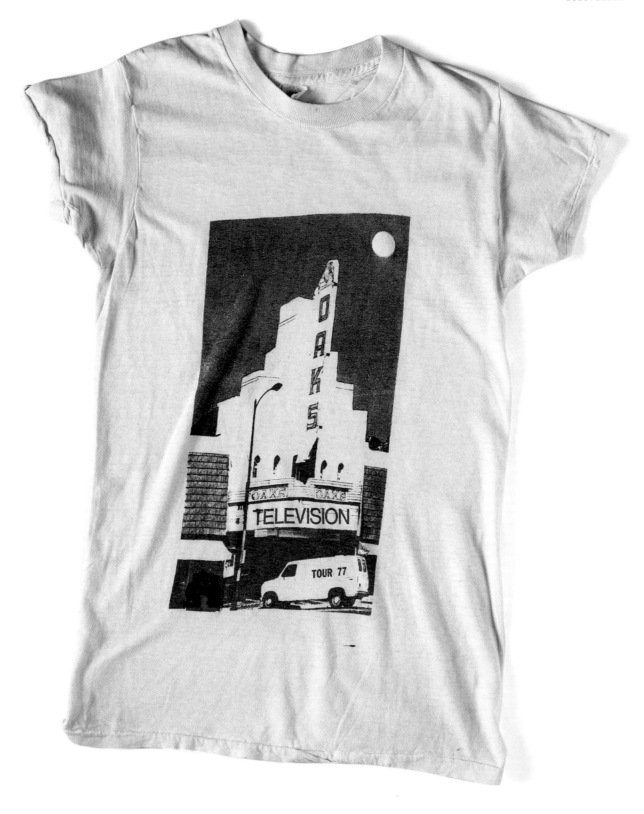

Devo

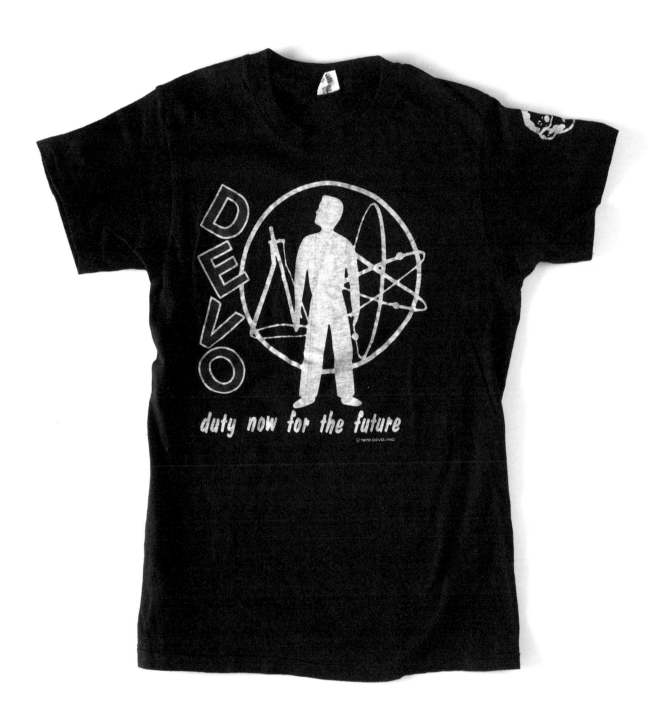

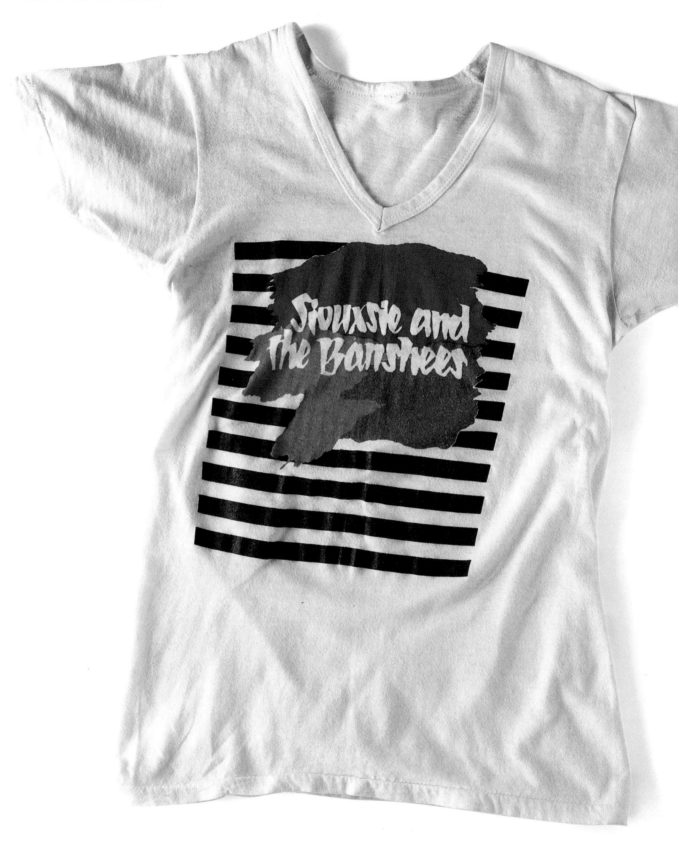

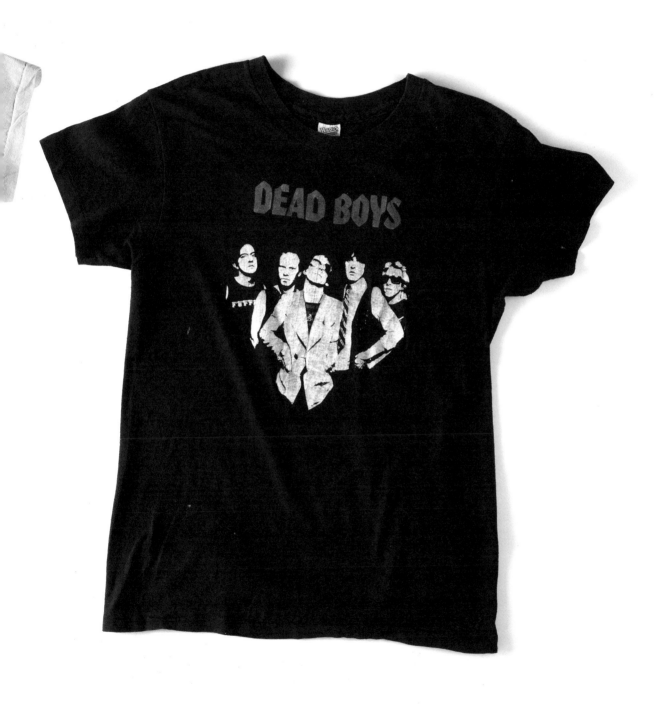

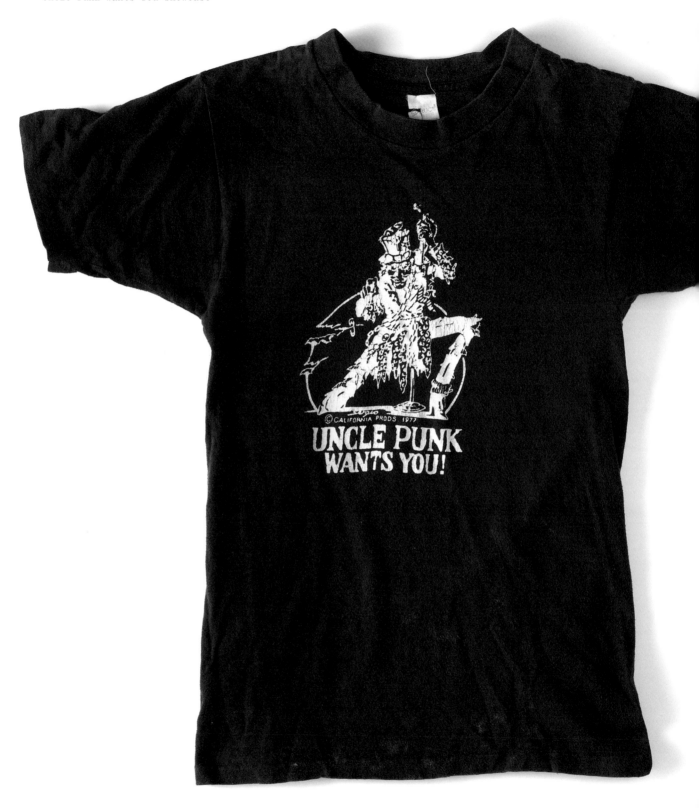

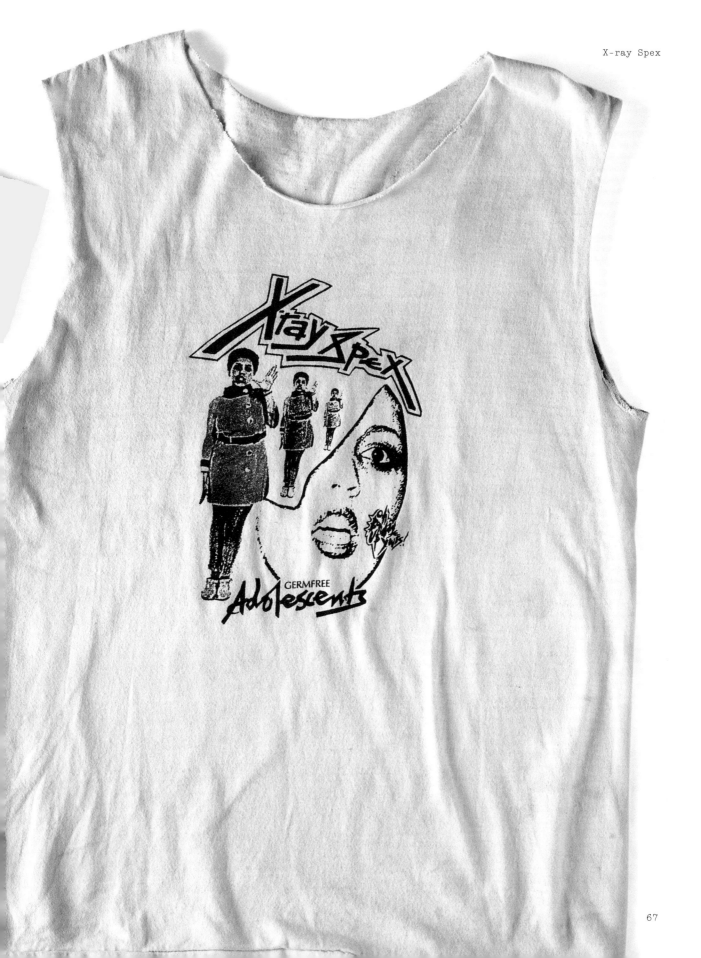

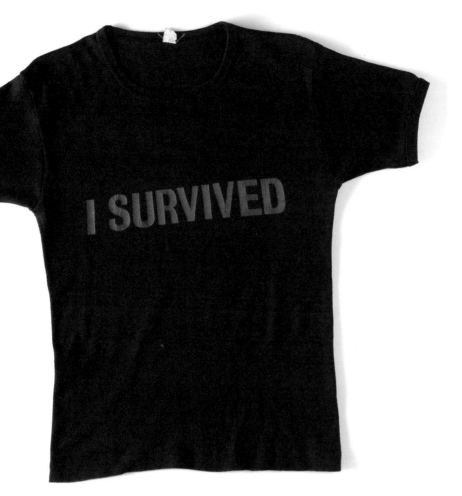

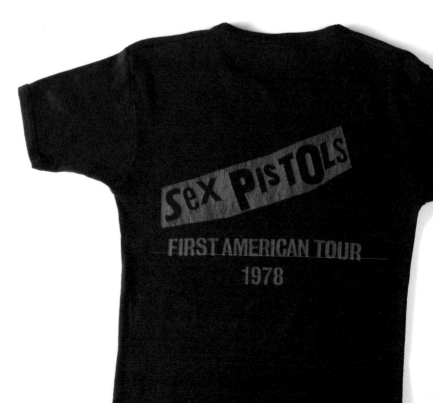

After Sid died and all the historical/hysterical shit that went down in the aftermath of that tragedy was over, his mom, Ann, was going back to England and didn't want to drag all his stuff back with her. She asked Eileen Polk, Jerry Only, and me if we'd like to split up Sid and Nancy's stuff, meaning mostly a large trunk of clothing Sid still had with him from a Sex Pistols tour. After going through everything, I grabbed this odd top as an afterthought, which Nancy bought in New York I believe—but didn't live long enough to wear more than once.

Howie Pyro

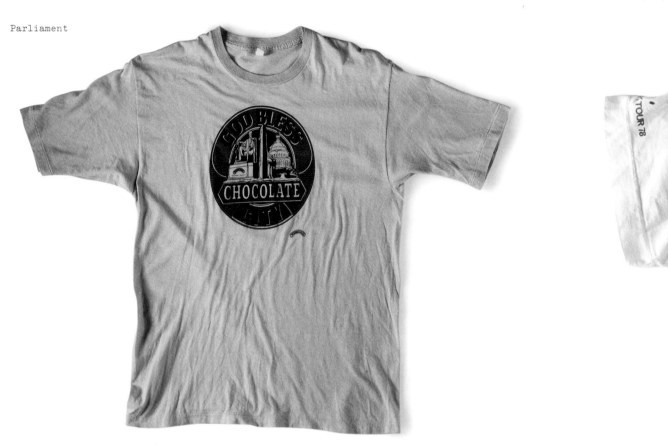

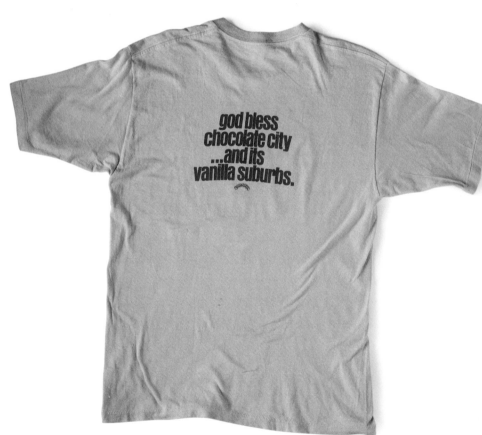

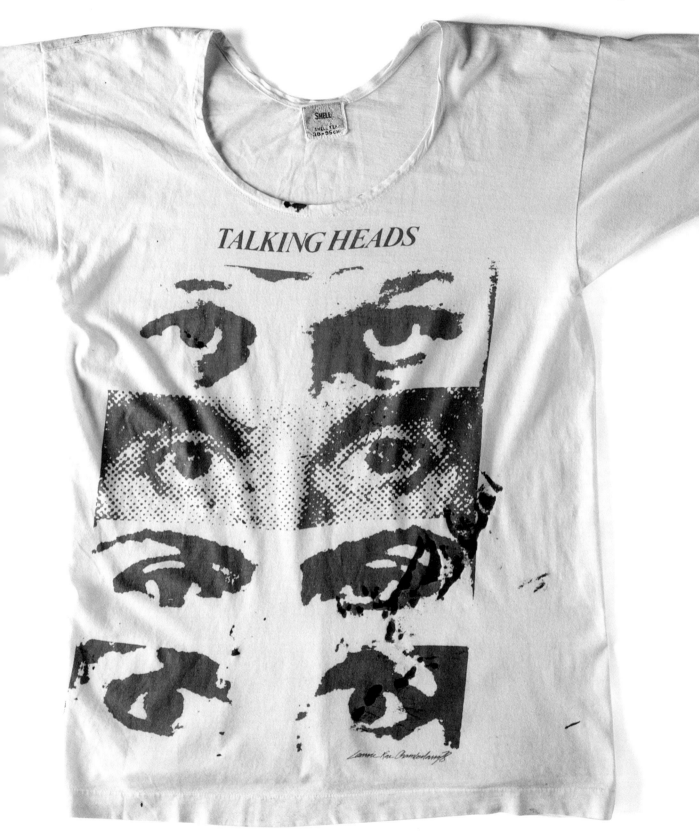

1978. Eric's house. North Hollywood, California. Three things stand out in my memory: the smell of bong water on the carpet; Wacky Pack stickers plastered across the closet door; and Van Halen's first album.

Were I a few years older, perhaps I would have been lucky enough to see one of their early shows at the Troubador, or even these four local boys opening for Kiss. But being just five years old at the time, the best I could do was take it all in at eye level with the wood-grained speakers in Eric's bedroom.

The first droning feedback notes of "Runnin' with the Devil" were like an air-raid siren from the days of the red scare, a warning of what was to come, and I was floored by what I was hearing. Thirty-one years later, and that song and the ten that follow still make for a more radical LP than almost anything I've heard since. Period. As the years passed and I grew up with the heshers in my neighborhood, from album to album I followed Van Halen along for the ride. From the stadium-punk histrionics of "Light Up The Sky" to the maritime white-boy blues of "Could This Be Magic," from the menace of "Mean Street" all the way to the MTV-era party and thrash of "Hot For Teacher," these four kids from Pasadena never let me down.

There are of course those diehards who will argue that they just kept on going, but for me, the love affair ended with the departure of Diamond Dave. But that's a debate for another time. There's no question there were bands that were harder, faster, more serious, and certainly "cooler," but when Eddie, Alex, Michael, and Dave did their thing, I was 100% in. Still am.

Justin Warfield

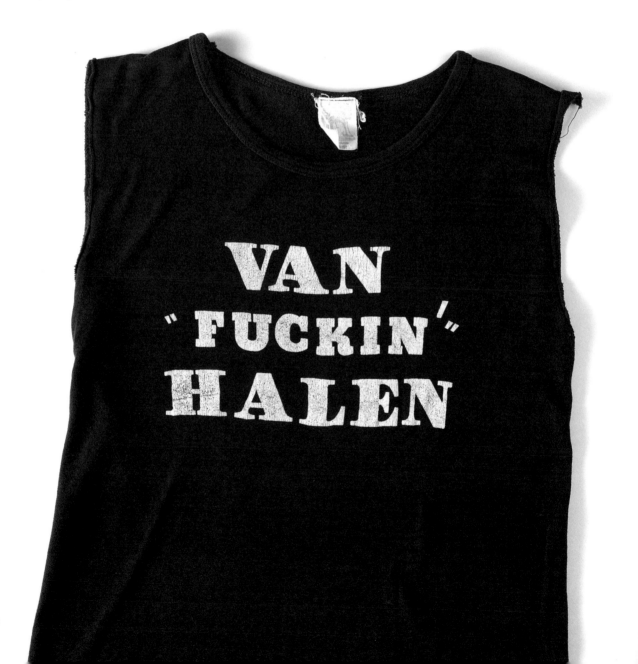

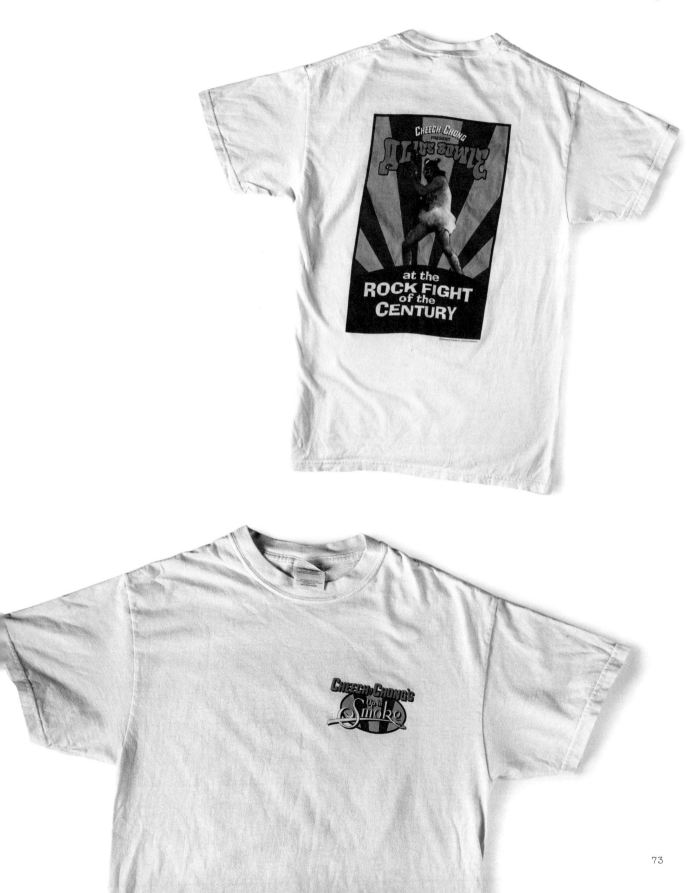

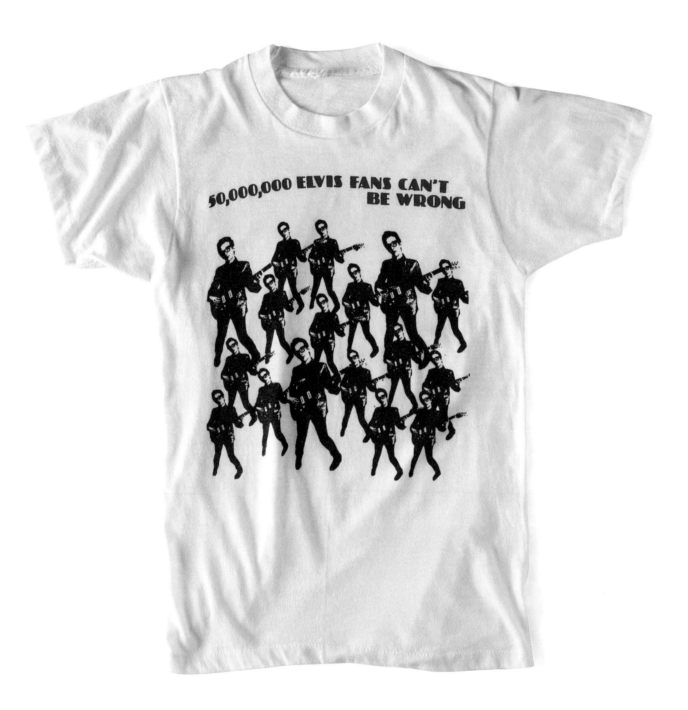

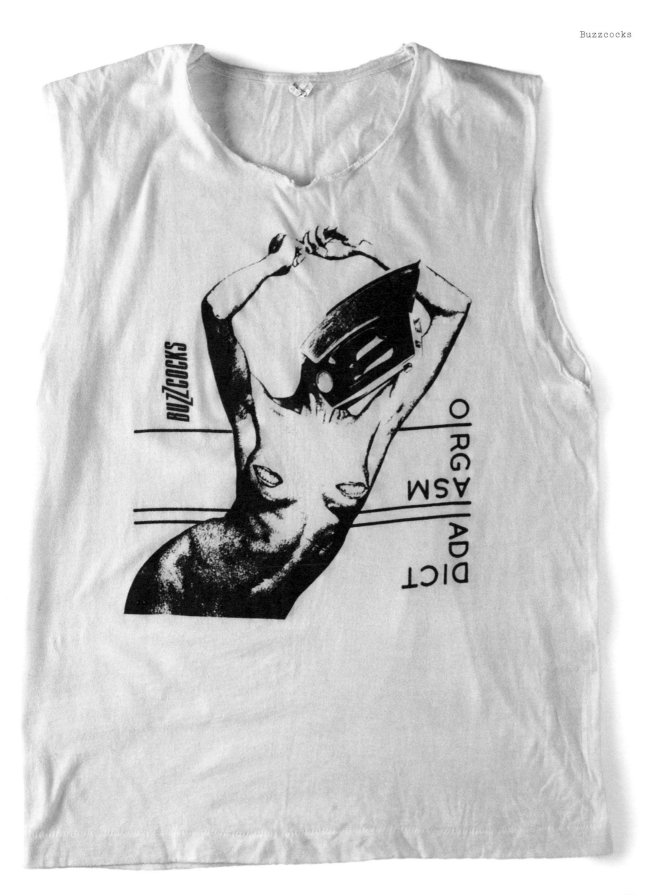

Conceived to be worshipped, the Screamers hit the streets of Hollywood and in one day became iconic. Black pointy boots, future-shock hair, thrift-store rags, and handsome faces were all it took. Luckily for us worshippers, the music was an unexpected onslaught of distorted synths, keys, drums, and the yowls of the loveable mental-patient singer, Tomata Du Plenty. The Ramones sang "Gimme Gimme Shock Treatment," and the Screamers delivered it.

Kid Congo Powers

Imagine the exhilaration of knowing that you are part of something that is completely and utterly new and different. Imagine that all your life you have felt cut off from the rest of humanity at the most elementary level—you do not communicate well with others. Imagine feeling so lonely and twisted that at times you have really, really wanted to kill yourself, even though you were just a kid. Imagine that the people who were supposed to love you—your family—have continually and deliberately brutalized and betrayed you in ways other people couldn't begin to imagine. Imagine that you are at the end of your rope. Then, imagine walking into a room where, for the first time in your miserable, horrifying life, you feel a part of things. These people understand you because these things have also happened to

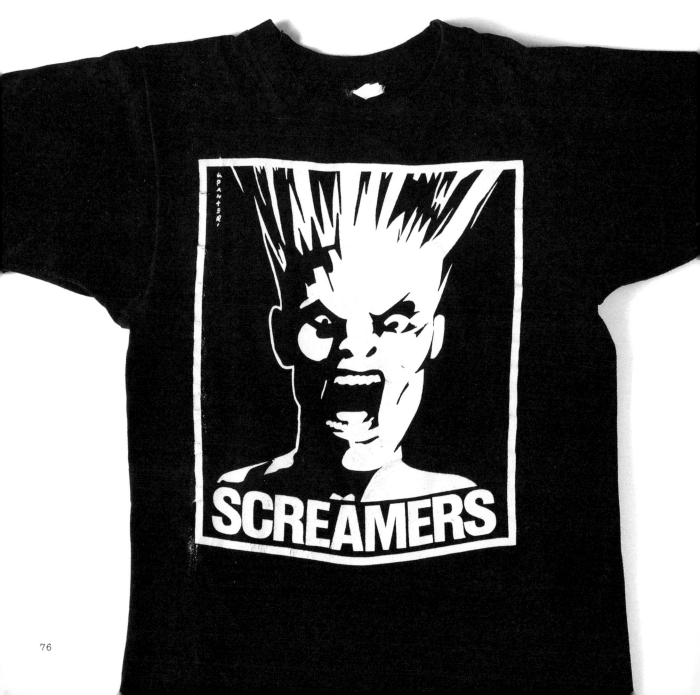

76

them. There's no need to explain your silence,
your shyness, your need to get totally obliterated
every night of the week and to maybe fuck some cute,
lost boy against a wall in a dark corner of the club
without ever asking his name and then just dive
into the sea of bodies pogoing. There's no need to
explain the way this music, this noise, makes you
feel. There's no need to explain why, when you get
dressed up every day, you do everything you can to
make yourself look as ugly on the outside as you
feel on the inside. There's no need to explain your
hurt or your anger or the damage you feel, because
it is perfectly self-explanatory in this place, in
this music.

Nicole Panter

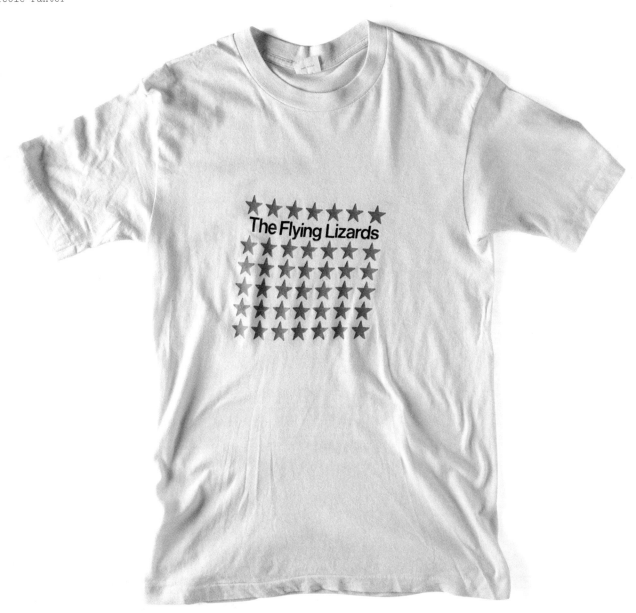

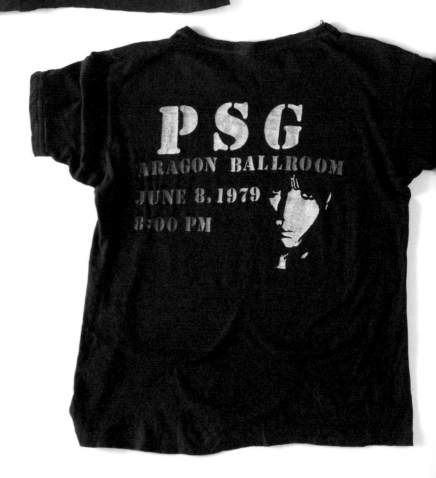

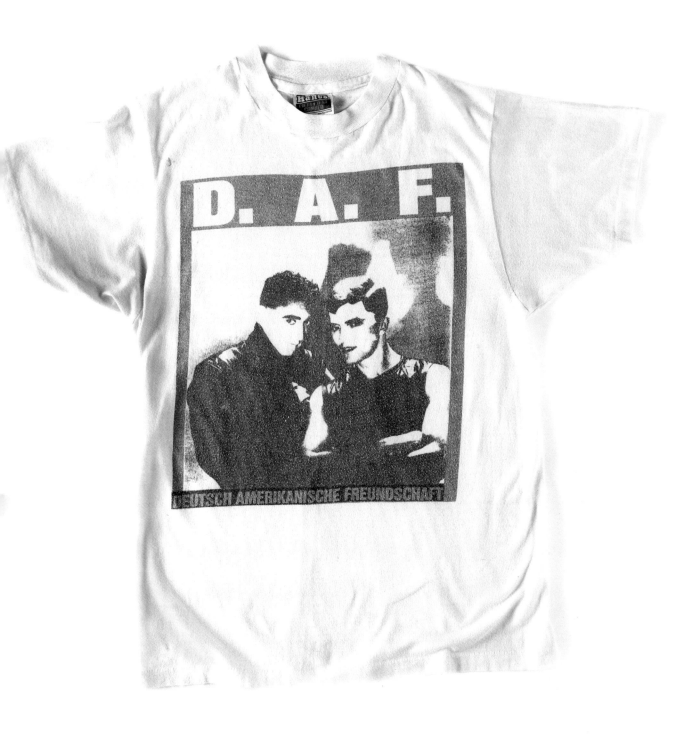

Magazine

Soft Cell

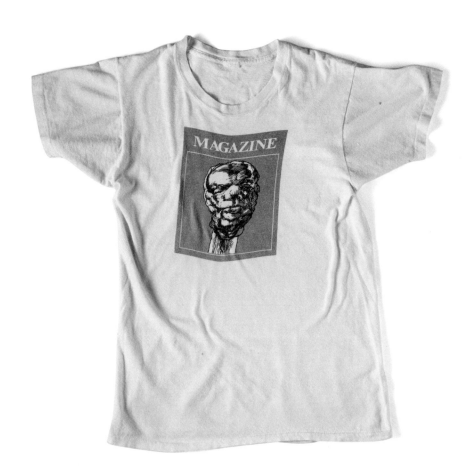

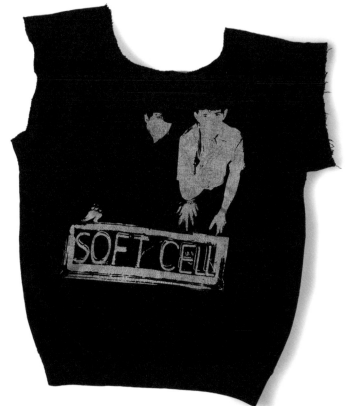

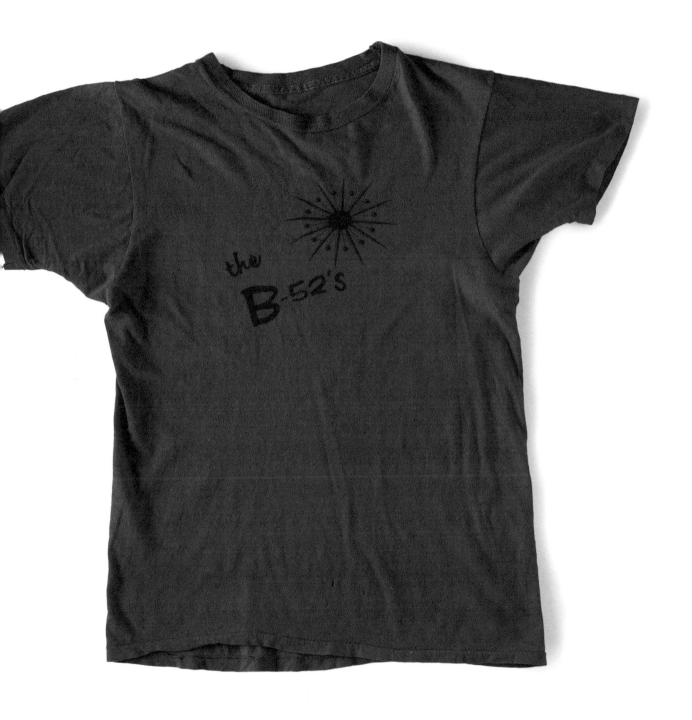

I didn't know there was rock without cheese until
Throbbing Gristle. To find art that rocked was a
revelation. I'd thought it was sarcasm but I was
wrong. It was heartfelt and sweet and naive and mean
and relentless, persecuted and provocative at the
same time, and sexual in ways I hadn't experienced.
Genesis came to my house in San Francisco and
borrowed a keyboard for a psychic TV concert, and
he was just a prince—totally polite and gracious,
a humanitarian, an explorer, and a triumph of
nobility. I still haven't seen them live, but when
I do I'm going to get really close to the stage.

Roddy Bottum

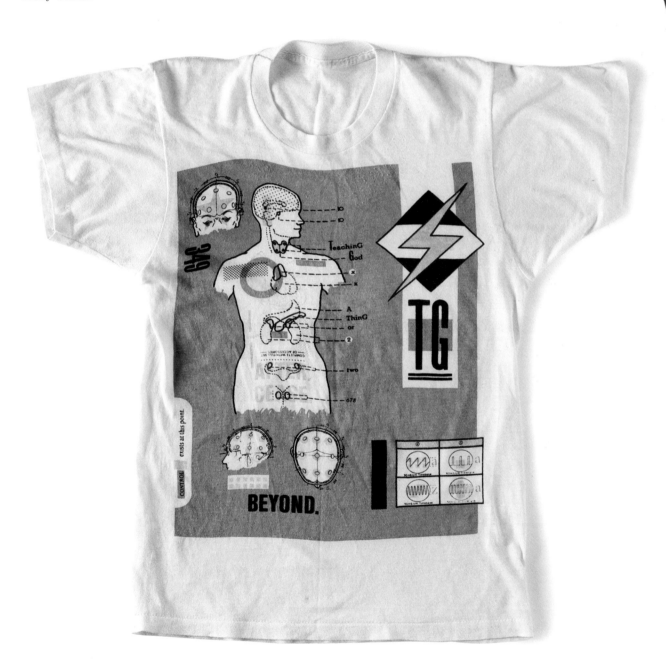

WE ARE COMPELLED
TO PUBLICISE THAT
INDUSTRIALIZATION
WILL TAKE PLACE.
THROBBING GRISTLE

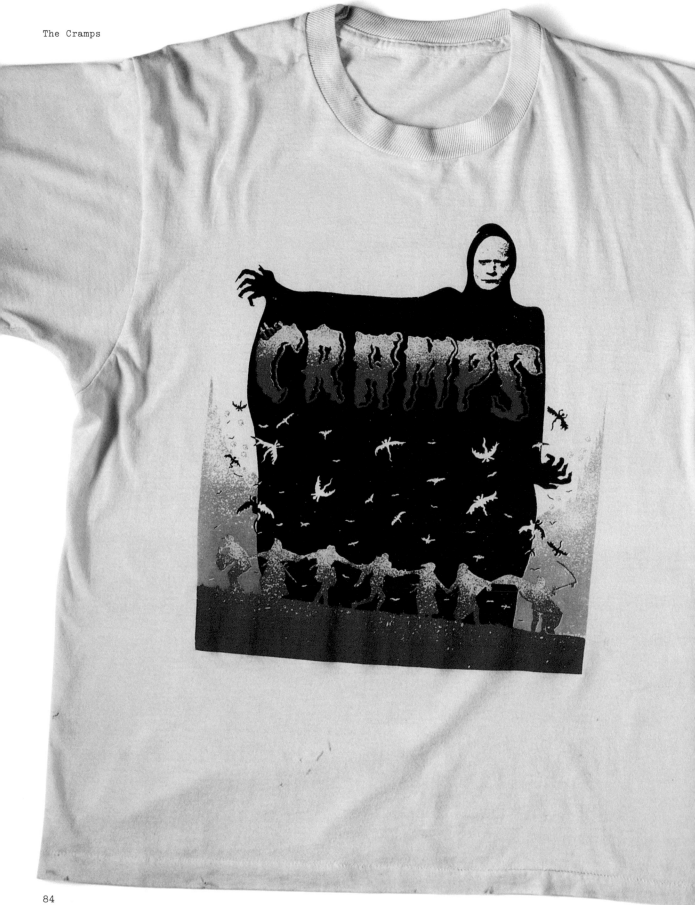

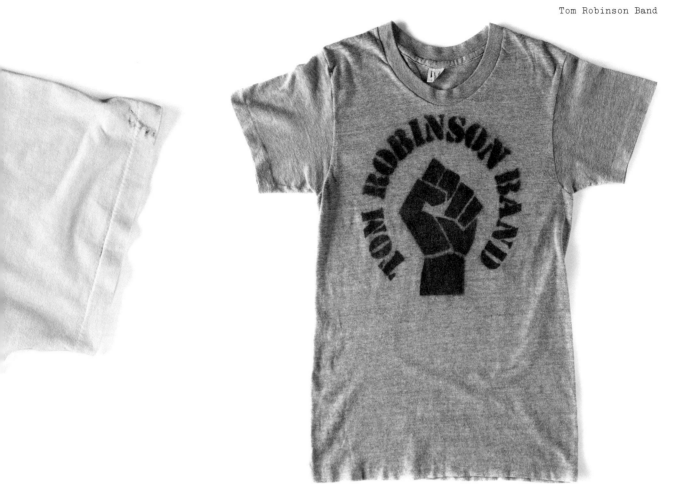

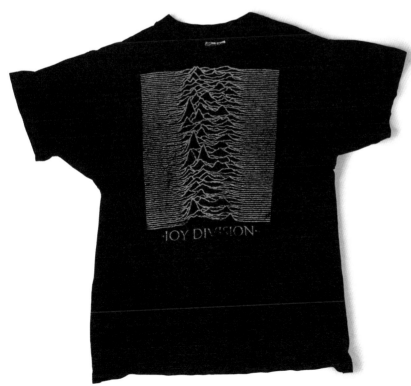

Rude to punk asceticism, devoid of any efforts at
personal control, and unforgivable by all moral
barometers, the Germs fascinated and scared the shit
out of me. Others pontificated about the Hollywood
abyss... They were its natural embodiment.

Brian McMahan

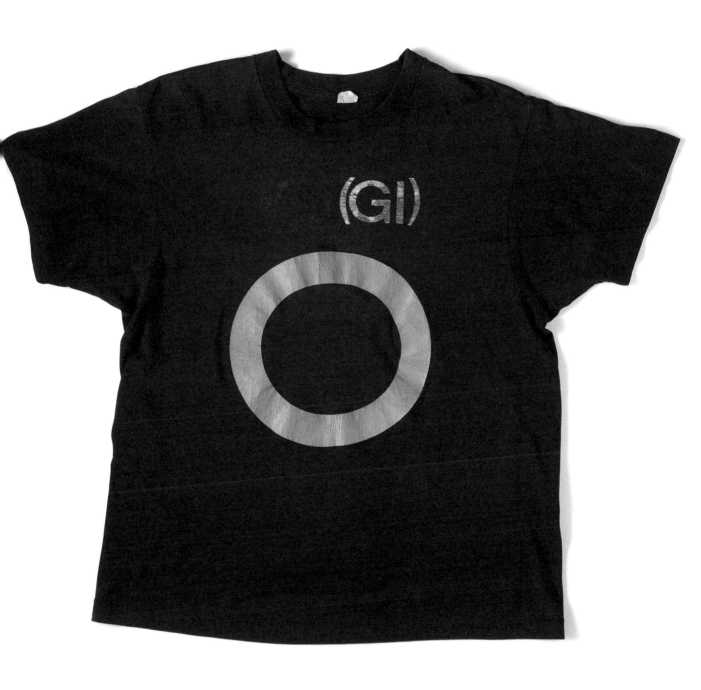

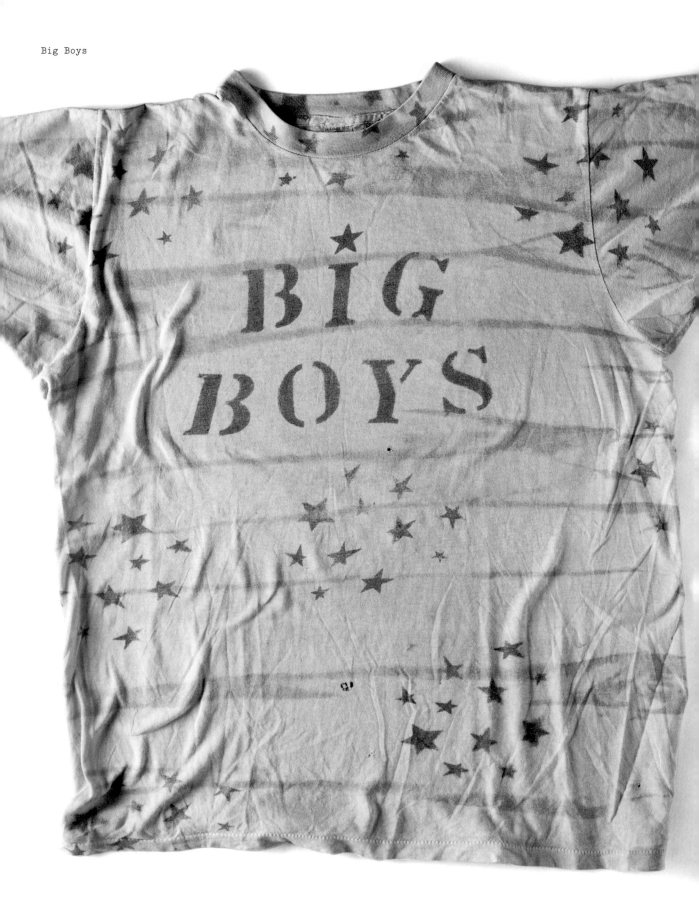

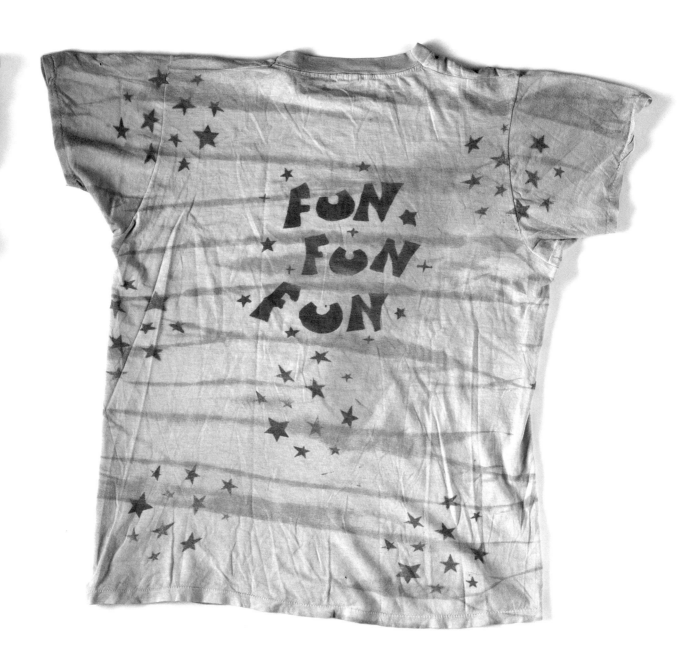

The Big Boys were part of a DIY community of out-casts in Austin, Texas. Chris Gates and I decided to try and start a band to play at Raul's once, just to see if we could do it. We were skating at the Pflugerville ditch and flipped a coin to see who would play bass, since we both played guitar (me on acoustic—Bert Jansch, John Martyn—and Chris elec-tric—Ted Nugent, ACDC). We decided to get another skater friend to sing, Randy "Biscuit" Turner, since we were already all friends through skating. Steve Collier—another skater—was the first drummer.

Chris, Biscuit, and I all did art and would take turns with record designs, doing the front, the back, and inserts. We all made posters for shows, or just crazy art posters to make a statement about something that might have just happened. We would also "fix up" our clothes, but Biscuit would usually take it to a whole different level... actually, to a whole different world of glitter cowboy boots, day-glow clashing with day-glow T-shirts, hair, pants, and pretty much anything that would sit still long enough for him to apply what he saw fit—usually day-glow and plastic toys.

If you learn anything from this book, I hope it's that the DIY spirit is timeless and will always be, whatever they call it next. The big question now is: What are you going to create?

Tim Kerr

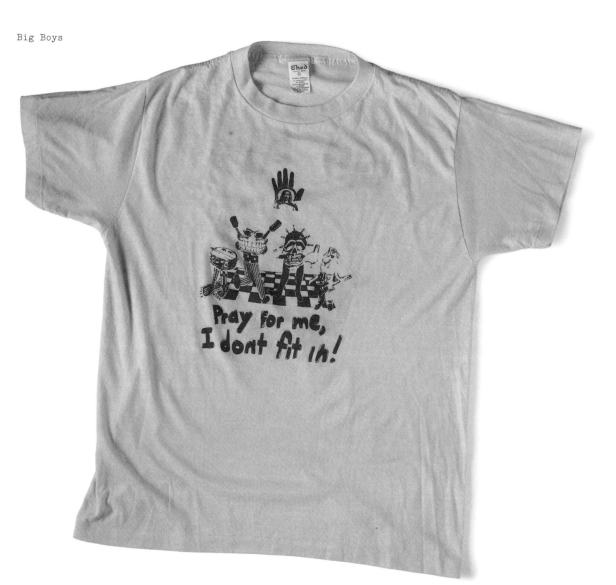

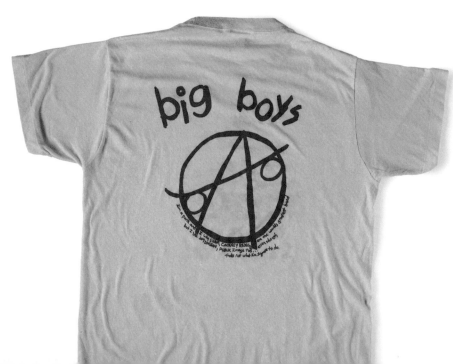

So I'm drinkin' a coupla beers and hanging out
listening to Howlin' Wolf or some other happenin'
character with my comrade Jeffrey, who is in a
sitch where he's decided his band, the Creeping
Ritual, needs to make a name change. He'd made some
personnel moves within the group, so he figures
it's time to come up with a new title. We've become
pals and roommates through association with the LA
punk rock underground and over the course of a few
years I'd compiled a list of band names—the Plastic
Hassle, Negro Stereo Tightass, and others—but he
really became excited when I mentioned <u>The Gun Club</u>.
I guess that was a winner!

Keith Morris

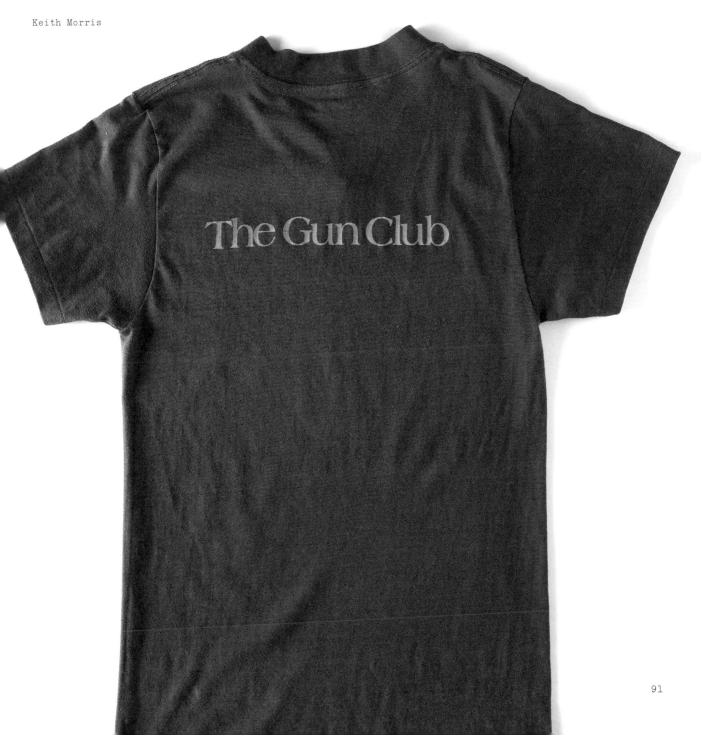

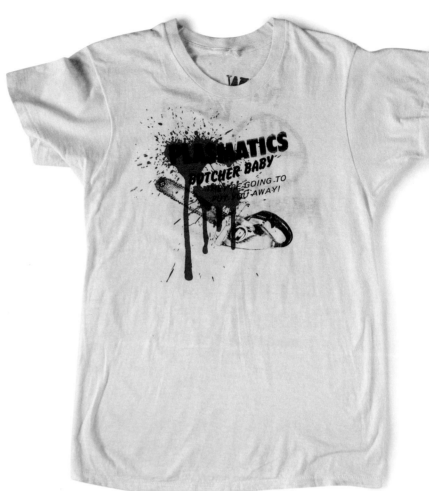

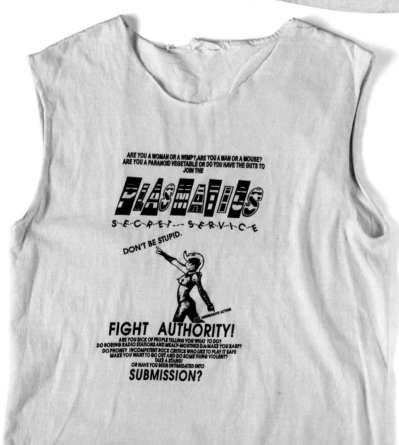

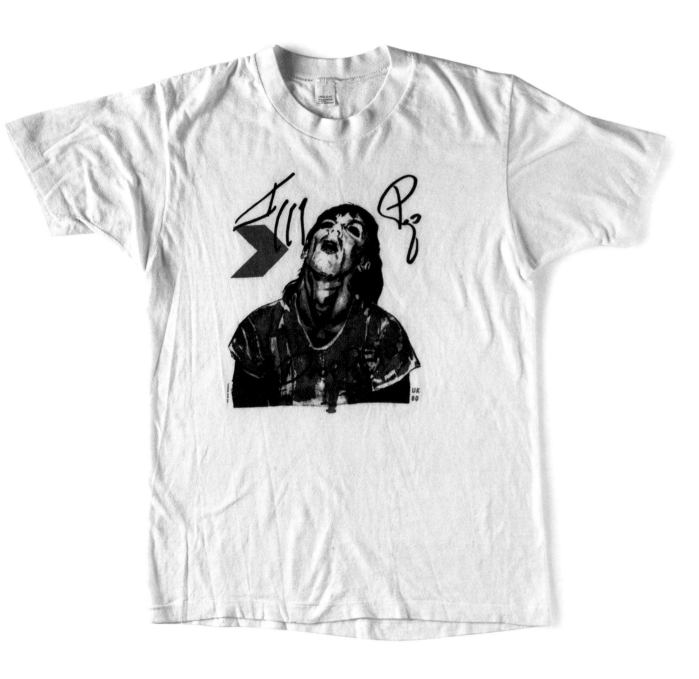

When I joined Malignant Growth in early 1982, there were three bands that you had to like, the Growth's Holy Trinity of pre-Punk demigods: Sabbath, Coop, and the Stooges. I'd been a huge Alice Cooper fan since I was a kid, and I'd been listening to Sabbath ever since Jeff Hepler put on "Master of Reality" the first time I went to his house—when he'd pulled the album cover from under the bed, his jack-off sock was stuck to it. The Stooges, however, I was wholly unfamiliar with—for all I knew at the time, "I Feel Alright" and "No Fun" were originals by the Damned and the Sex Pistols. Within months of joining, I'd be singing "I Got a Right," and my obsession with Iggy would grow to such proportions that I'd convince my bandmates to change our name

to Fading Out, a line from a song on "Raw Power." Upon hearing that a certain punkette had bedded Iggy both times he'd played Cincinnati, I made it my mission to fuck this woman; doing so would no doubt pass some kind of punk rock mantle—at the very least—down from Iggy to me. I had never laid eyes on this woman, but for a year or so, she was my Unholy Grail. Decades later, when I told this story to a fellow poet, he chuckled and said, "That girl was my second wife."
"Is she even hot at all?" I asked him.
"Well," he said, "she sure was back then."

Brett Eugene Ralph

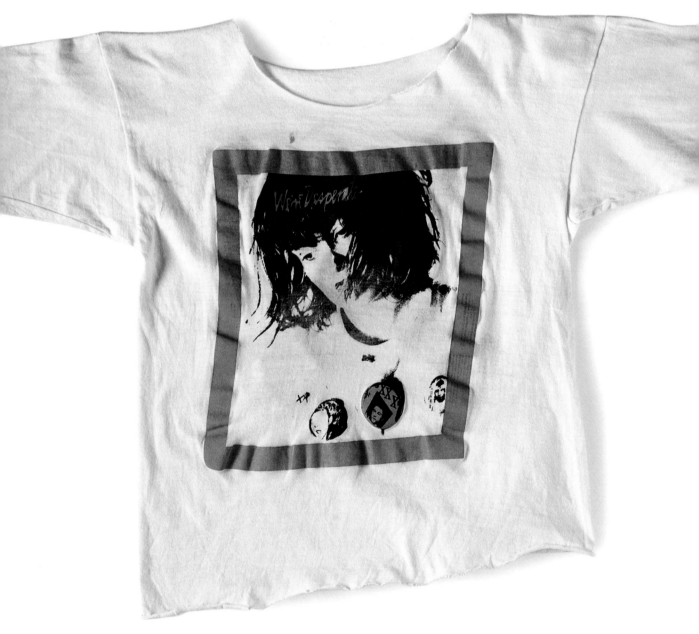

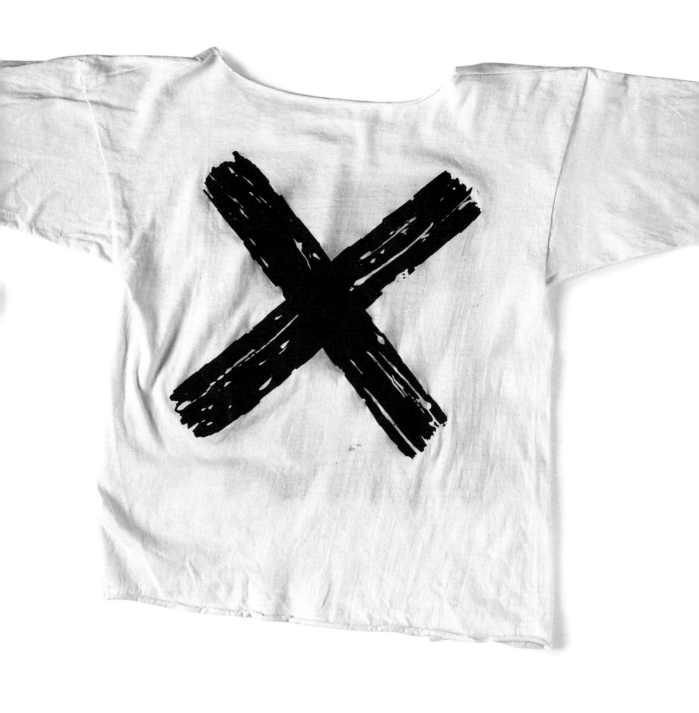

Public Image, Ltd.

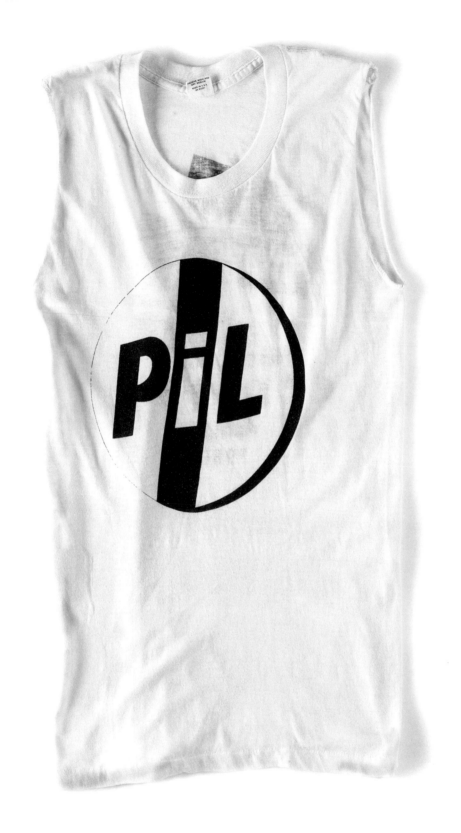

96

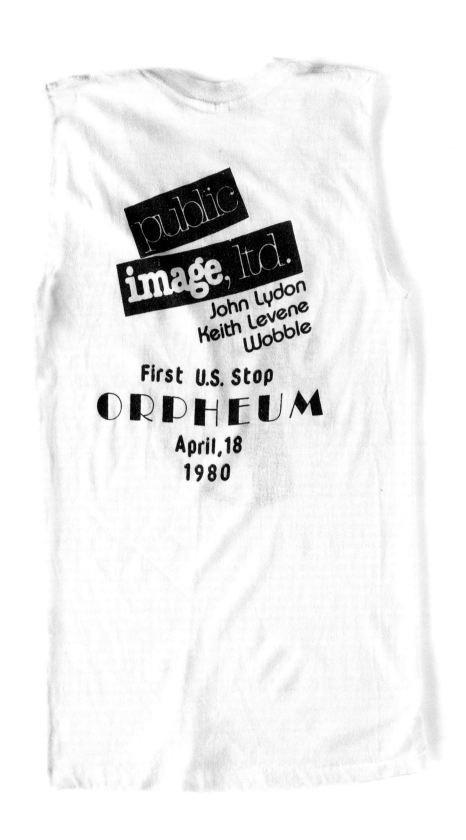

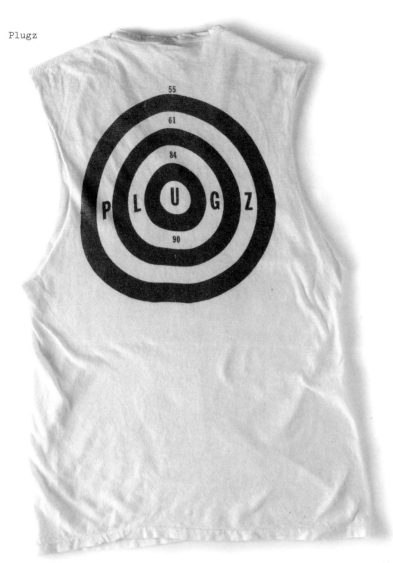

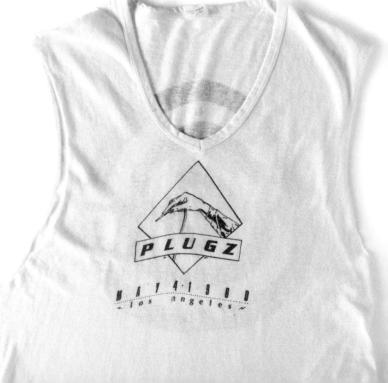

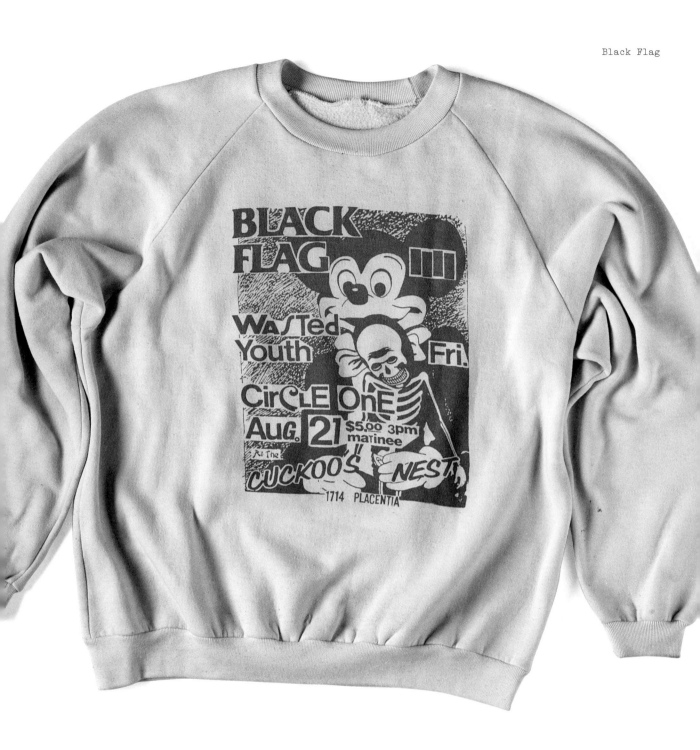

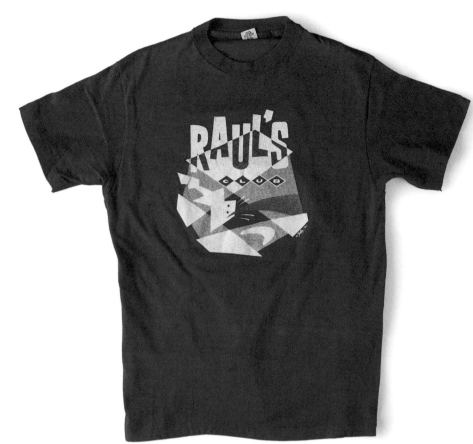

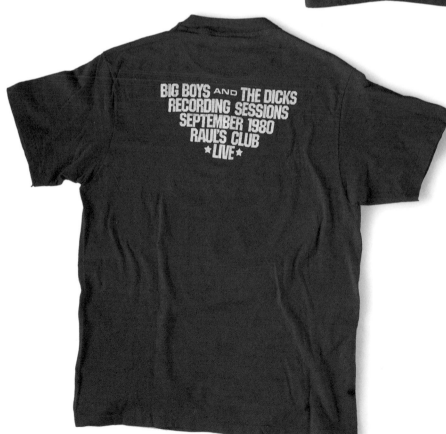

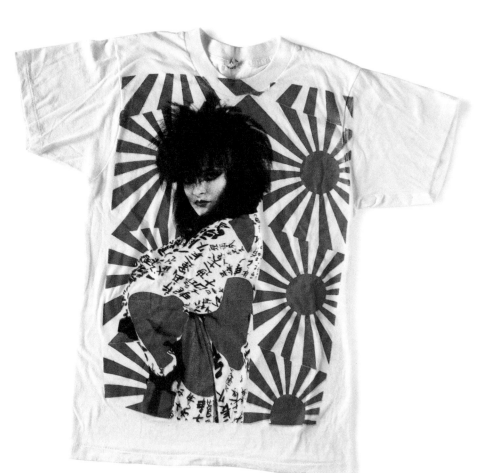

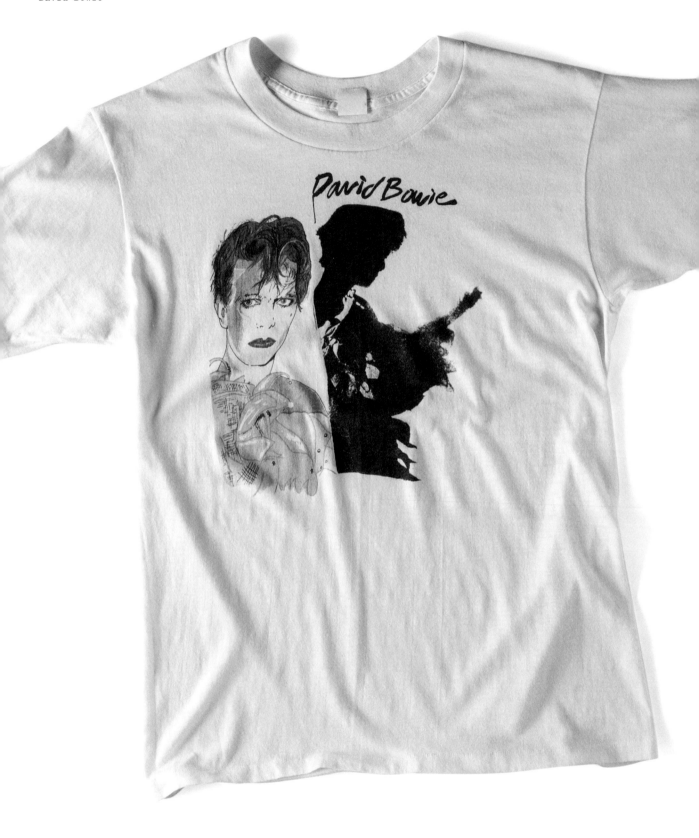

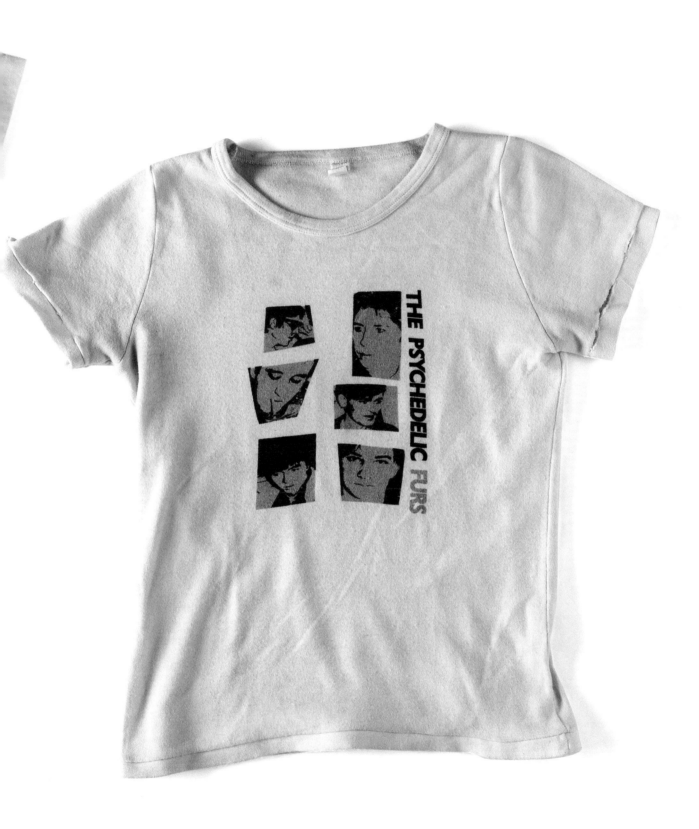

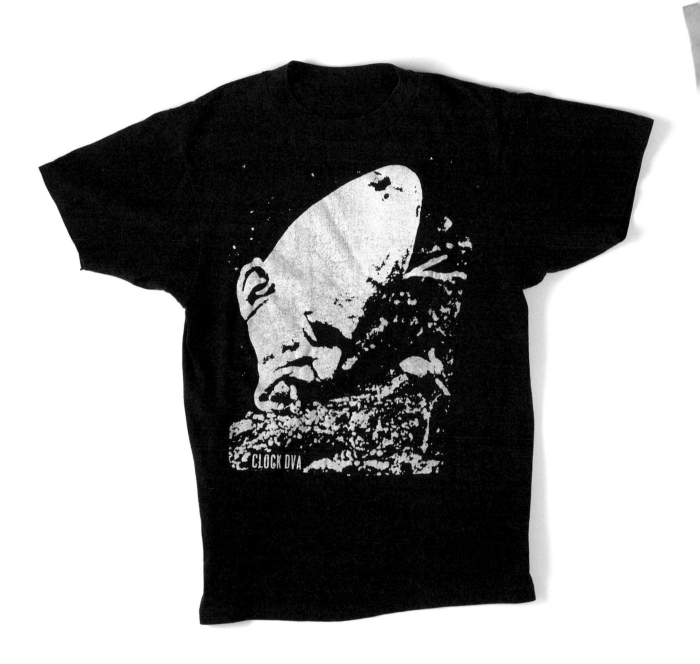

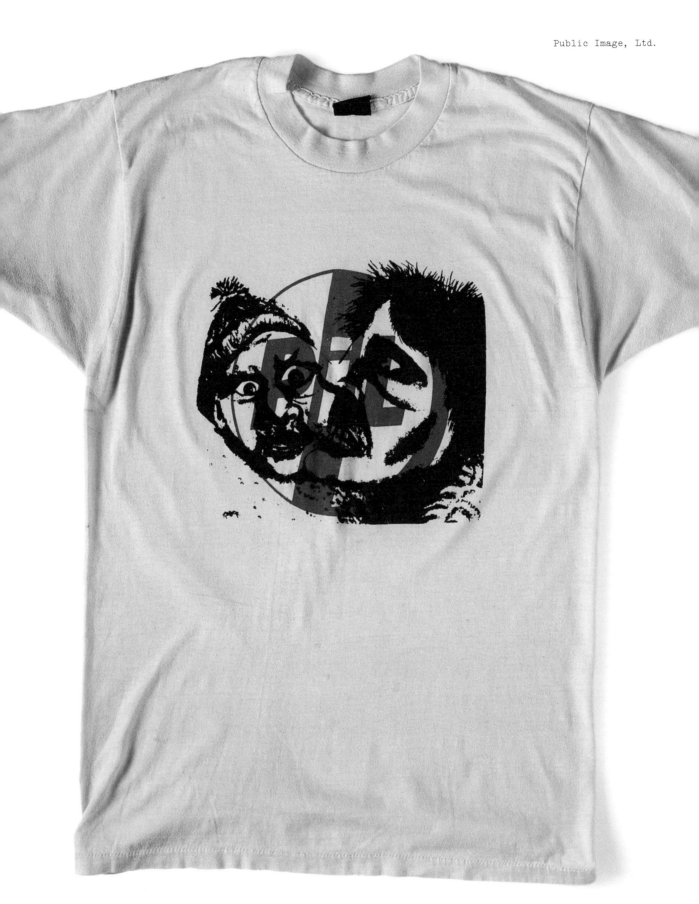

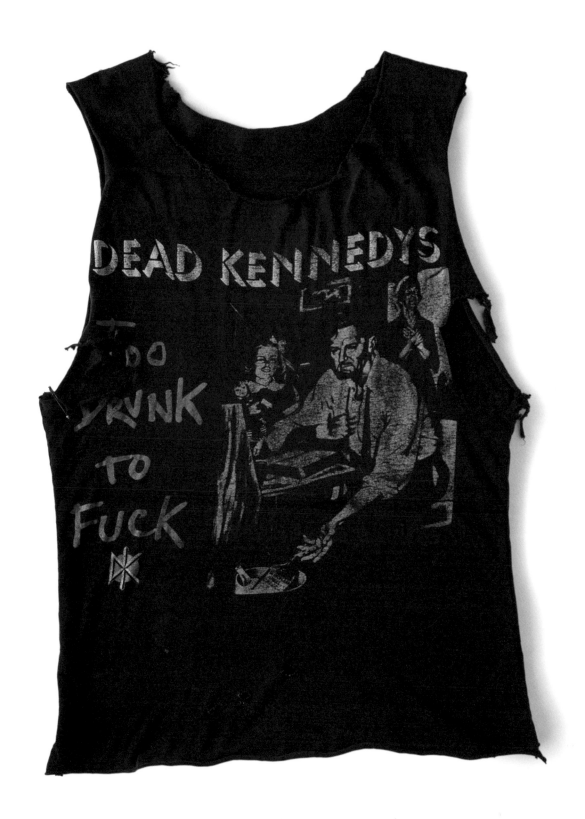

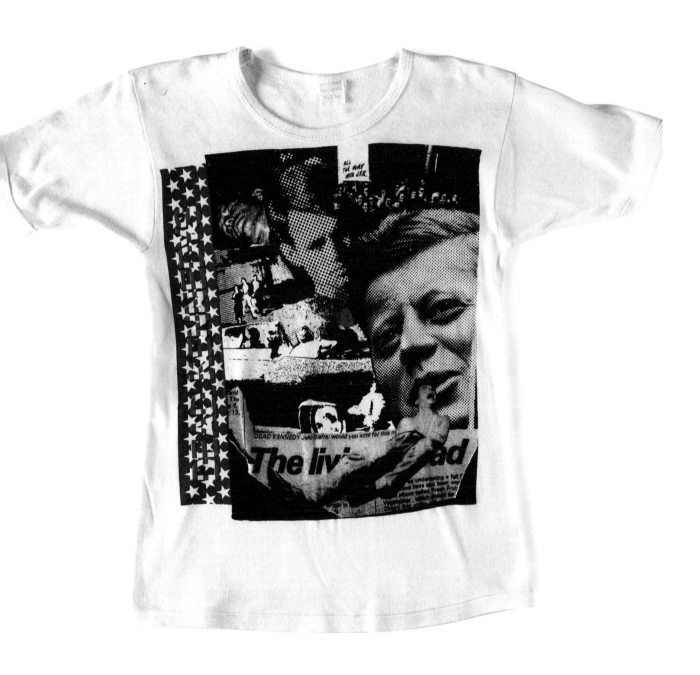

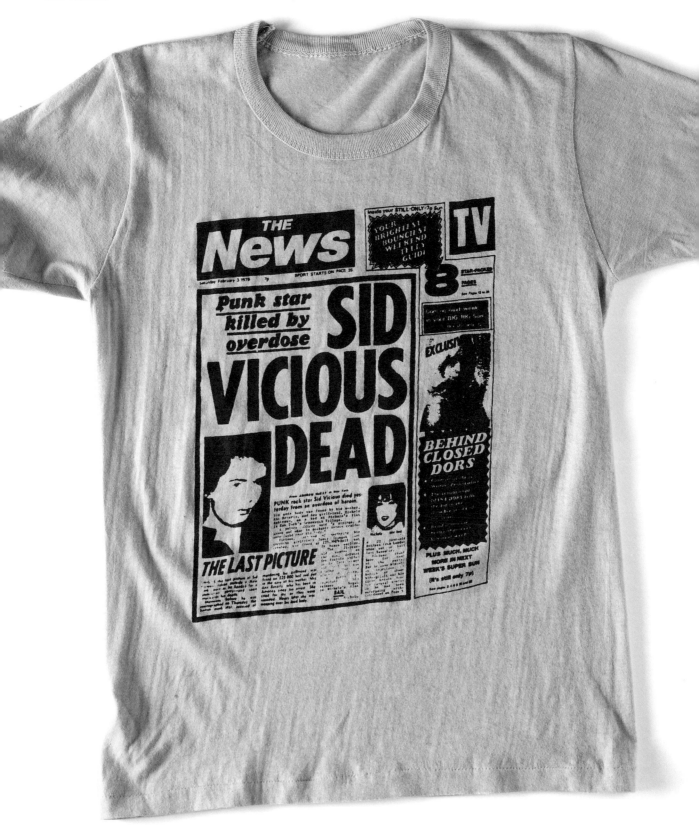

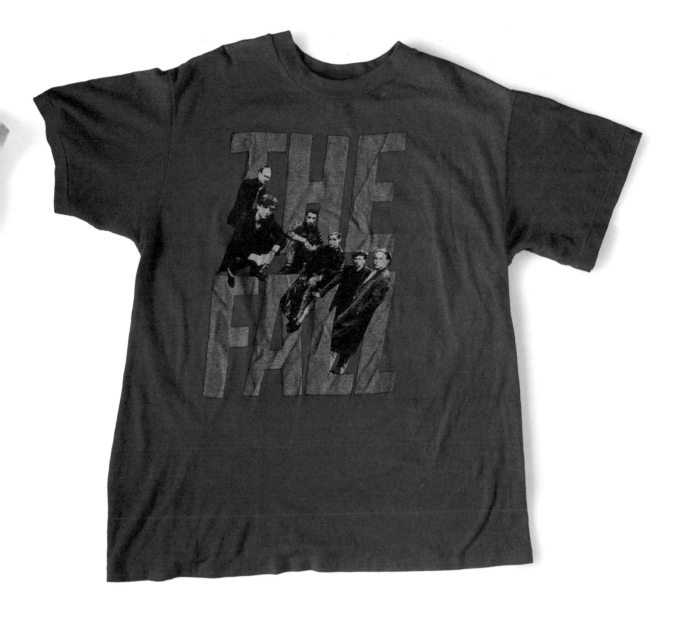

T-shirts are affordable works of art that you frame with your body. Like all good works of art they also communicate to other people a little about who you are—be it a warning sign or common language. Over the years T-shirts have also been chances for artists to reach a few thousand people with a silk-screen, and many celebrated contemporary artists started out making shirts in a garage—Jamie Reid, Neville Brody, Glenn Danzig, and Ray Pettibon come to mind immediately. Those silk-screens also allowed a kid with $10 to own a Rolling Stones Warhol, an Alice Cooper Avedon, or a Patti Smith Mapplethorpe.

As a wiry youth with extra-long Neanderthal arms, T-shirts were the only things I could fit into right. My awkward teenage years fell during the crossover from stadium rock to small punk venues and ultimately to mid-sized post-punk shows. It was an extremely rich time for imagery, and image could make or break a band. The lines were drawn between the cultures, and a punk shirt couldn't be too psychedelic. As with all strong trends, though, the lines soon became blurred: bands like Siouxsie and the Banshees introduced a new type of psychedelic band shirt of a darker variety, and the Plasmatics put out great punk shirts on Dr. Pepper-sponsored stadium tours.

But the reason I like to collect them is for the real payoff—when T-shirts become like a roll of cotton film. There is no better, no more revealing piece of clothing than a well-worn favorite T-shirt.

Scott

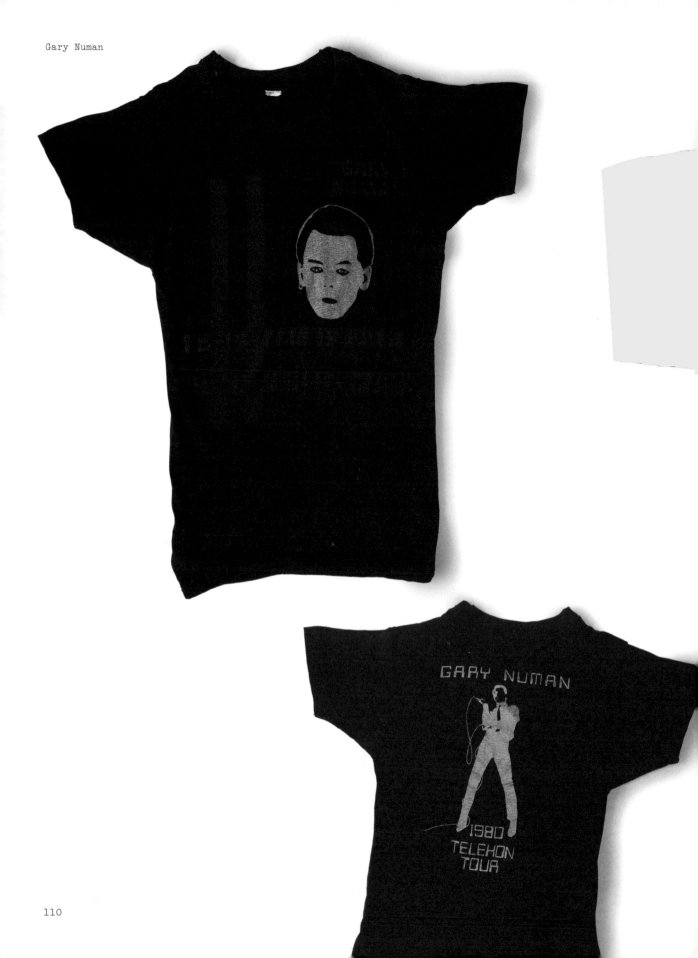

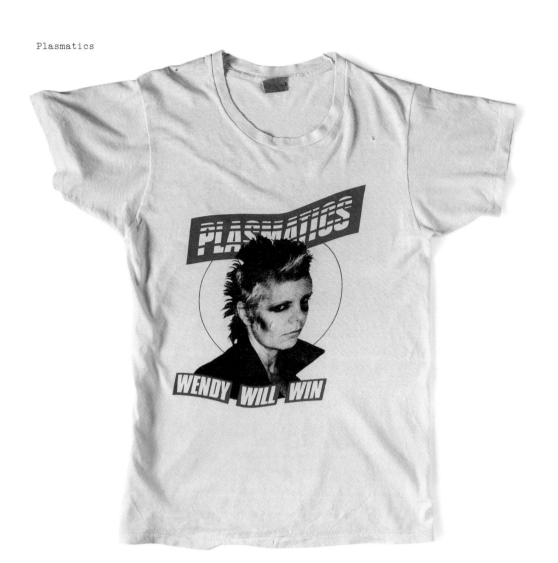

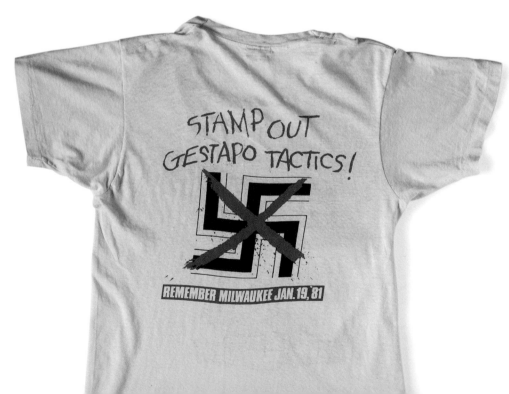

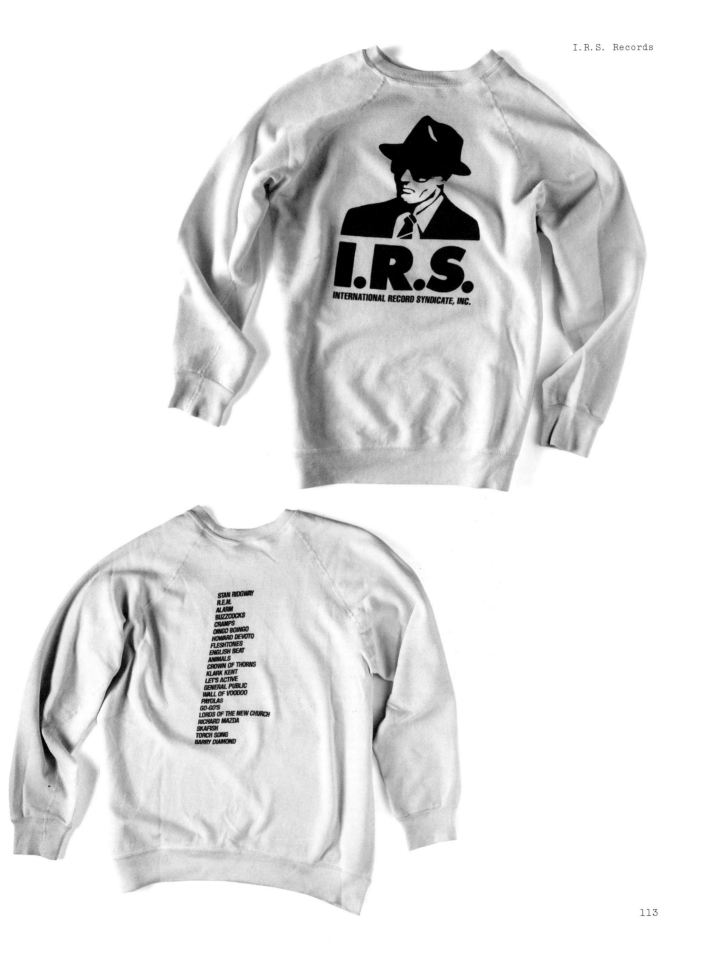

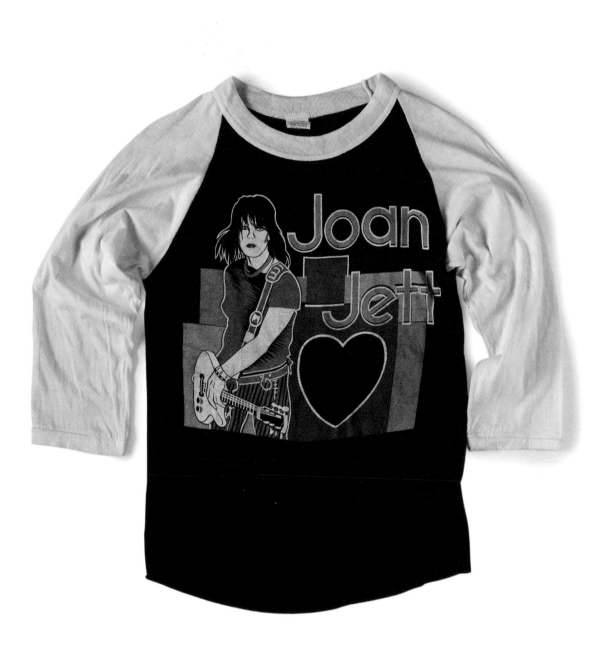

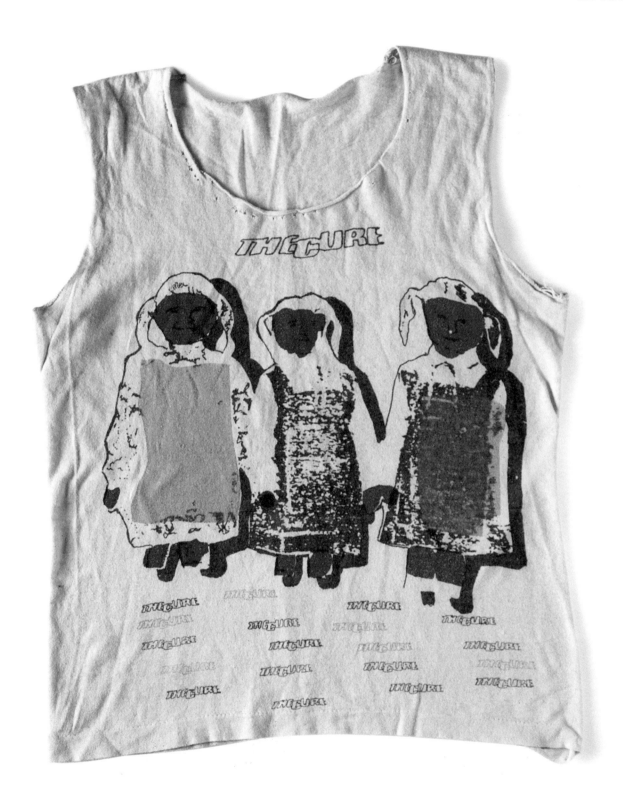

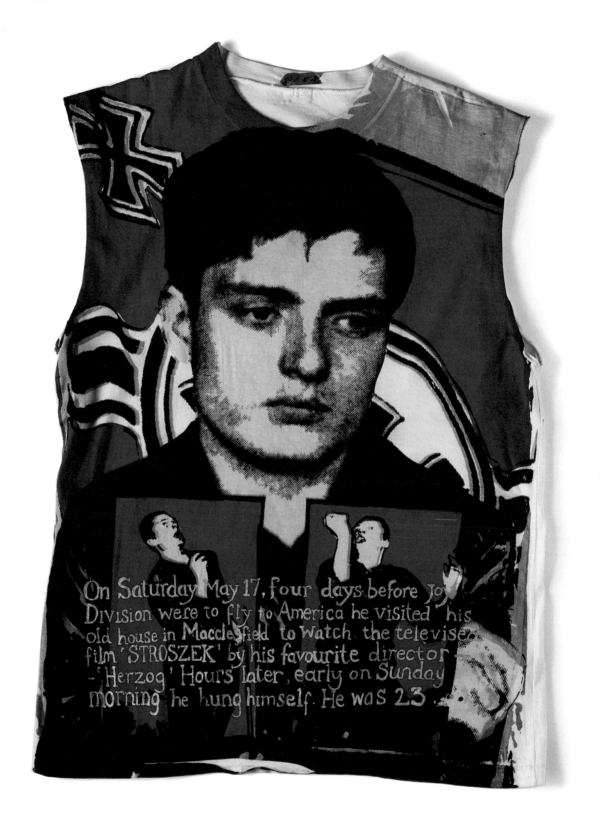

On Saturday May 17, four days before Joy Division were to fly to America he visited his old house in Macclesfield to watch the televised film 'STROSZEK' by his favourite director - 'Herzog' Hours later, early on Sunday morning he hung himself. He was 23.

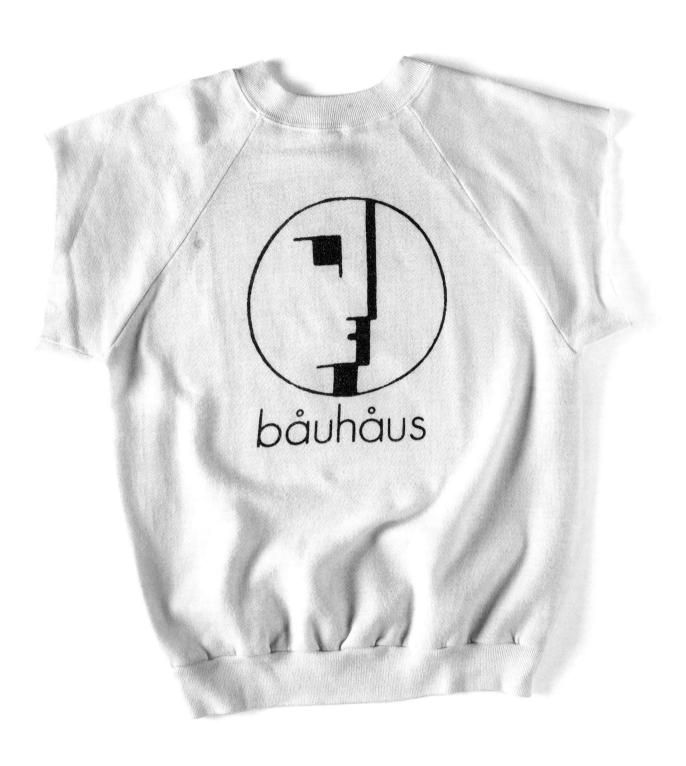

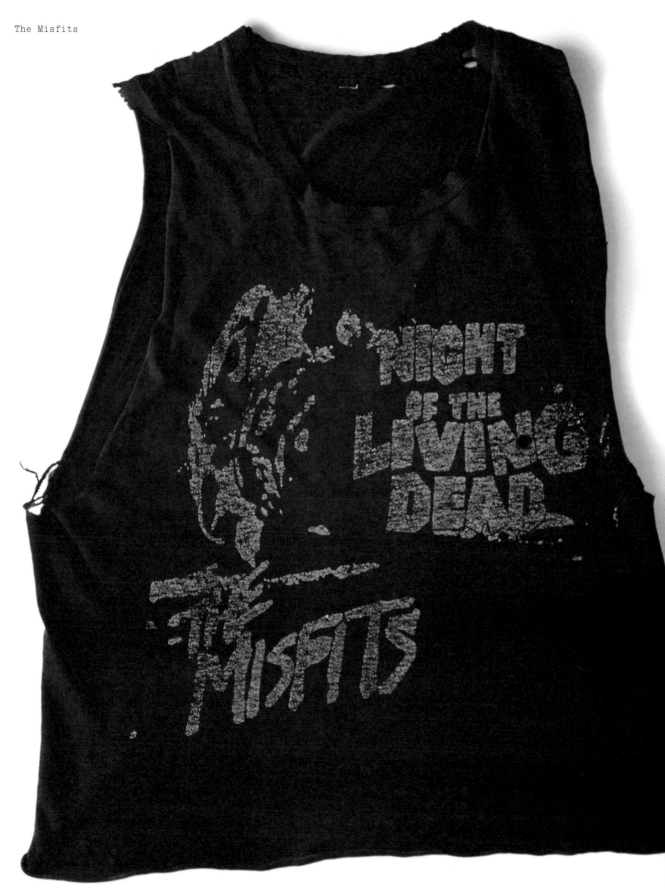

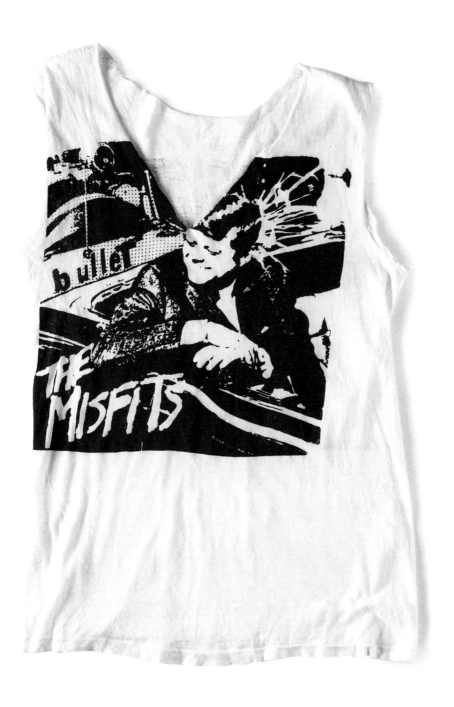

I was twelve in 1982. Glenn's mom and my mom were old friends, and I was always around the Misfits practices. There was a two-week tour scheduled from Jersey into the Midwest and Glenn himself sewed a crazy little Rat Fink costume for me. My job was to sit on the stage in front of the kick drum, while Doyle and Jerry took turns randomly bouncing me back and forth with their boots throughout the set. Then haul gear. It was an education.

Will Oldham

Stiv Bators

The Decline of Western
Civilization

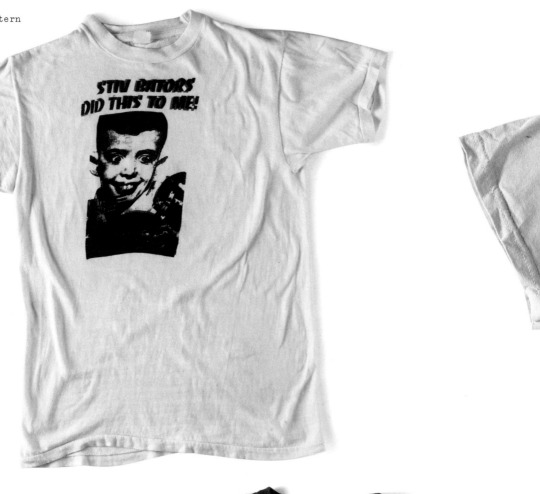

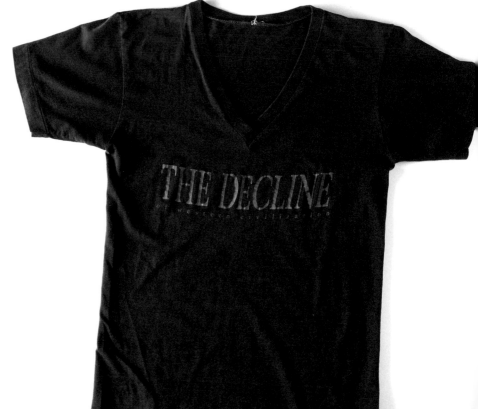

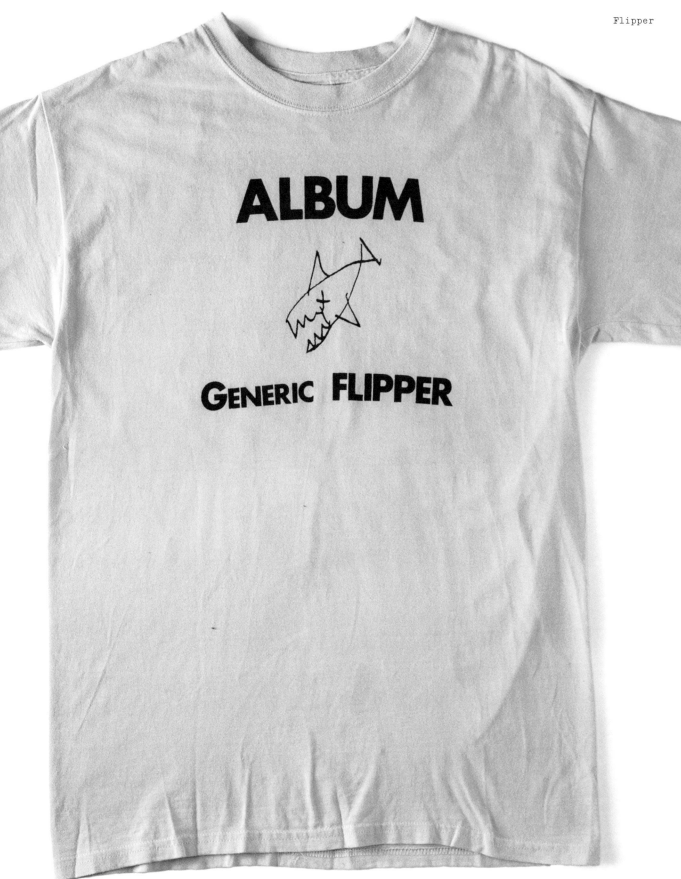

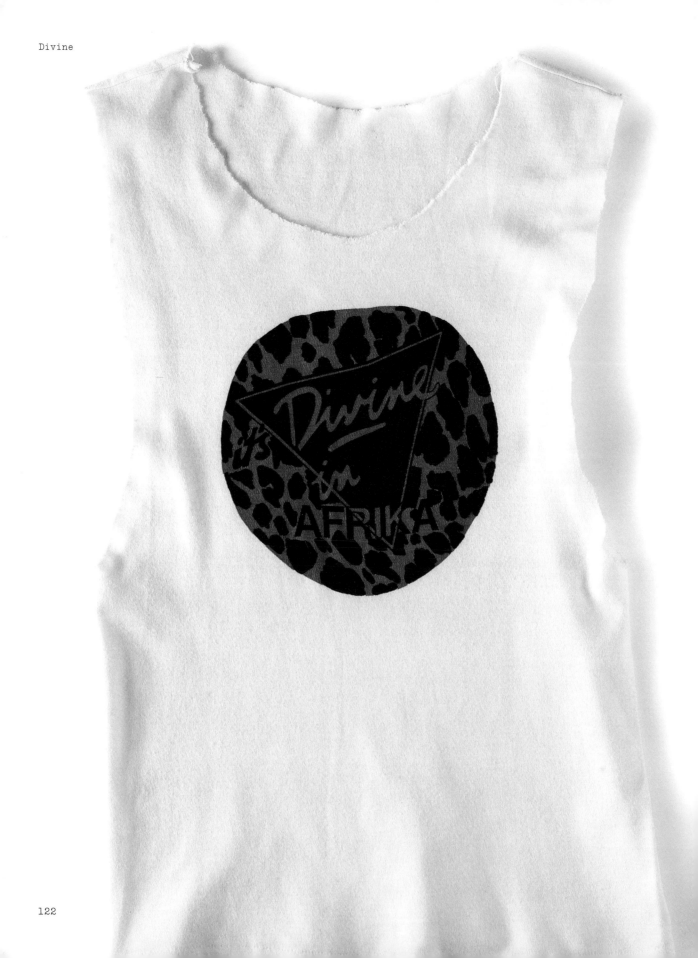

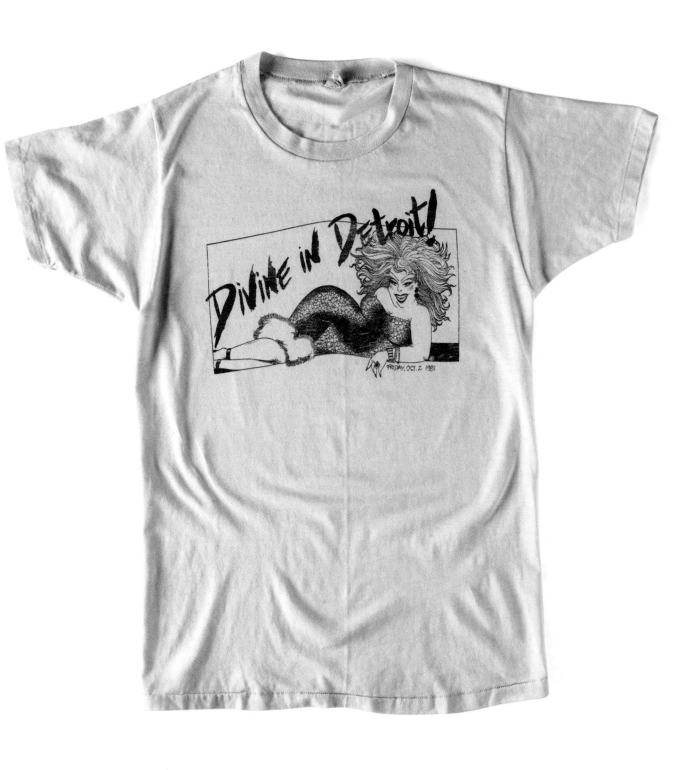

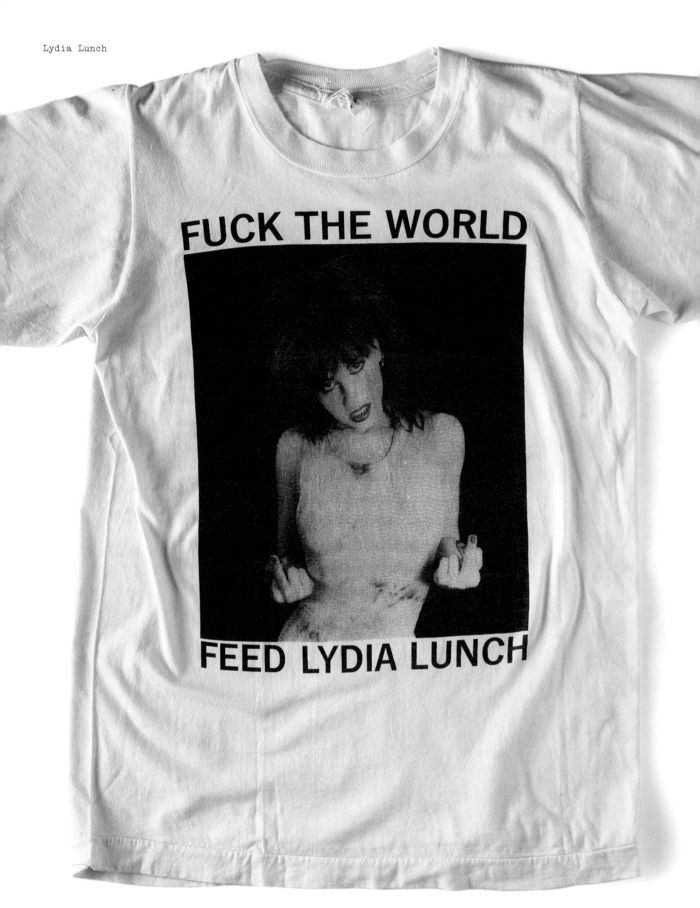

<u>Lydia Lunch</u> is awesome. One of the first times I met her she made me stand lookout while she peed in the stairwell of some Bowery flophouse. She was a wildcat no doubt, I was only too happy to start playing with her after years of spying on her in the subway station and the laundromat. She taught me songs by humming them in my ear with the lights off. Unnerving, but it got the job done. She never wore underwear.

Thurston Moore

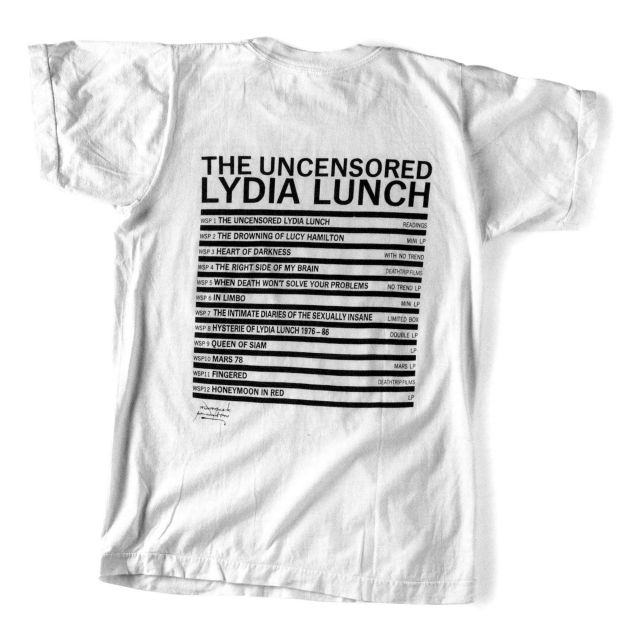

I met Lydia in London in 1982, introduced by Mick
Harvey. I had all the records already. She lived in
an apartment in Baron's Court with Murray. We met
and made plans, wrote and regaled. We were thick
as thieves, lusty as pirates. The Queen of Siam
with ice-blue eyes, red-black heart, white-knuckled
rides, broken arts and broken limbs. An enigma of
poetry, pain, and pleasure. Take no prisoners, fuck
'em all. Save the wails.

Jim Thirlwell

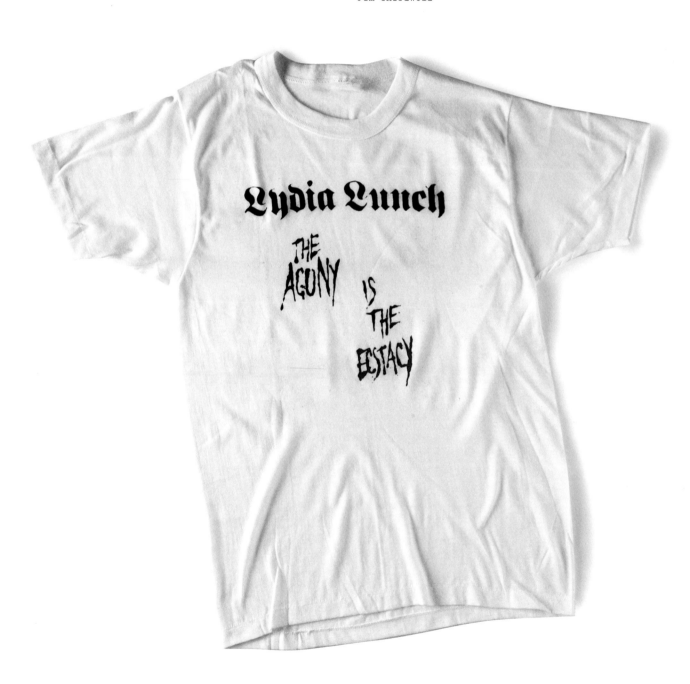

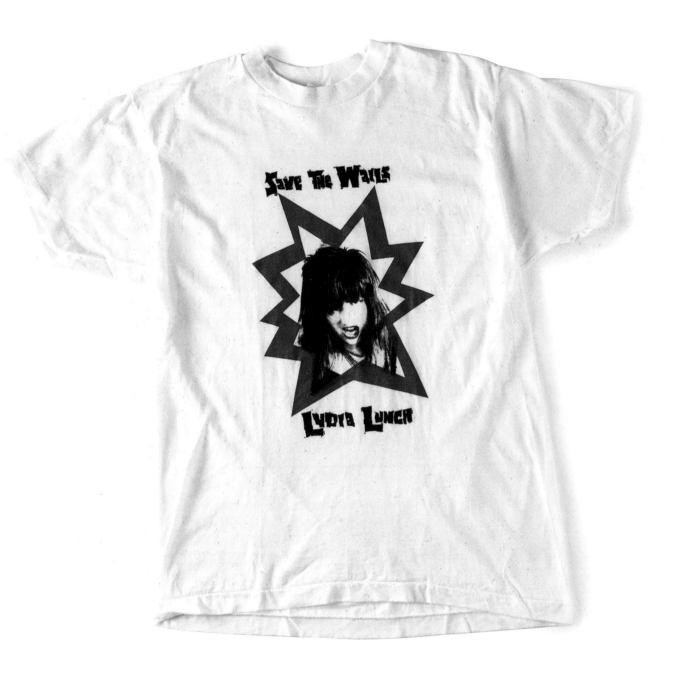

I listened to my hot pink copy of Teenage Jesus and the Jerks over and over when it came out. Looking back at that band now, I see that they were maybe the only true punk art band to come out of New York or the U.K. or anywhere.

All the elements were there: no-one played an instrument, the extremely short songs were full of negative sentiments, and the band broke up immediately after making a couple of records—not because everyone hated each other, but because of punk's constant motivator, boredom.

The sound was what made TJ stand out. Unlike most punk bands, they weren't playing three-chord garage rock, updated '50s music, or free jazz. They made an indescribable noise that was fast, abrasive, and new. You can't just pick up your guitar and figure out how to play one of their songs. Teenage Jesus still sounds fresh if you listen to it now.

Lydia was and is the American Johnny Rotten. Or he is she, I can't tell. Working with her kick-started my career. She was the first woman I ever met who, when routinely accosted on the street, thought nothing of stopping, turning to the guy and saying, "Well come on, let's fuck. You're such a big man, let's see your cock." She's a one-woman war; an antifeminist feminist.

Richard Kern

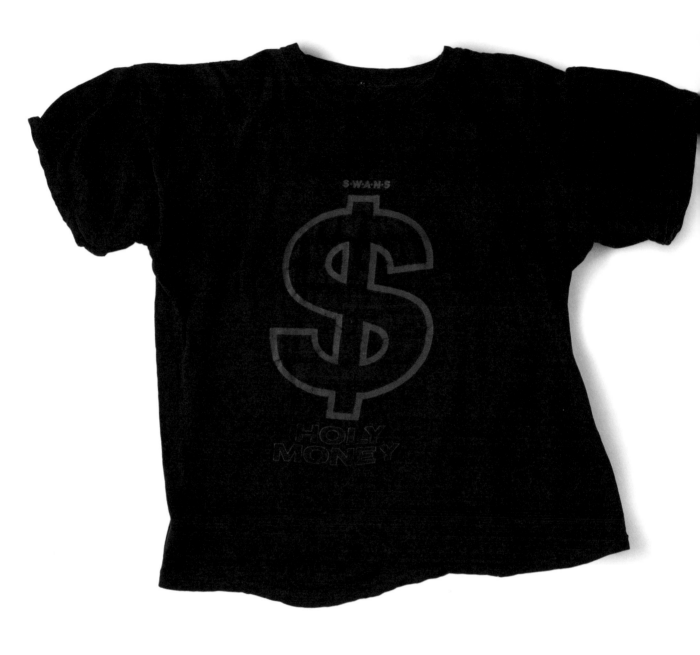

Susan Martin was Lydia's manager. The walls of her apartment on East 6th Street were covered floor to ceiling with dozens of Michael Gira's stunning drawings. Grotesque and violent, they were savagely scrawled, and depicted various tortures and gnarled characters with hoses running from their asses into their mouths, among other things. The <u>Swans</u> live at the Pyramid: snot, saliva, semen, mucus strands from the microphone, and Michael's sweat-slick flesh tortured in self-hatred and excrement obsession. Stooges on 16rpm.

The music as a bludgeon. Enveloping and crippling. We submit.

I'm an infant. I worship him.

Insecurity. Self-hatred. Venomous bile.

Snot pouring from Roli's nose, swinging thru the air in arcs.

Harry Crosby's merciless bass thud delivers blunt blows below Norman's tortured Stringscree.

And tumbling barrels of sound erupt, belching from the volume pedal... and later we wreaked havoc at Blanche's and other long-defunct East Village watering holes.

Jim Thirlwell

I saw Neubaten's first US appearance, at Danceteria
in 1983, and though the spark burns have healed, my
hearing has never recovered.
 They were not a rock group. They were an amplified
construction site. When Danceteria unplugged the
PA, the circular saws and jackhammers continued, as
deafening as before. The stage was destroyed.

Stephen Merritt

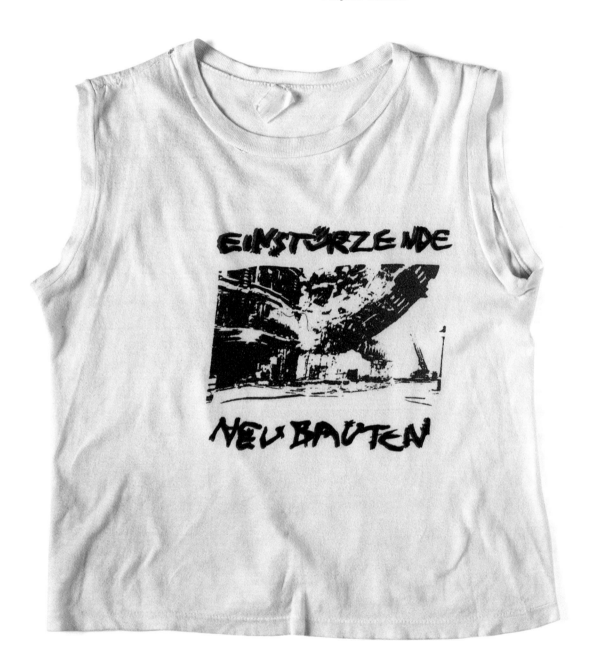

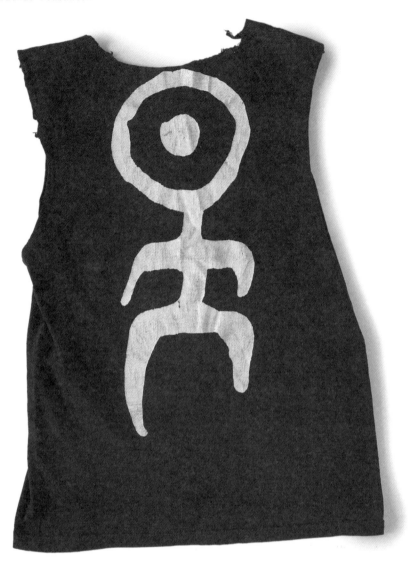

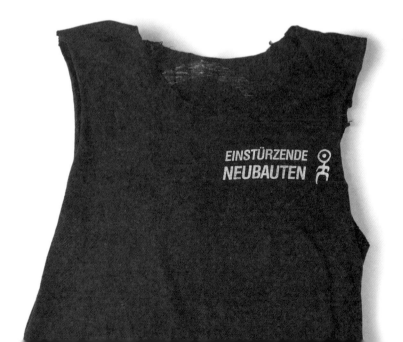

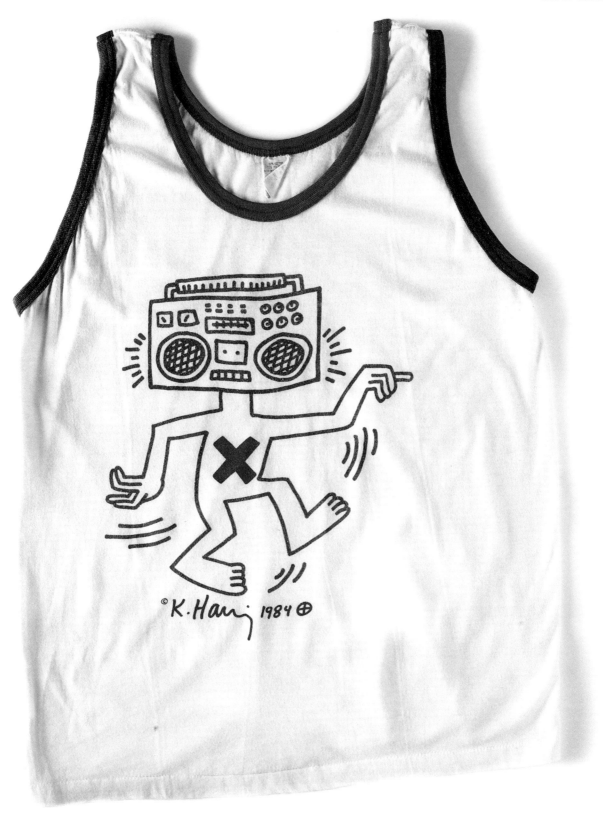

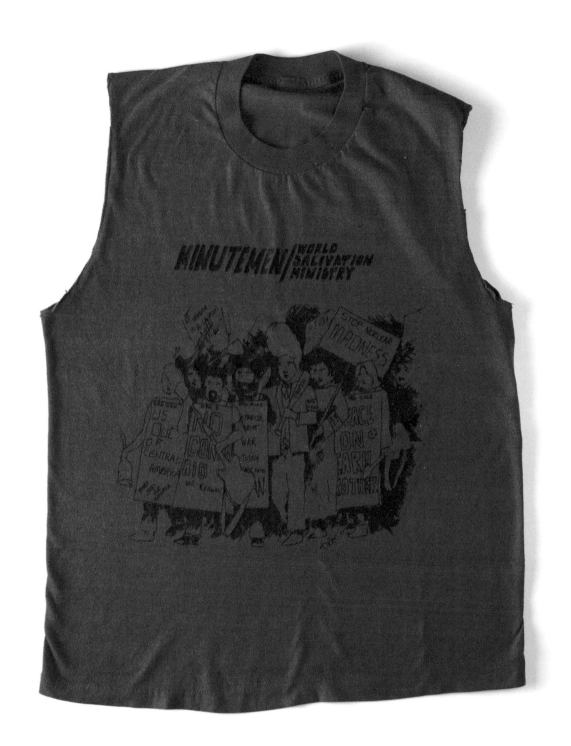

The Coconspirators tour 1985 with the salivation ministry wound up being the Minutemen's last headlining tour—our actual last tour was later that fall, opening for R.E.M.

 D. Boon made the drawing, which showed us as part of a rally, making folks take notice of what was on our minds. In Providence, Rhode Island, we had a tour stop at the Living Room and D. Boon told me there was something trippy about his amp (a Fender Super Twin), and I told him to touch the strings of his guitar to the mic stand—whereupon huge sparks flew and they melted and snapped in a flash! I looked him right in the eyes and said, "You ain't using that amp anymore!" We borrowed one from one of the opening bands. The next day he got a new one (red-knob Fender Twin) before the gig in New York City. That was a fucking pants-shitter, scared the fuck right out of me.

Mike Watt

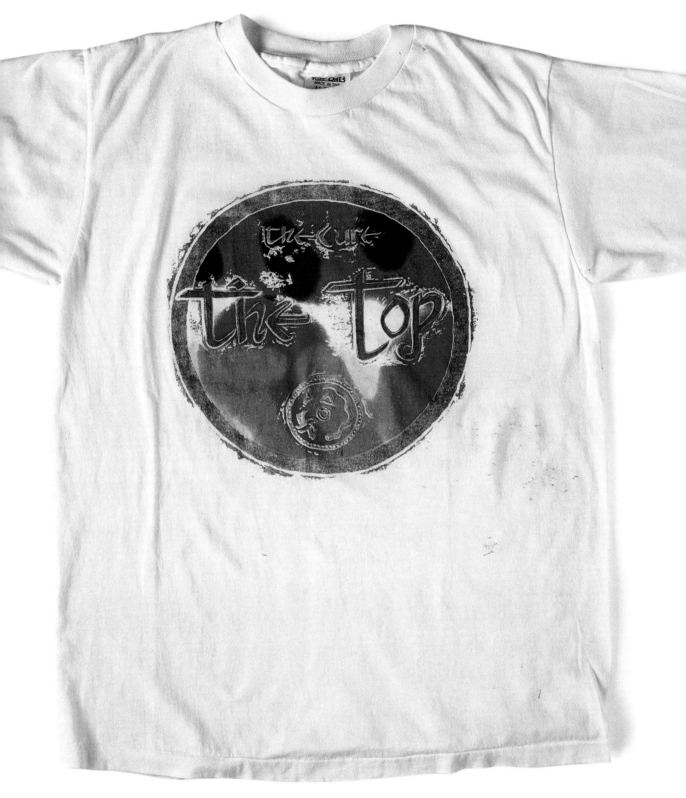

Boy London

Public Image, Ltd.

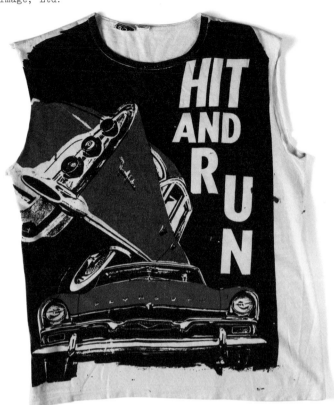

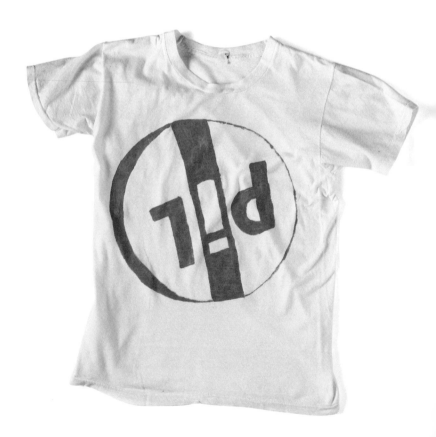

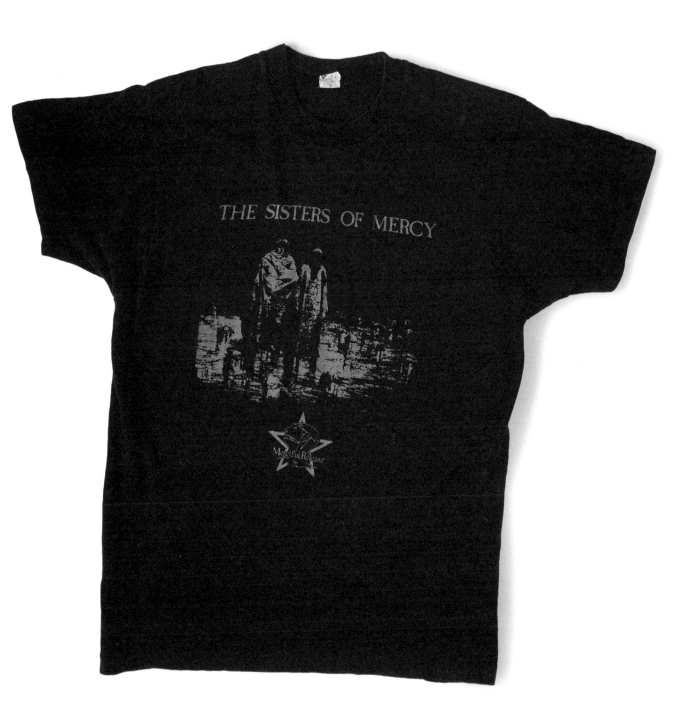

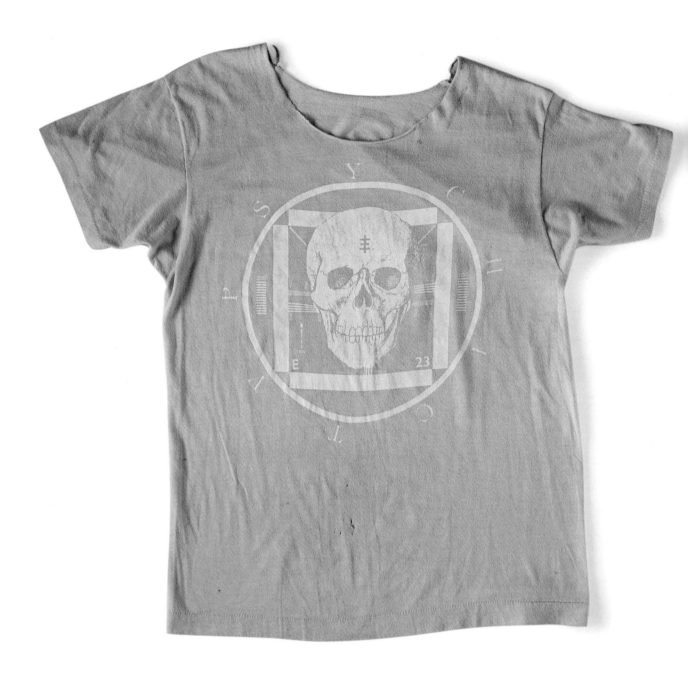

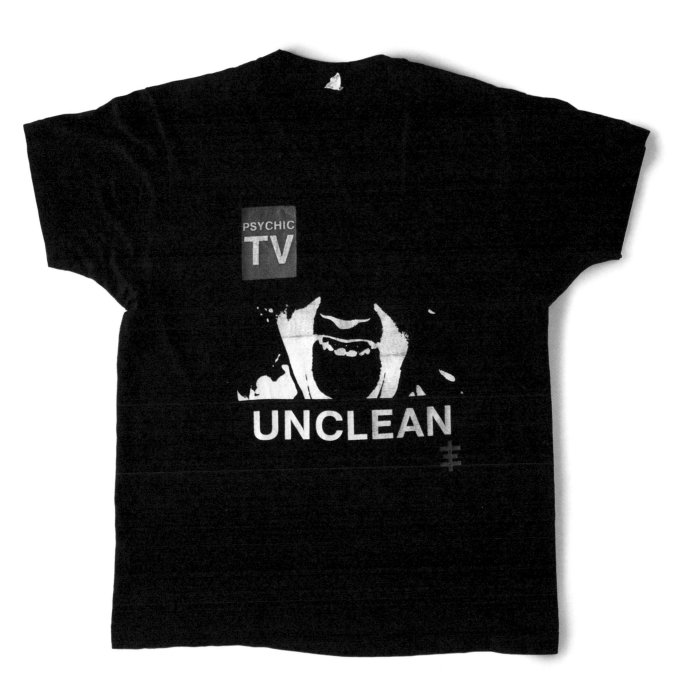

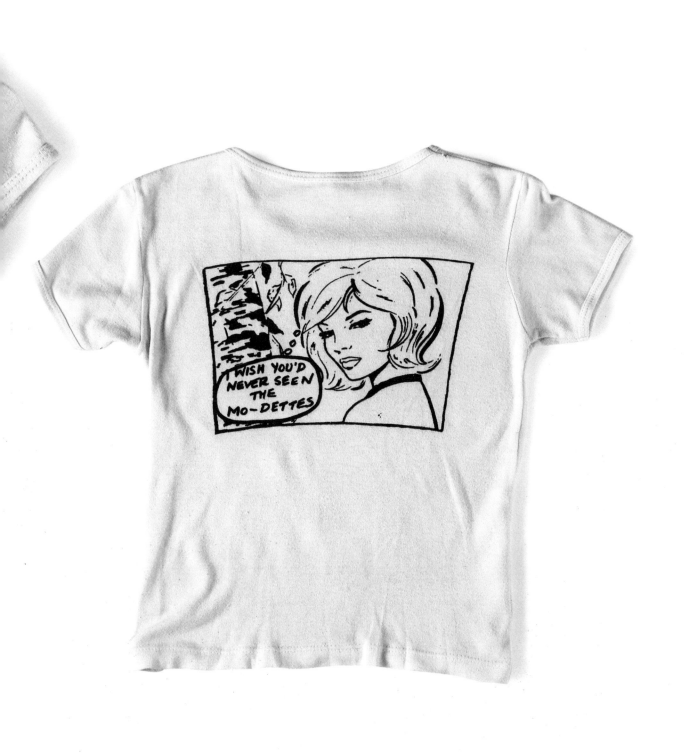

"Come celebrate Tootie's birthday with us!"—screaming from the top of a photo-copied pink flyer with heart-shaped cutouts of Tootie, Jo, and Blair. I couldn't believe it! There was a band who were obsessed with Facts of Life—and proud of it. I was in stunned. You see, that was 1981, and that was the time you'd get your ass kicked for saying something like that. LA punk had become overrun with bad hardcore, slam pits, skinheads, boots, chains, fuck Reagan, etc. The scene sucked hard—until I discovered Redd Kross.

Jeff and Steve McDonald led the sonic ode to '70s glitter, bubblegum pop, the Beatles, the Osmond Brothers, serial killers, anything on TV, Linda Blair, and Pink Flamingos—all of which was chemically enhanced by all the drugs two teenagers could score in Hawthorne, CA. And the look was, well, a death-sentence: two towering teens over six feet tall with teased long hair (well, past their ears, but that was long!), ruffled thrift-store tuxedo shirts, and gold lamé pants accessorized with Flying Vs and Partridge Family covers.

As they were booed, spat on, called "faggots," and pelted with anything a roomful of skinheads could reach, I became their all-time biggest fan. And I still am. The rest of the world may not know it, but when it comes to all things cool, kitsch, sleaze, trash, and catchy rock-and-roll, Redd Kross started it all. And that, kiddies, is a fact of life.

Jennifer Schwartz

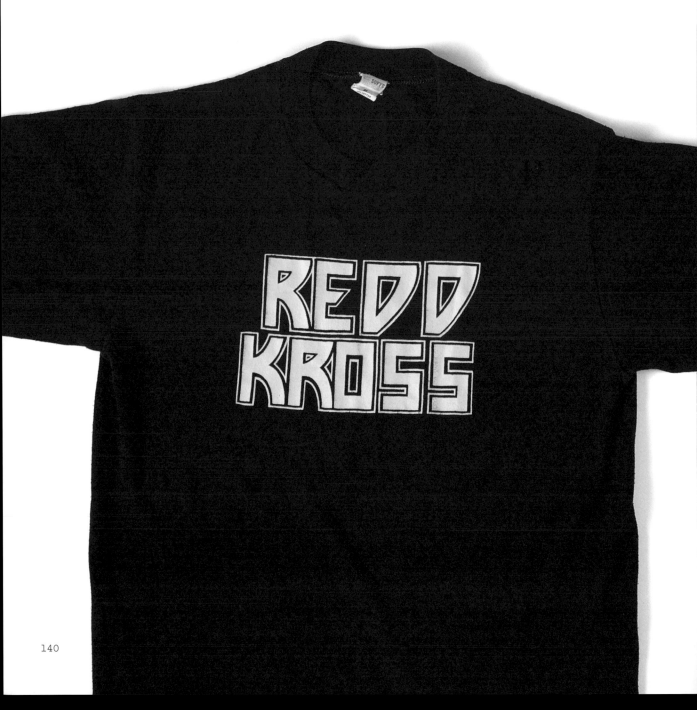

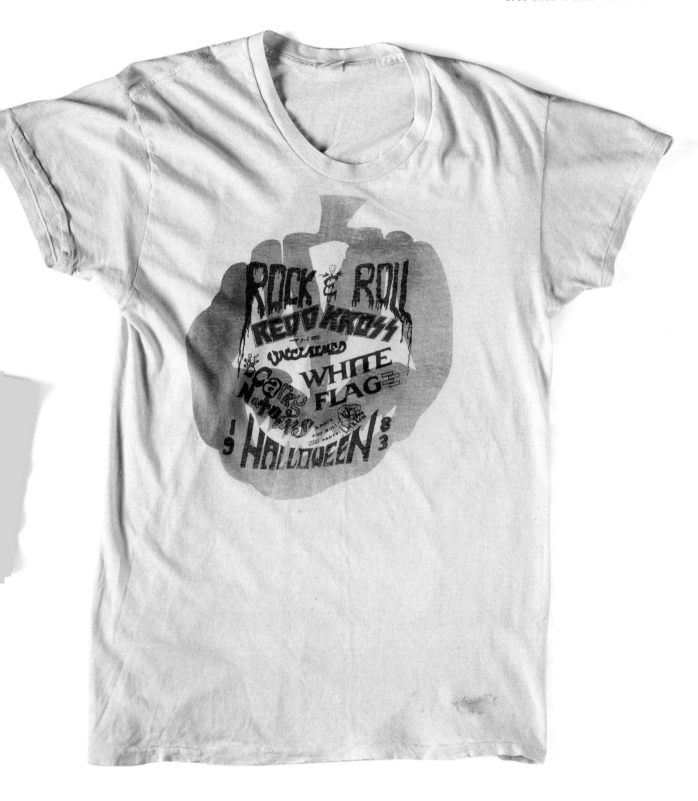

The Bangles

Social Distortion

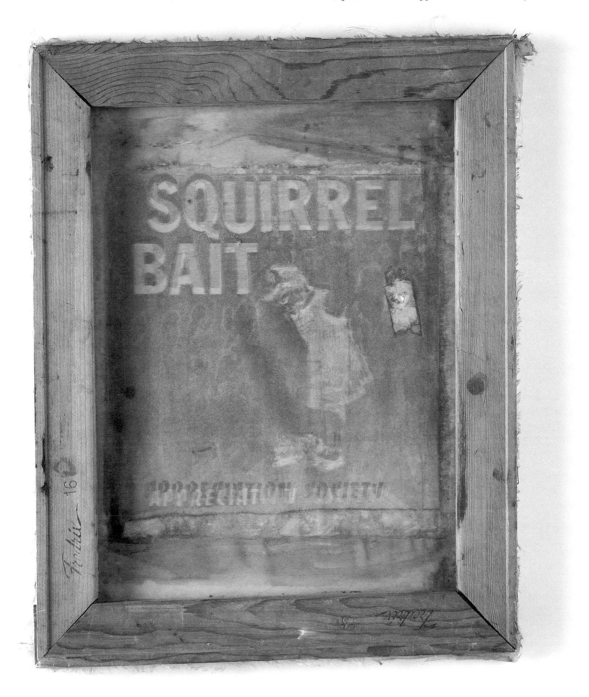

Summer of 1983, back home to Louisville from my freshman year at school and working as a lifeguard. I was doing my own silk-screen rock shirts when I started playing in a basement band with my buddy T.R.'s brother Clark and his friend David. David and Clark wrote everything and played guitar and bass. I provided spastic drumming and technical expertise in churning out T-shirts with my laundry-room Hunt-Speedball silk-screen setup. Canvas stretchers, emulsion, a 150W light bulb, latex paint...

The Squirrel Bait Appreciation Society screen was conceived and produced around the same time as some of our successively astounding basement cassettes. The image was taken from a 1950s Ladies' Home Journal, successfully fulfilling the nonsequitur requirement. Like the bands, shows, fanzines, and posters of the time, the idea was to make something new with group inspiration and the most basic tools.

Richard Schuler

143

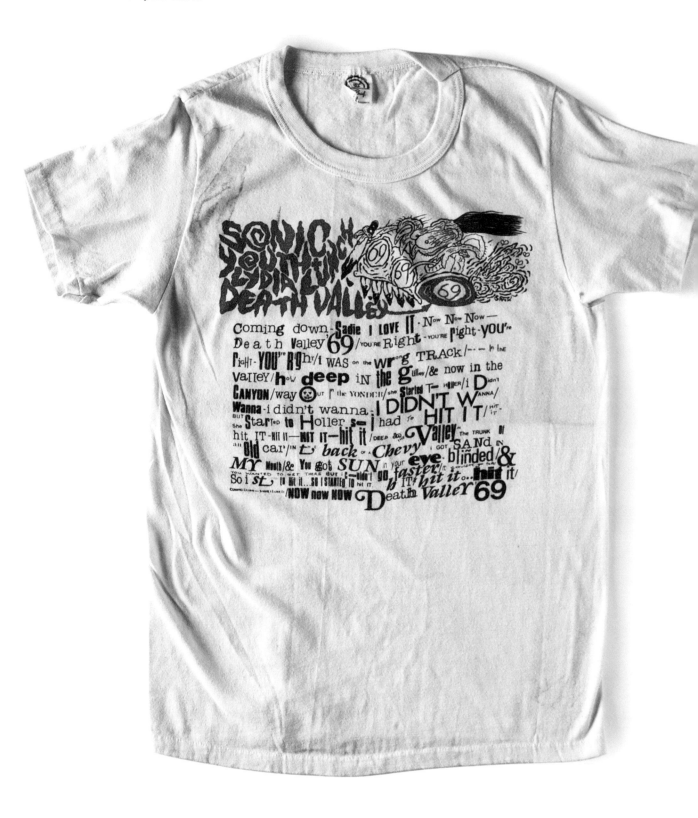

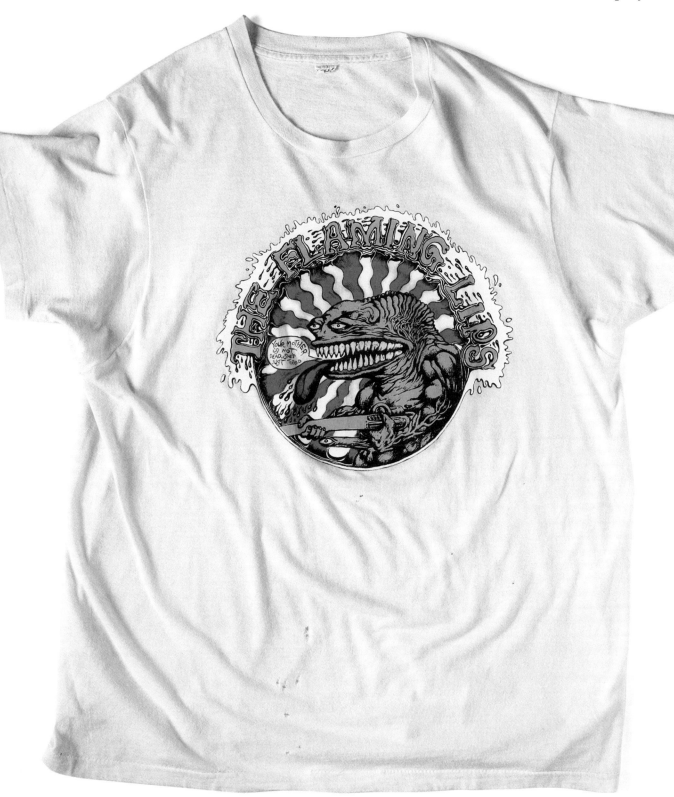

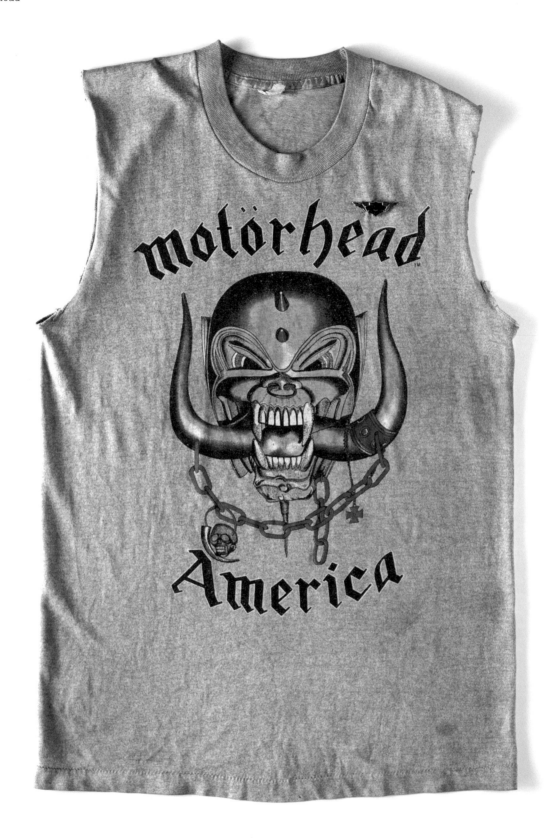

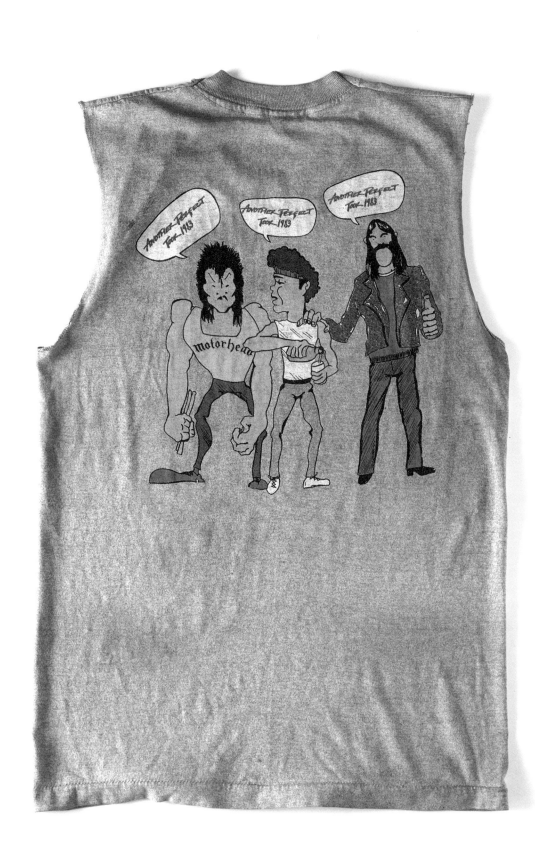

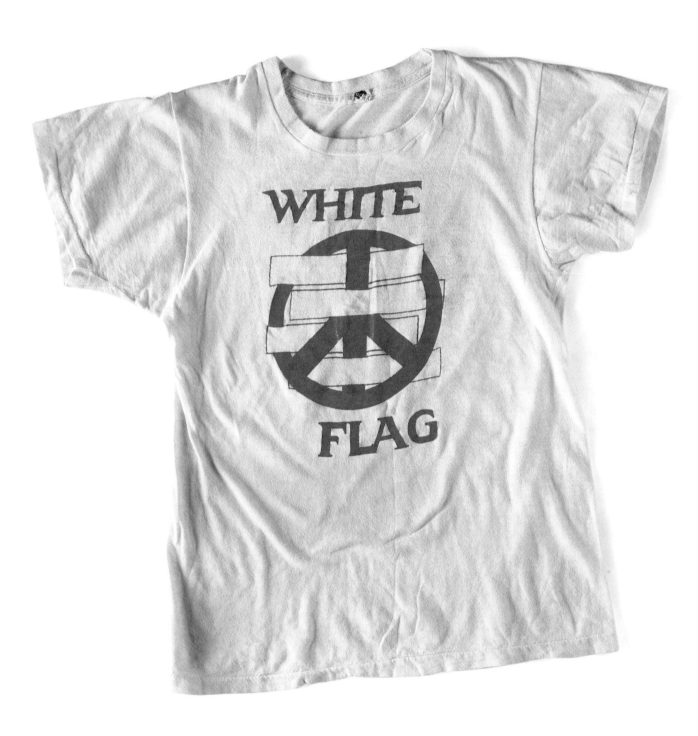

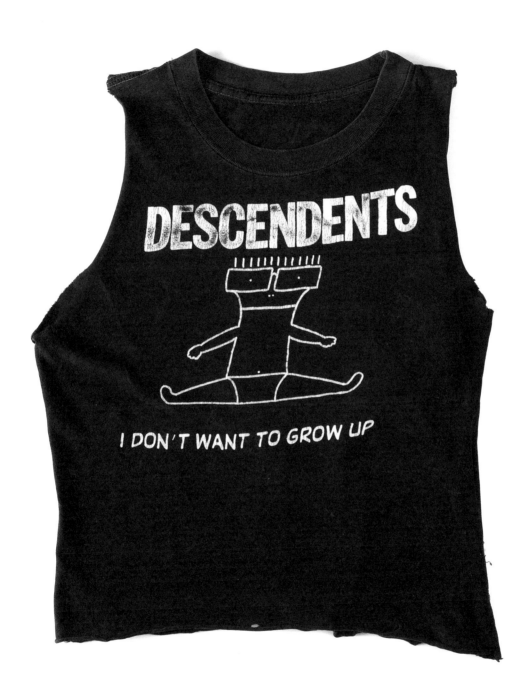

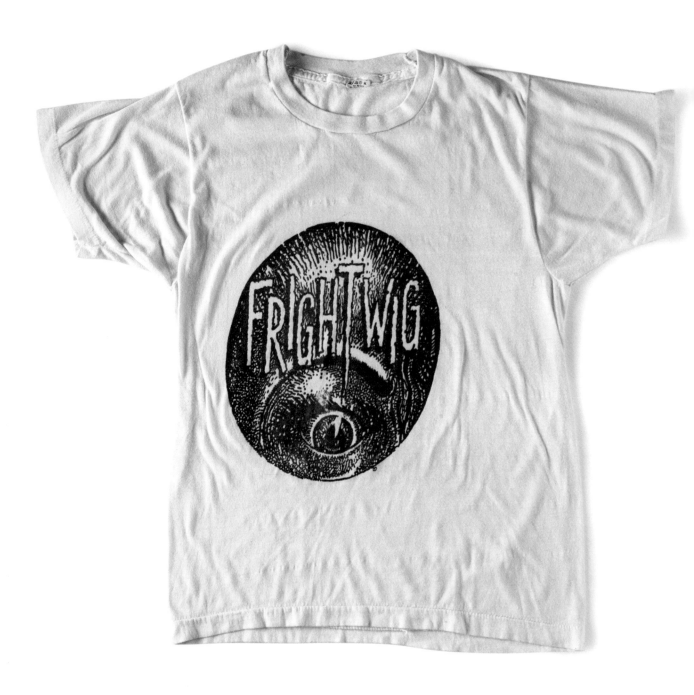

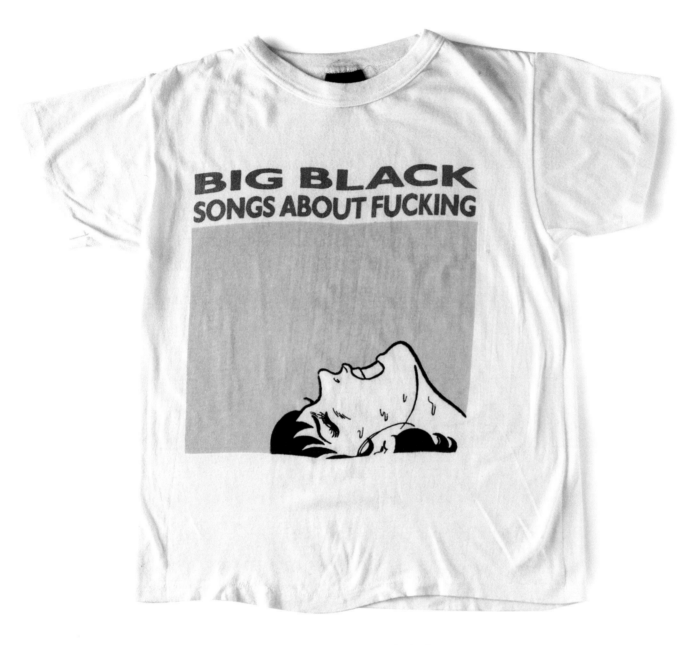

Big Black were a perfect martini of shock,
intelligence, and humor. I used to think Albini was
like the mad scientist from Reanimator, but anorexic
from junk. A disfigured bassist, drum machine, and a
Teutonic rhythm guitarist with interests in sadistic
experiments—like watching a snuff film, I was both
repulsed and intrigued. And I saw a lot of that
shit at Albini's house... it was always a cultural
experience to sleep on Steve's couch. One time we
went to a party that was so crowded, Steve lit a
propane torch, tucked it into the pocket of his
shirt, and marched through the crowd defying anyone
to fuck with him.

David Pajo

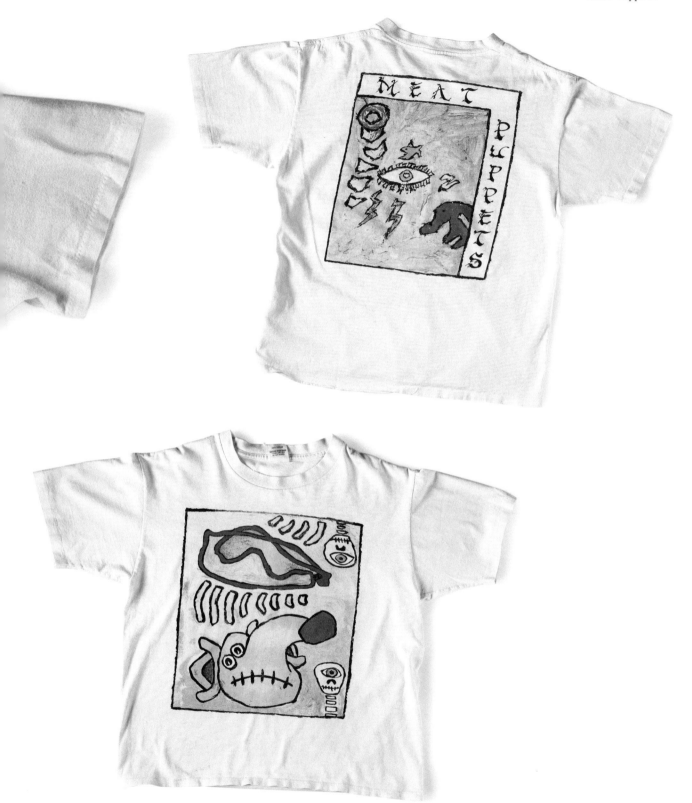

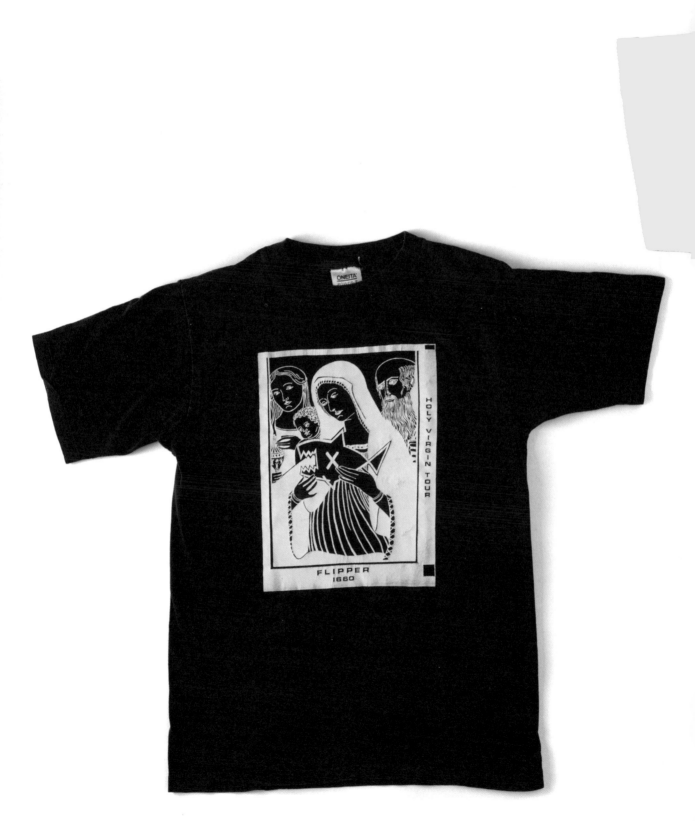

Deathtrip Films & ARTWARE proVISION

Richard Kern (photo: Tony Coke)

Lydia kept telling me about Richard Kern, this guy who came up to NYC, who made weirdo art fanzines called Valium Addict and Heroin Addict. He and Tommy "Bloodboy" Turner were enlisted to disturb, heckle, and interrupt her readings. The first one I witnessed was in the basement of the Pyramid club in the East Village. During Lydia's monologue, Bloodboy ran out of the crowd screaming at Lydia that what she was doing wasn't real art and then proceeded to chop his hand off with an axe, his arm shooting blood everywhere. People were freaked, it was very impressive.

Thurston Moore

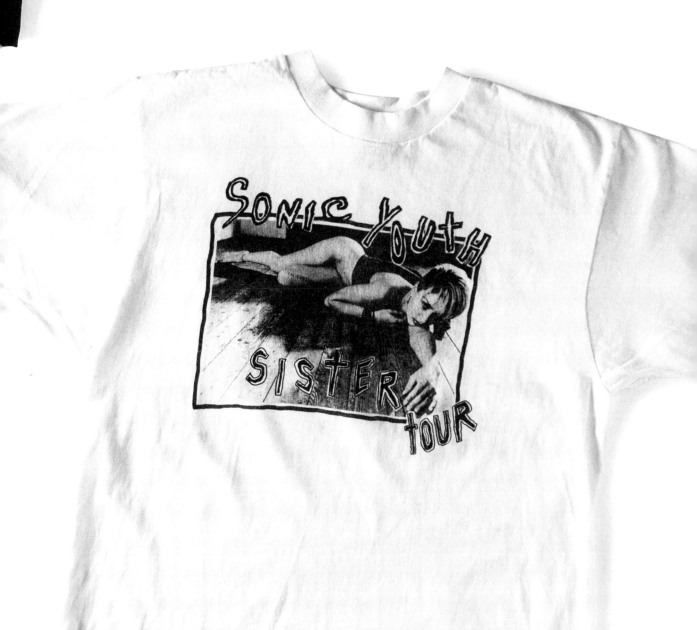

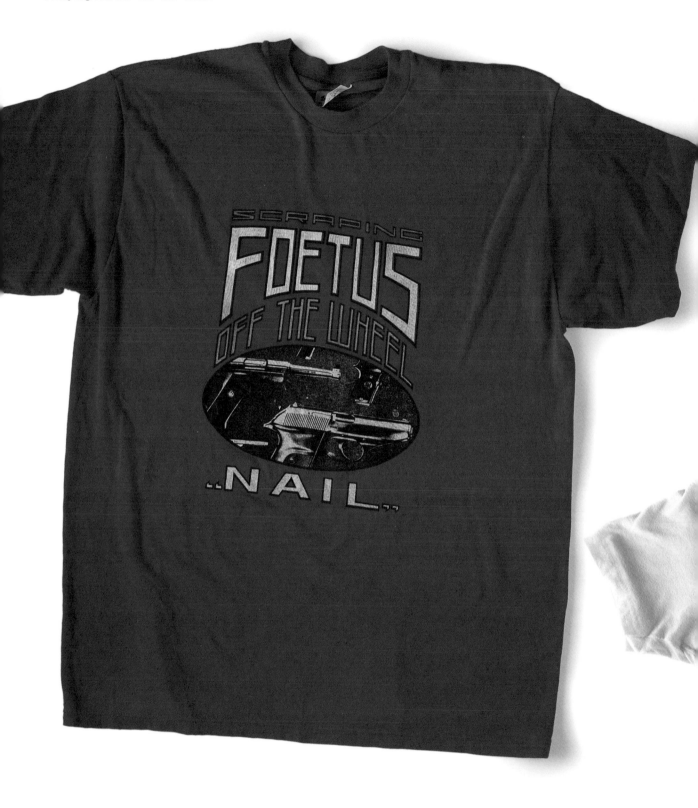

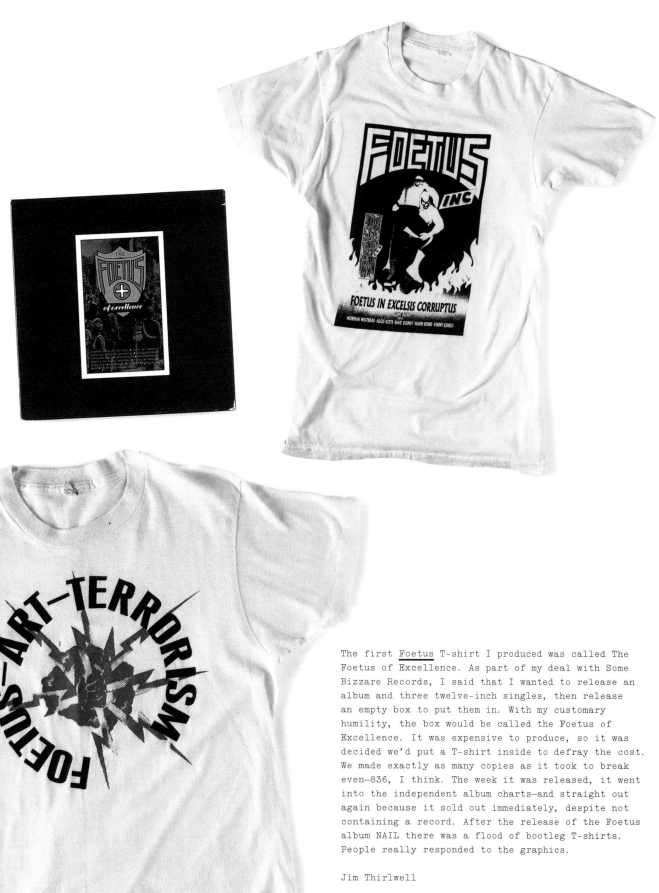

The first <u>Foetus</u> T-shirt I produced was called The Foetus of <u>Excellence</u>. As part of my deal with Some Bizzare Records, I said that I wanted to release an album and three twelve-inch singles, then release an empty box to put them in. With my customary humility, the box would be called the Foetus of Excellence. It was expensive to produce, so it was decided we'd put a T-shirt inside to defray the cost. We made exactly as many copies as it took to break even—836, I think. The week it was released, it went into the independent album charts—and straight out again because it sold out immediately, despite not containing a record. After the release of the Foetus album NAIL there was a flood of bootleg T-shirts. People really responded to the graphics.

Jim Thirlwell

Motorslug

Wiseblood

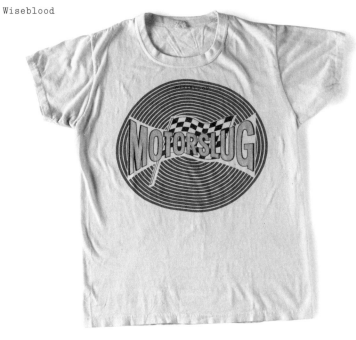

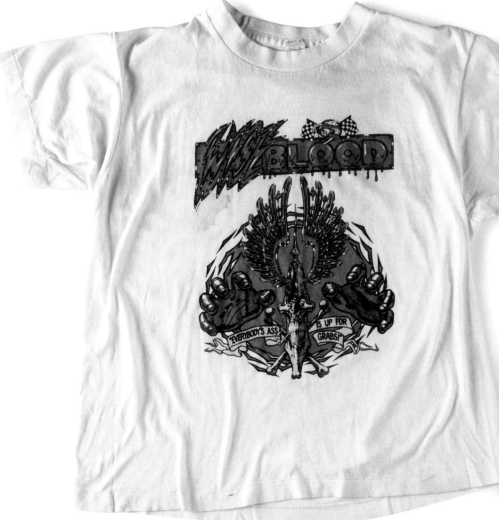

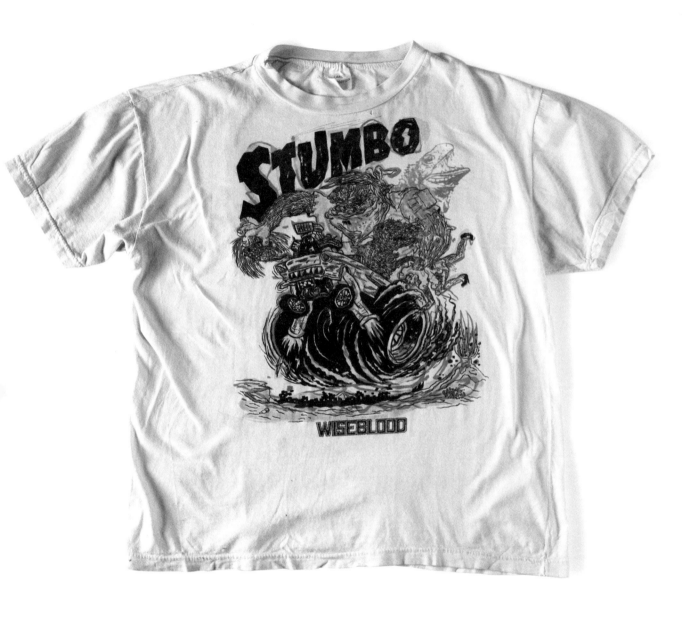

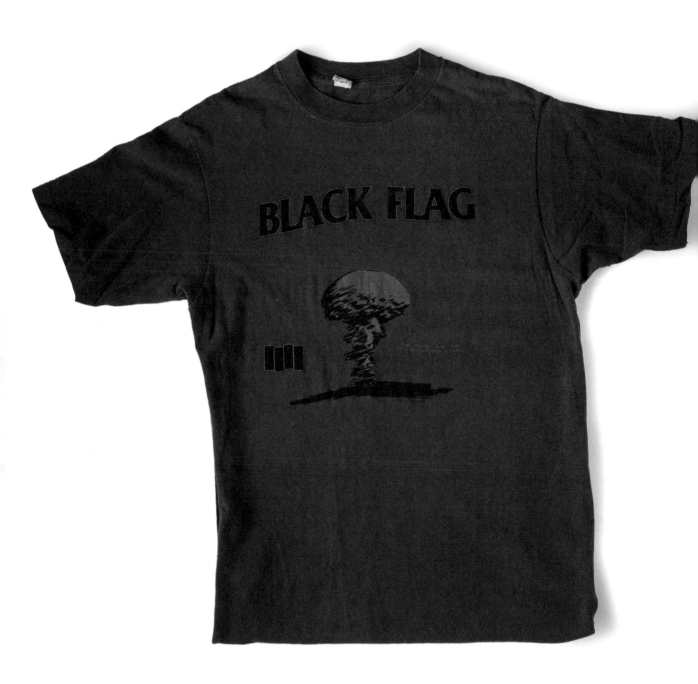

All we wanted was to get out of our dead-shit nothing town. The only thing remarkable about our 1985 nationwide tour was the number of shows that fell through, leaving us with a grand total of seven. We did get to run around broke in New York for a couple of days. It was both exciting and a letdown. As a kid I imagined that so much more was happening in the places I was reading about than where I was. It turns out that that's true of everyone, everywhere. In 1989 when the Seattle thing was heating up nationwide, we met a kid from New York who had traveled for five days across the country to see a couple of local bands. We were stunned. Every town is a dead-shit nothing town, and it's up to you to do something about it.

Mark Arm

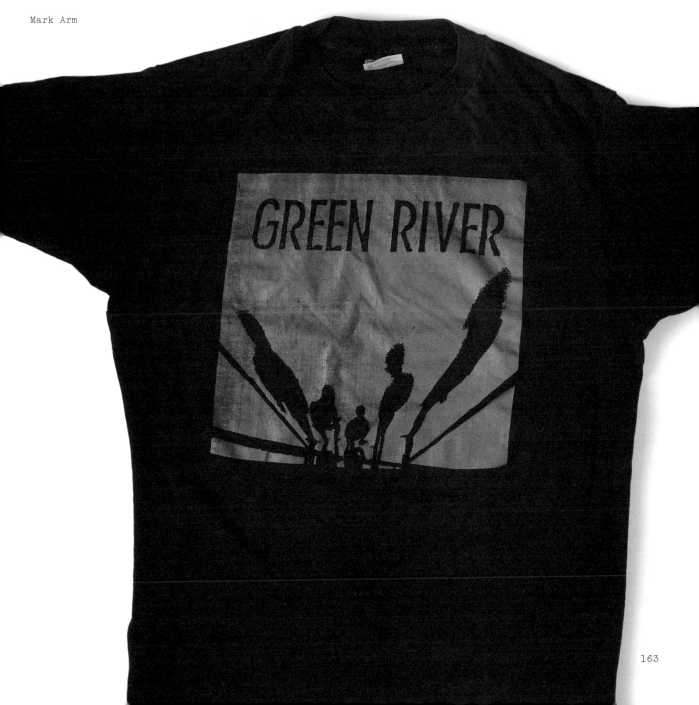

Dark Bros.

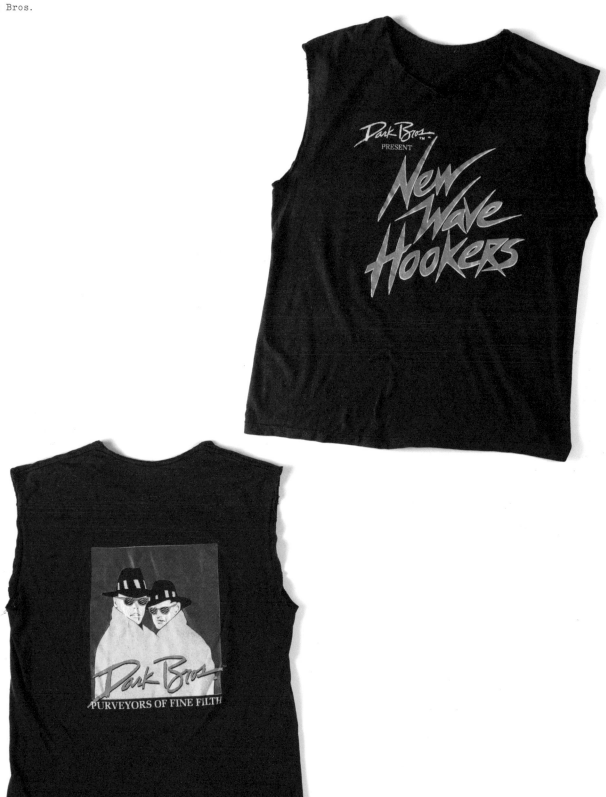

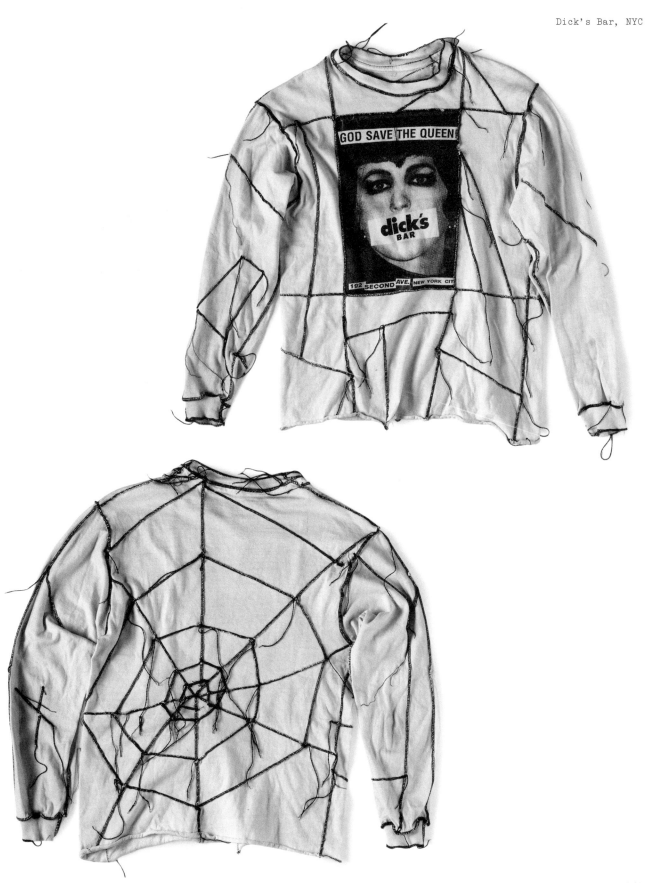

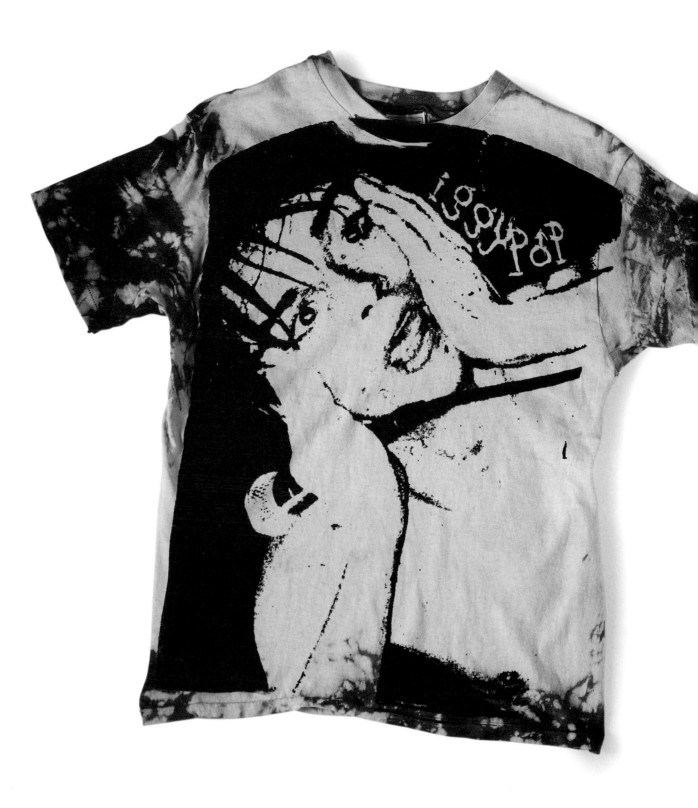

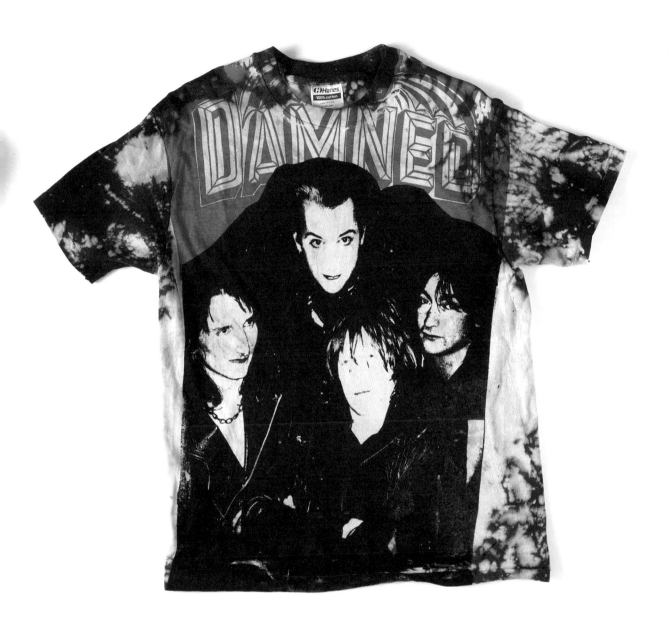

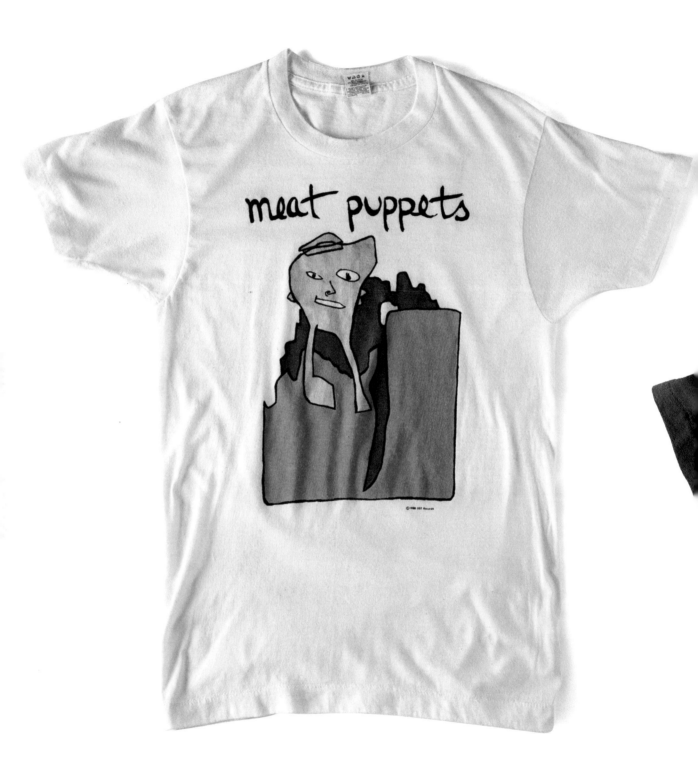

Kim and I formed the Lovedolls in the summer of 1984, after the movies Desperate Teenage Lovedolls and Lovedolls Superstar had come out. We weren't as cute (or horny) as the Pandoras, and we were nowhere near as polished as the Bangles, but we loved to rock and fuck shit up—along with drinking, fighting (mainly with each other), and getting high (they called us the "drug dolls").

Kim was way out of control, a precursor to Courtney Love, only more insane. Abby was sixteen years old, talented, gorgeous, and a complete hell-raiser. Janet was fun and cool but had a deadly violent streak. She and Kim would go at it all the time. During one practice, they got into a screaming match because Janet didn't like the smell of Kim's food. Steve McDonald was playing bass with us at the time (Abby had to take her SATs), and Janet's legendary rant ended up in the Redd Kross song Peach Kelly Pop: "Get that salami sandwich outta here!"

The fun and fistfights ended for me in 1988, when Kim kicked me out because I couldn't sing (it took her that long to realize it?). They got a few new singers, but fizzled out a while later. Janet and Abby both continue to rock hard in various forms. I never spoke to Kim again, but I heard her habits got the best of her in 2004. Her friend told me she left behind two young daughters, the eldest she called "Kitty" after my character in the movies.

Jennifer Schwartz

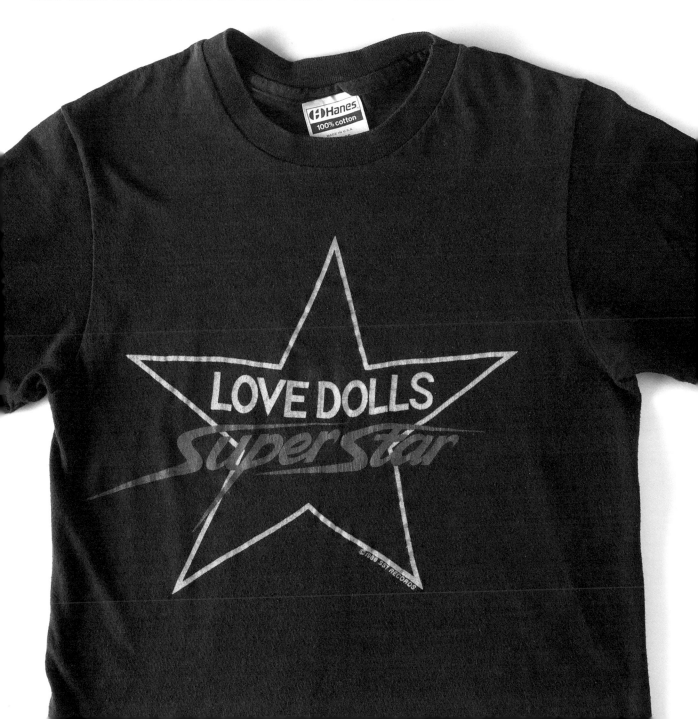

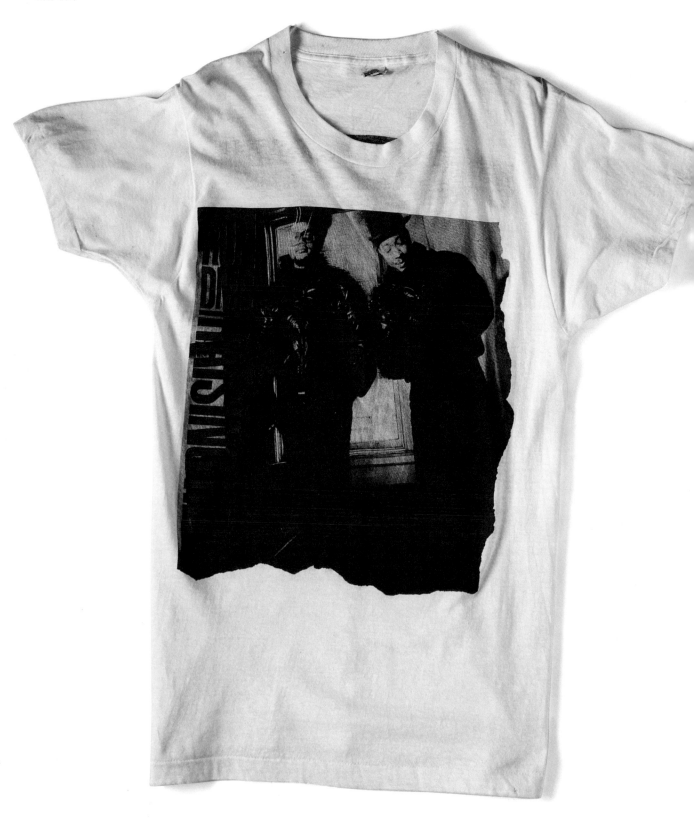

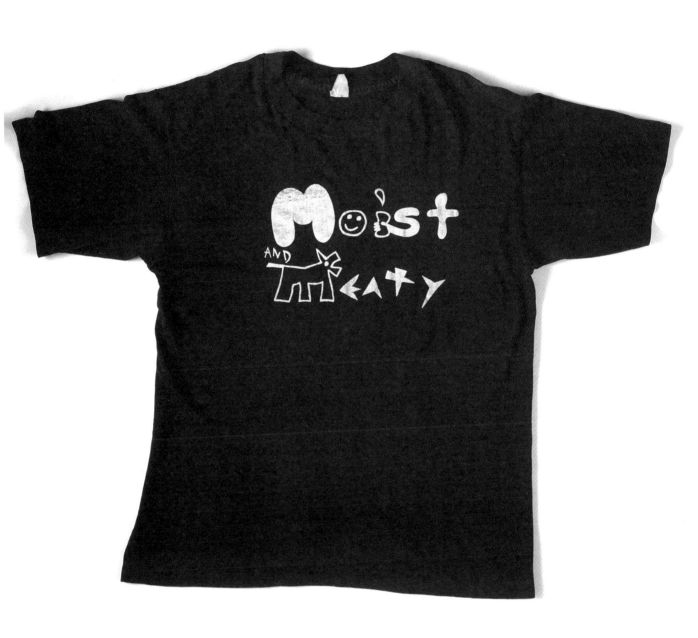

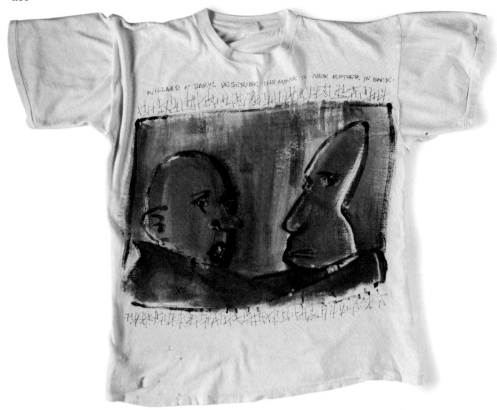

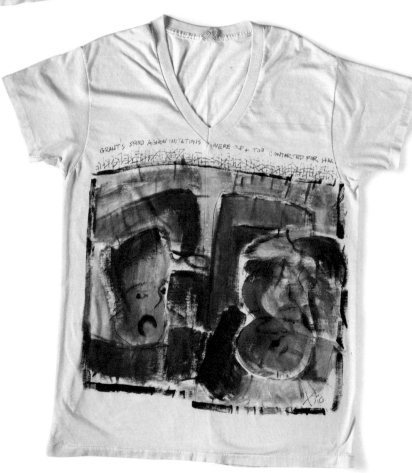

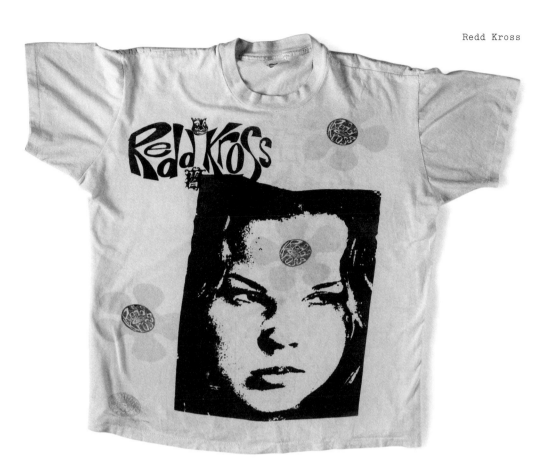

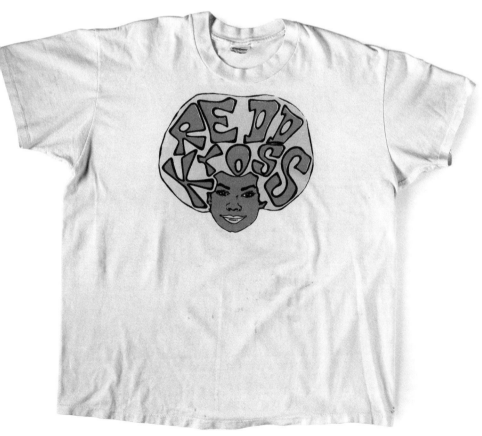

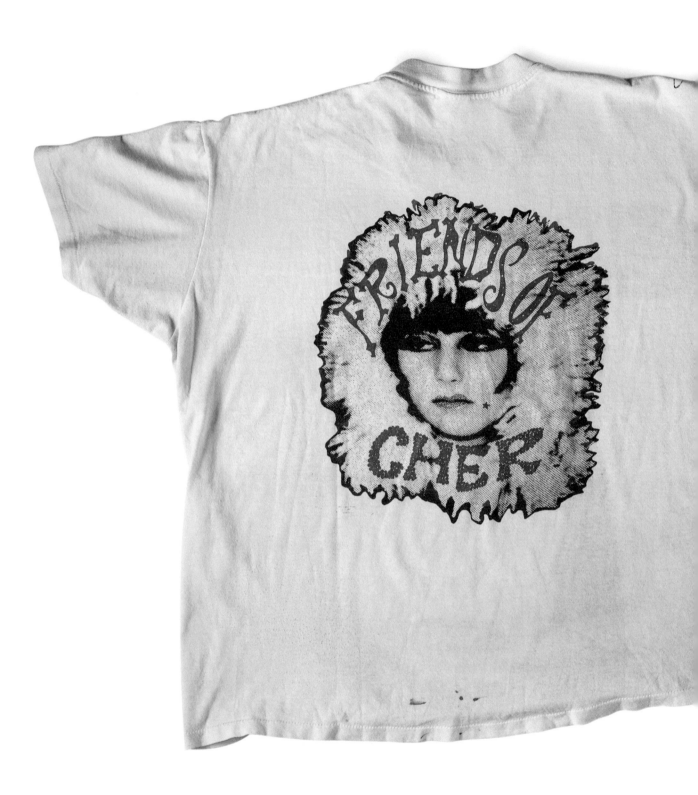

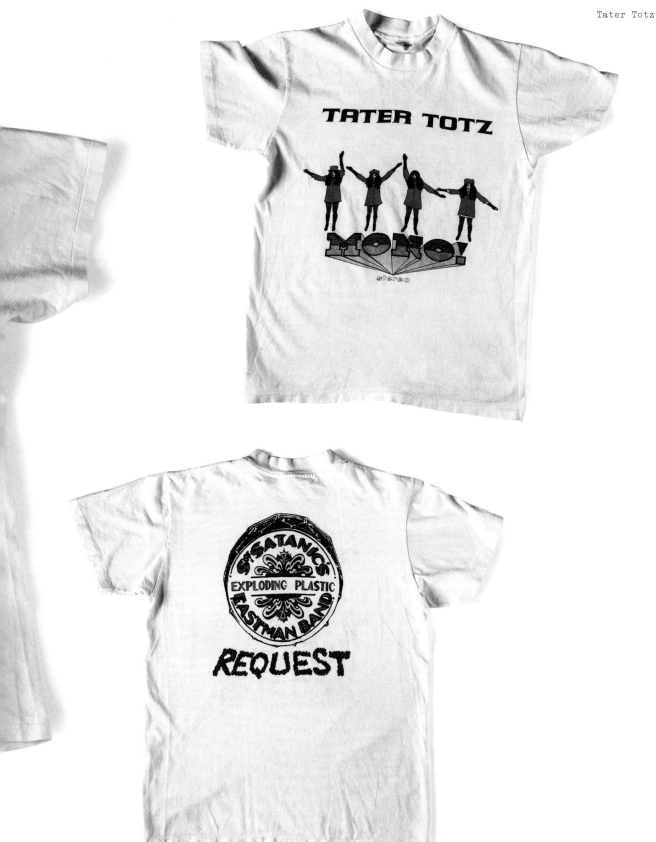

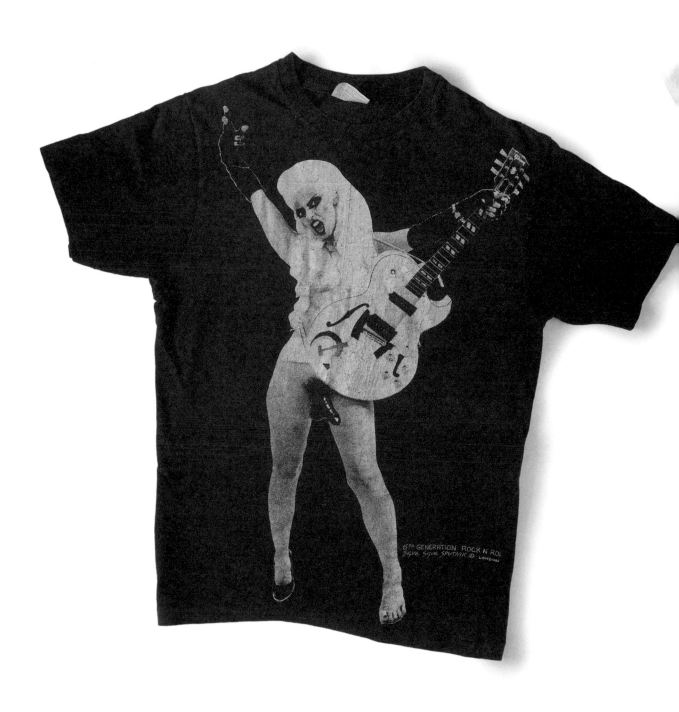

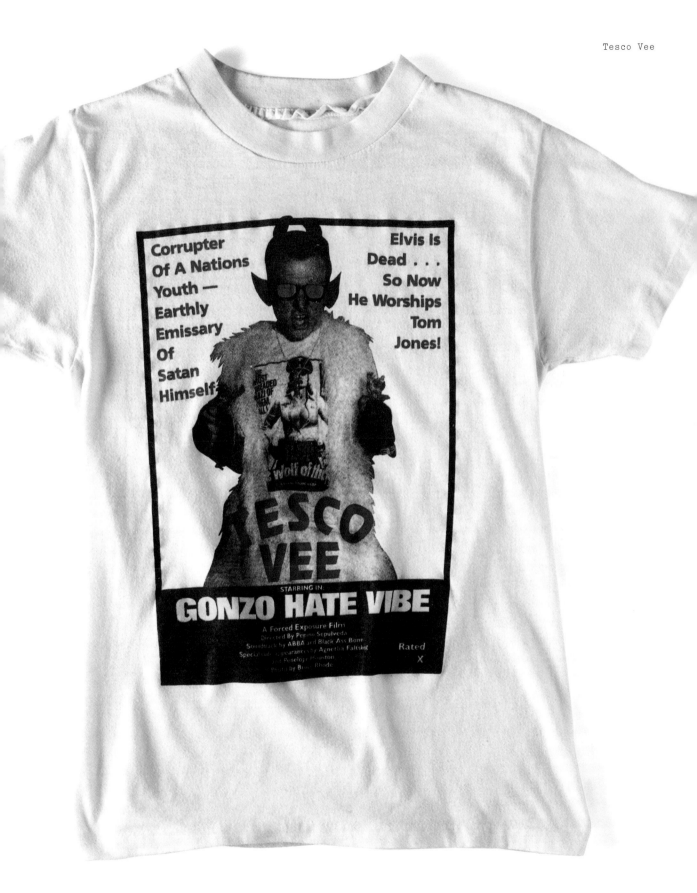

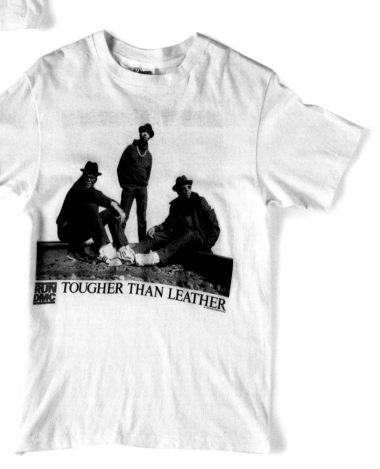

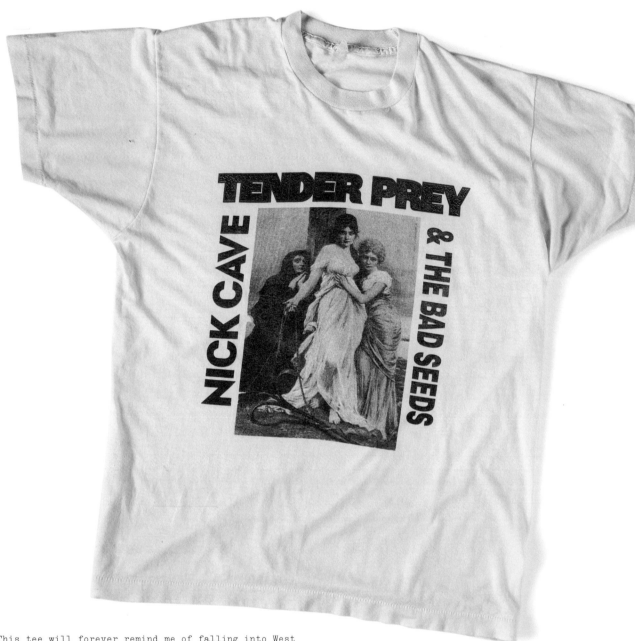

This tee will forever remind me of falling into West Berlin in 1986 when the wall was still standing. For me it was the beginning of an adventure as a Bad Seed in Berlin for three years. Nick designed this shirt for the Tender Prey album and tour. He was in the midst of writing his novel, And the Ass Saw the Angel, and we had just completed filming Wings of Desire with Wim Wenders. Maybe you can see the yellow junkie sweat stains in the armpits, which lend this shirt a certificate of authentication.

Kid Congo Powers

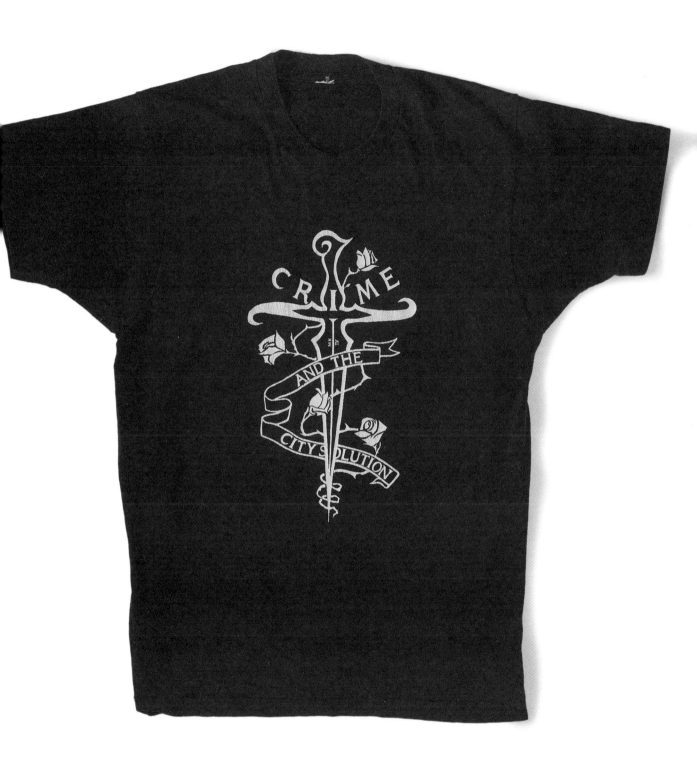

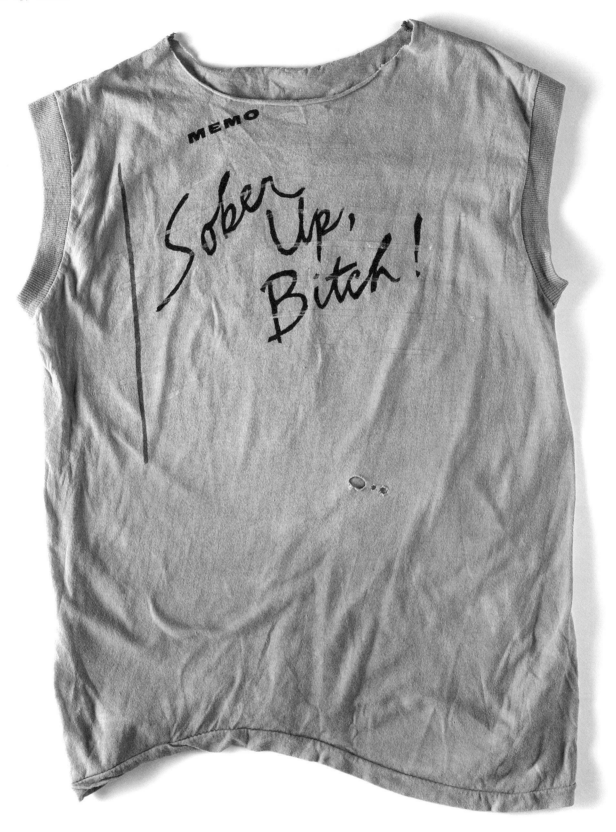

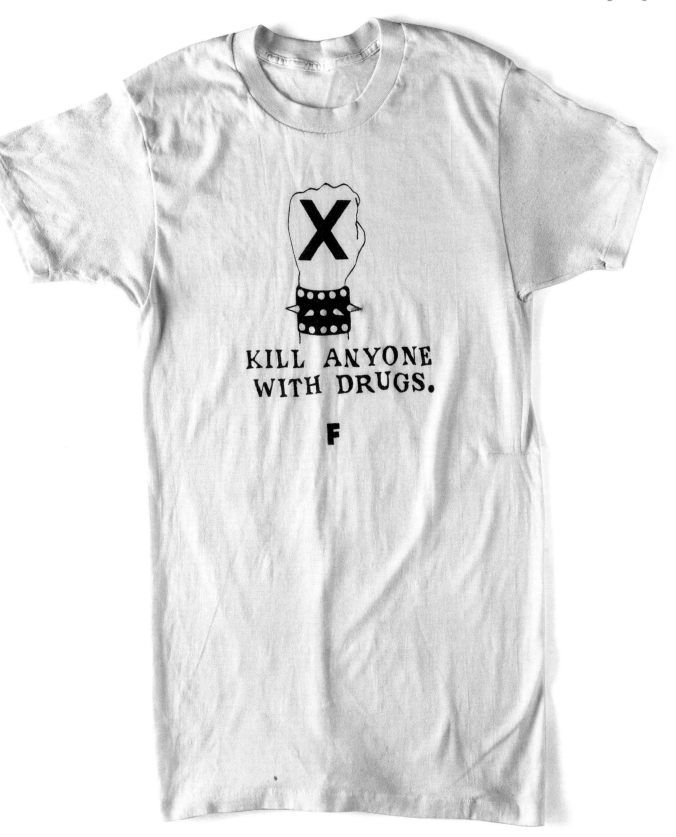

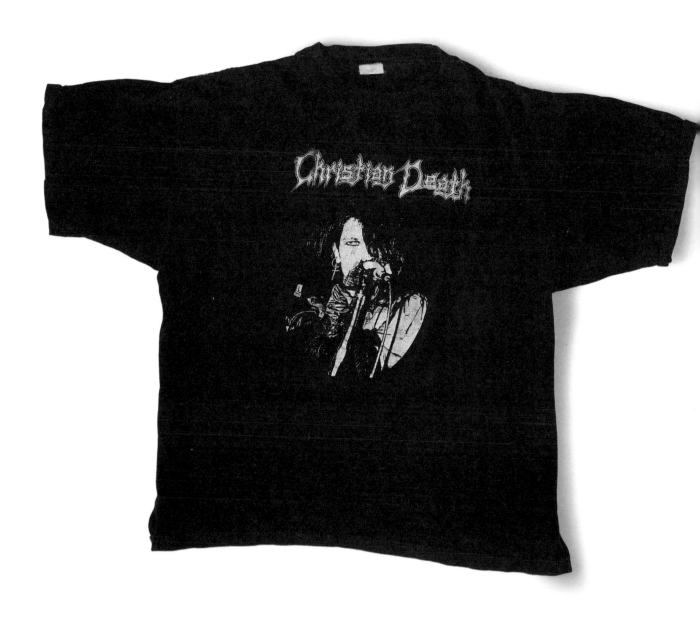

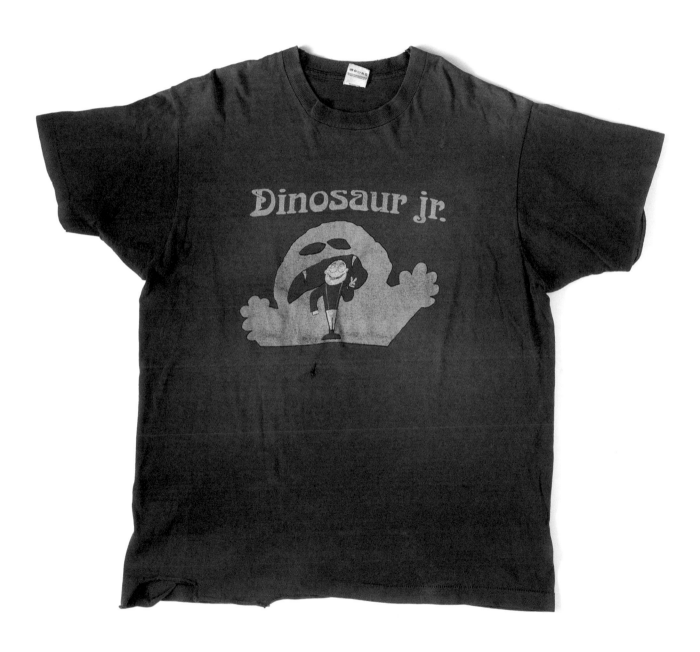

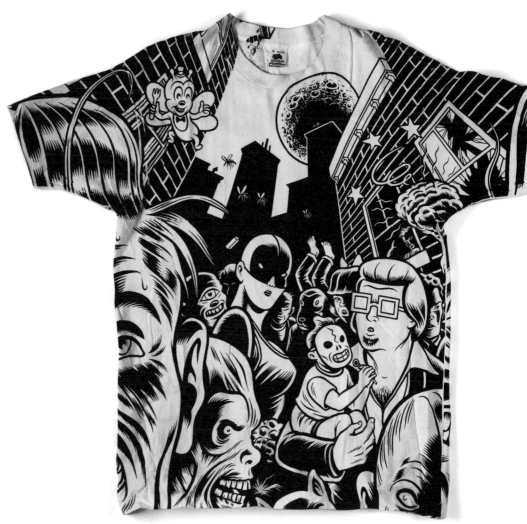

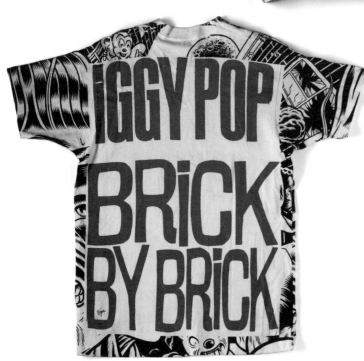

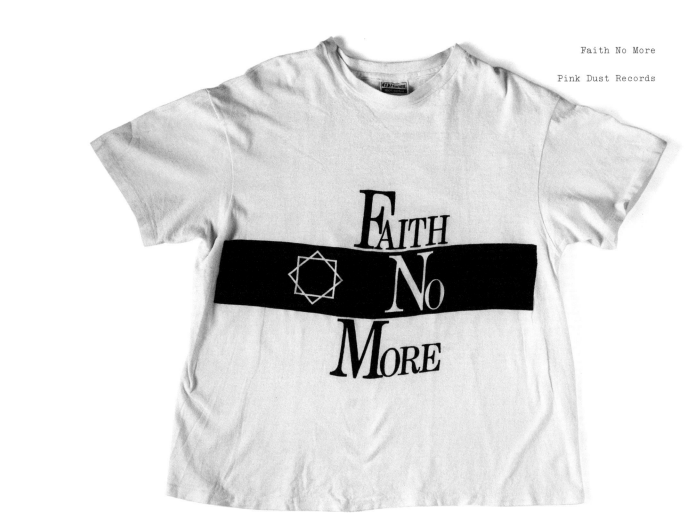

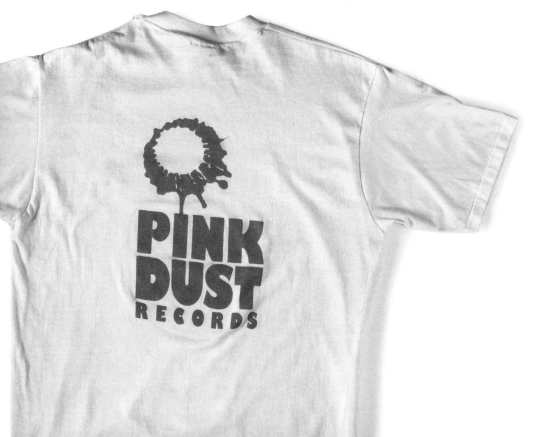

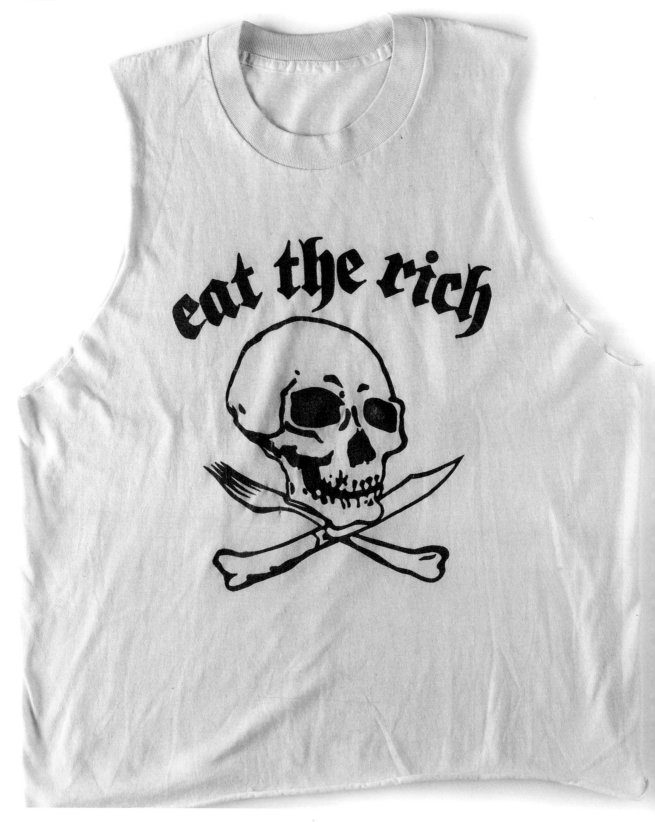

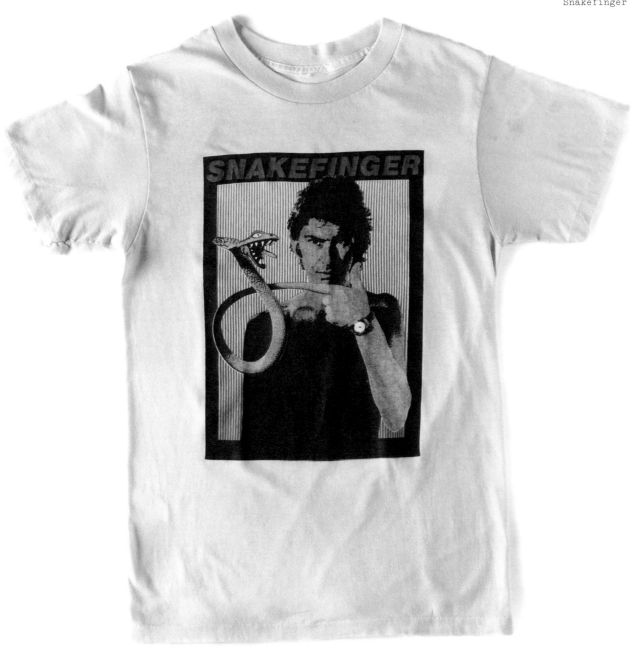

Meeting the Residents coincided with meeting my true self. Running away from home on weekends and hanging out a little with members of a jokey LA punk band who were so literate, sardonic, ironic, and brilliant. I was thirteen and living in Colton. It was 1982 and I was desperate to the point where I would run down two city blocks to see who it was when someone looked like they were wearing pants that were pegged and not bell-bottoms. So all at once I had the humor, the art that immediately turned me on, and all the kinds of avant-garde music they were into, way beyond punk. The drummer had me jumping up and down when I realized he'd left

his perfectly worn-in Residents T-shirt somewhere (I can't remember where) for me to steal/take. I was in heaven. I felt like wearing it made me smarter, cooler, older, prettier, taller. It almost made up for my mother grabbing my chin hard when I got off the Greyhound and saying, "You've been smoking." Of course, the genius of this T-shirt was lost on the residents of Colton and the 7th-grade class of Grand Terrace Jr. High School... And universal law being what it is, the T-shirt was eventually stolen from me, which broke my heart. Really.

Susie 1983

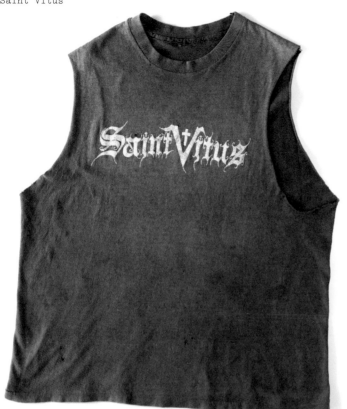

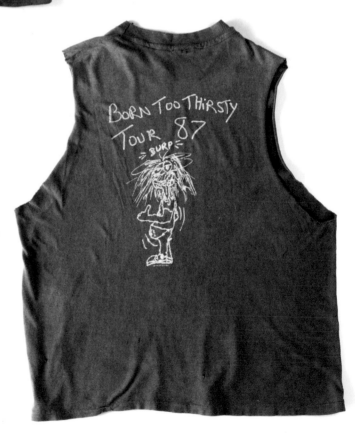

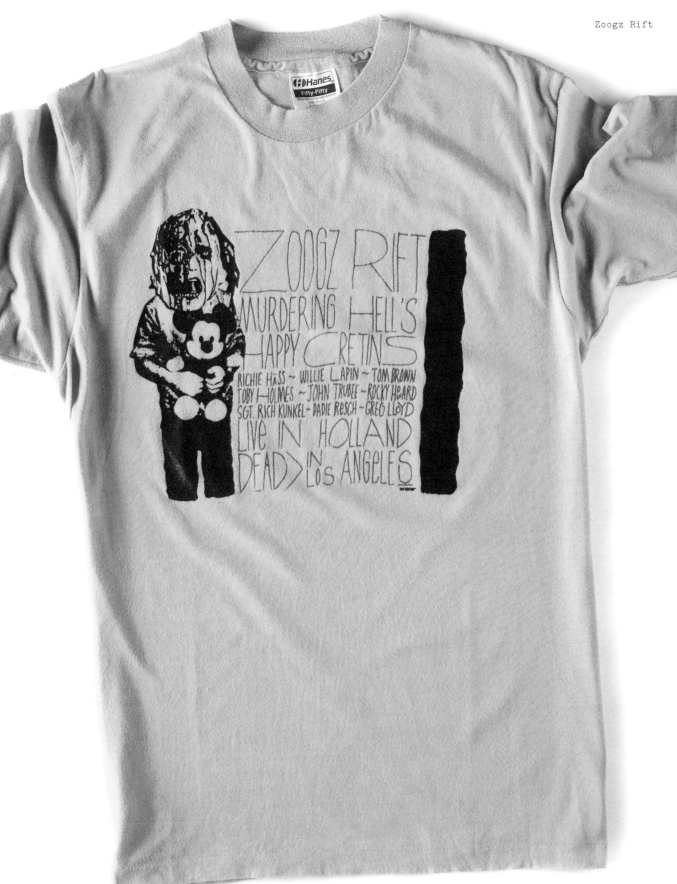

The title was a nod to the Circle Jerks. The album was recorded on the sly in a few after-midnight sessions at the first West Beach recording studio in Culver City. John Girdler recorded it, and Pat Smear (Germs, Nina Hagen Band, and Nirvana) helped us produce it. The band was a mayhemic and joyful synchronism of punk and pirate sea shanties. Almost every song was an inside joke that pleased us to no end. Mostly, we were very silly people who liked to rock out without pretensions. We also had chicks in the band who could actually play their instruments; and that seemed to give us some sort of credibility back then. The band was born in 1986 and had members from downtown L.A. and the South Bay. We took potty humor, social commentary, and obscure politics to new heights. We were a fixture at Raji's, but were also fortunate to play on some pretty amazing punk bills all around the globe. On the first Eat Fat's Die Young U.S. tour we brought a tent with us and spent a few of our nights sleeping in the dirt. This was a really fun band to play in. Good times. Members included Al Hansford, Jason Greenwood, Dez Cadena, Ingrid Baumgart, Travis Johnson, Steve Drojensky, Mia Ferraro, and Jula Bell.

Jula Bell

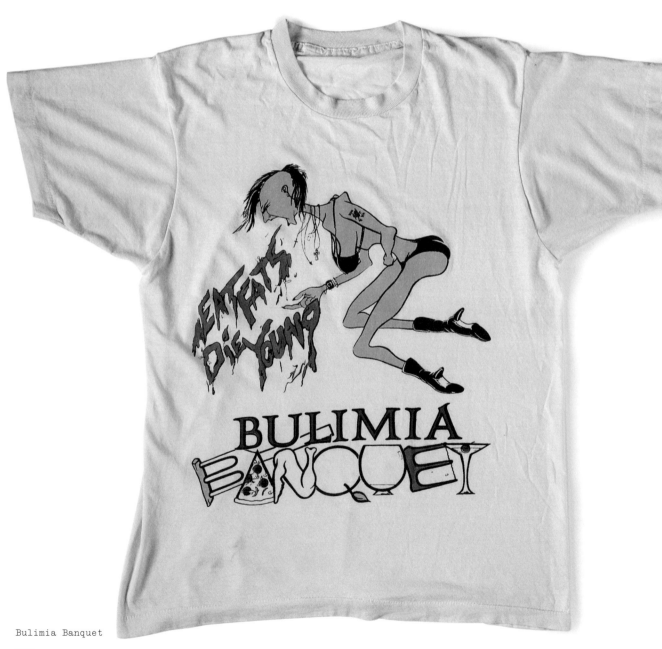

Bulimia Banquet

We met the Barker for the first time after sucking exhaust during an all-night drive to Chicago. He was trying to organize the air in a McDonald's parking lot. We saw him everywhere, all over the country, mostly after all-night drives or during four-day drunks. We saw his image at Wacko in Hollywood, so we stole it and put him on a shirt. Days later, at a condo in Davis, Matt became the Barker. Waking up after a drunken night (in which Dean from Cat Butt dumped on the hood of a random neighbor's Camaro), we all jumped in the pool. Matt stayed—for hours. We watched as his posture hunched and voice became all gravelly. He ran his hands over, just over the water, careful not to disturb the surface. "It's like glass... it's like glass..." He did this for hours and we just watched, stupefied. We didn't realize it then, but this was permanent. Our bass player had become the Barker.

Mark Arm

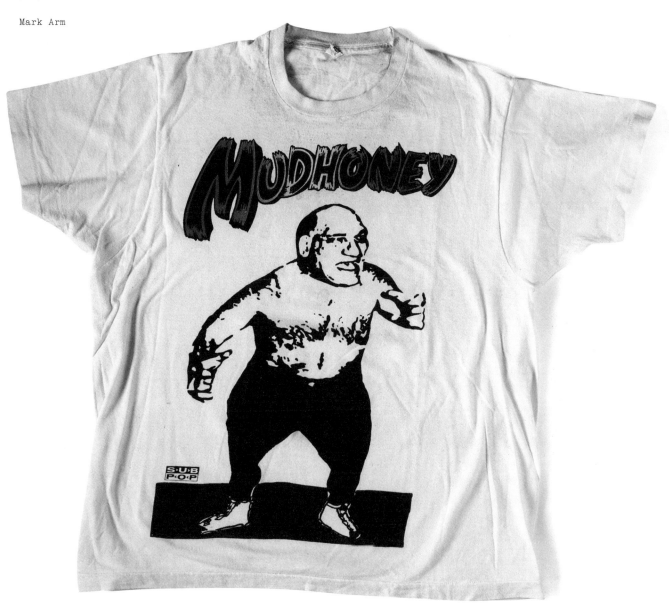

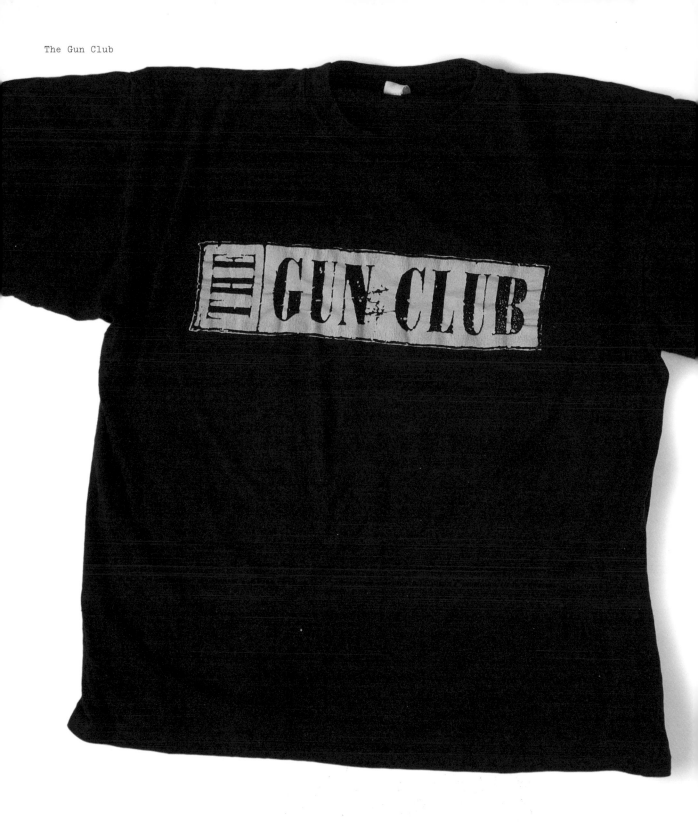

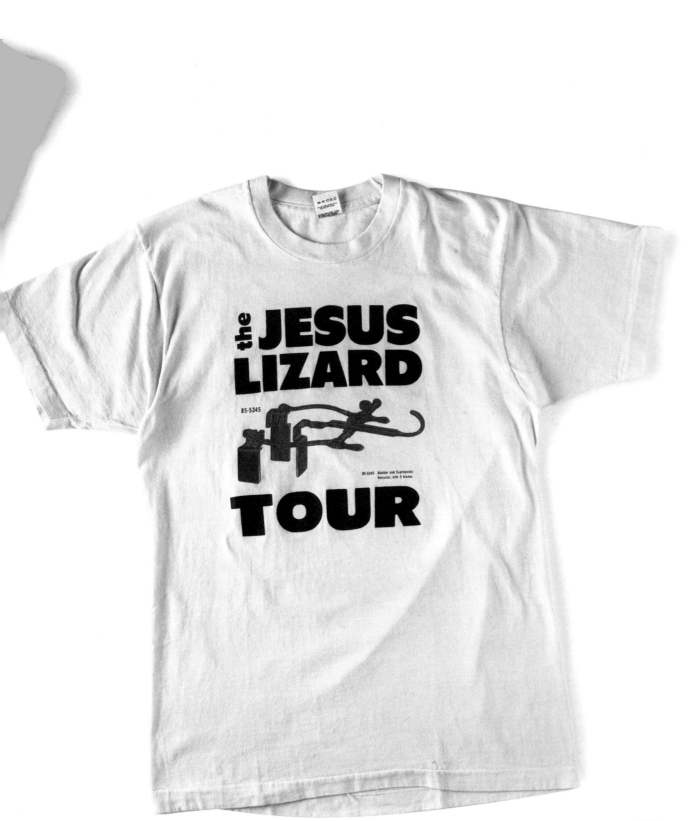

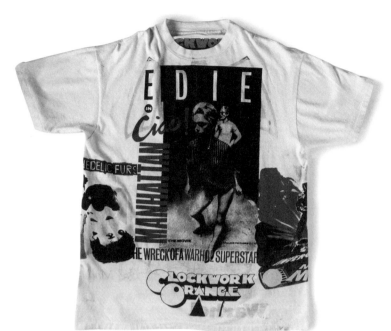

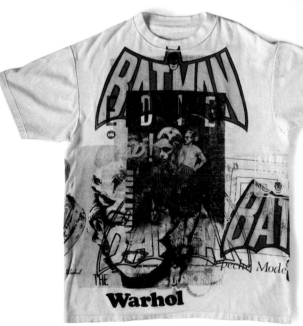

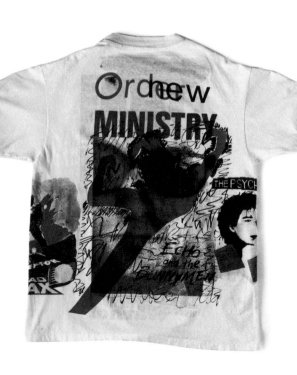

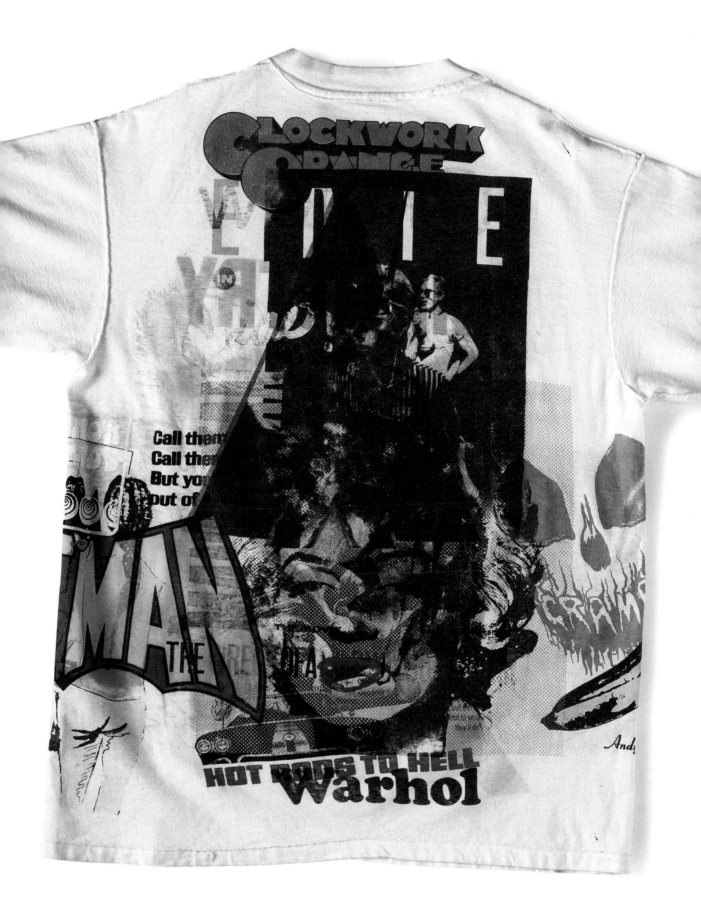

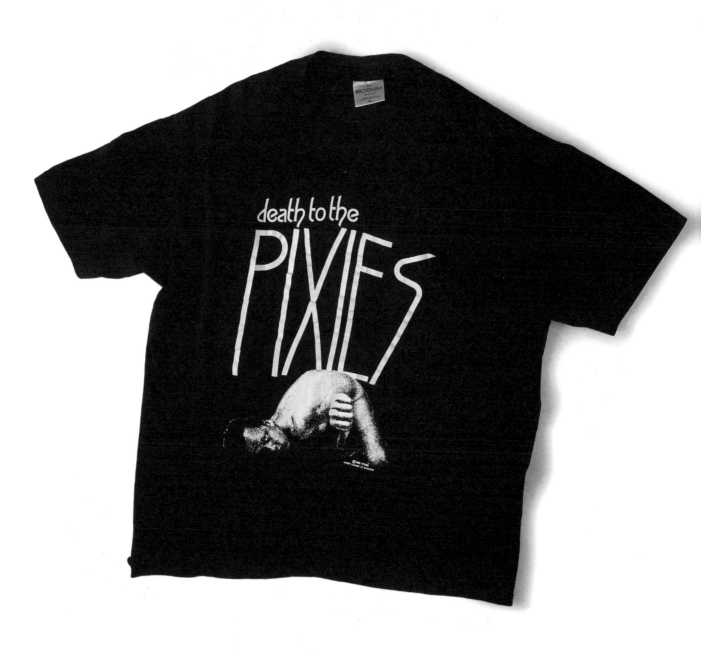

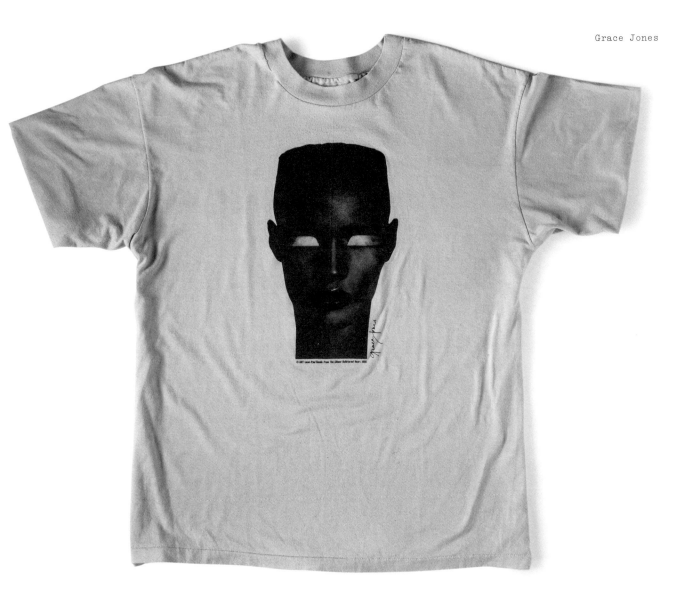

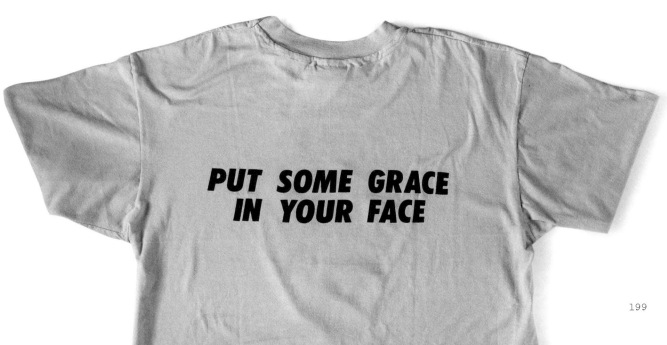

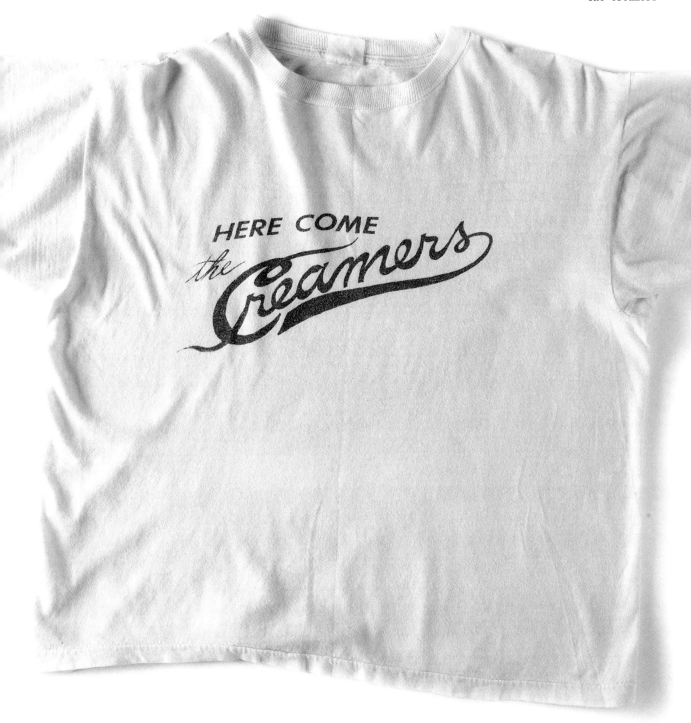

Sonic Youth

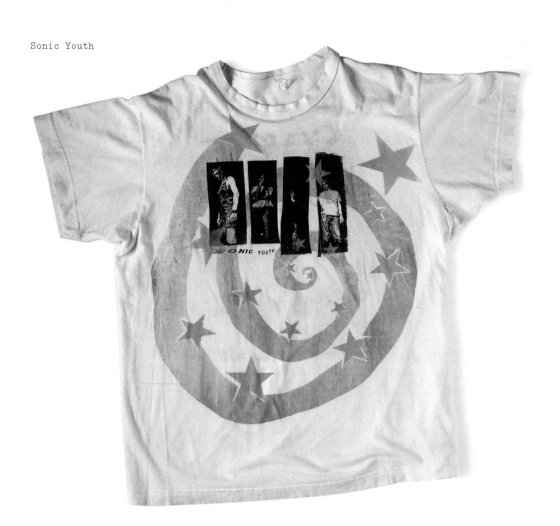

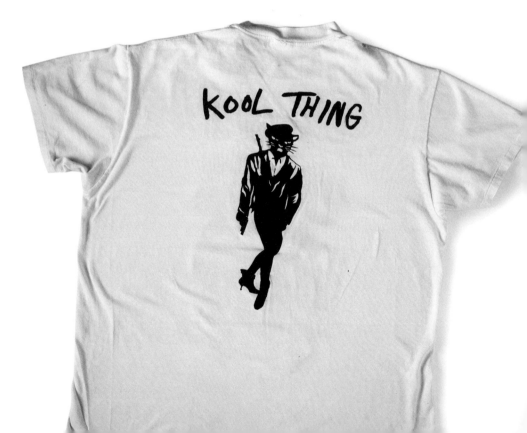

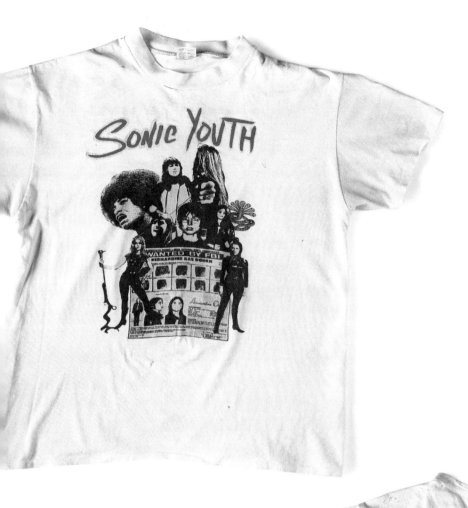

A cool T-shirt has no rules, the more unique
the better. I was doing solo sets on the 1994
Lollapalooza tour and decided to sell T-shirts
that were limited and designed on the spot. I hit
Targets and Wal-Marts and bought white Beefy-Ts and
magic-markered art and words on them, signed and
numbered them, and sold them for a couple of bucks
more than I paid.

Thurston Moore

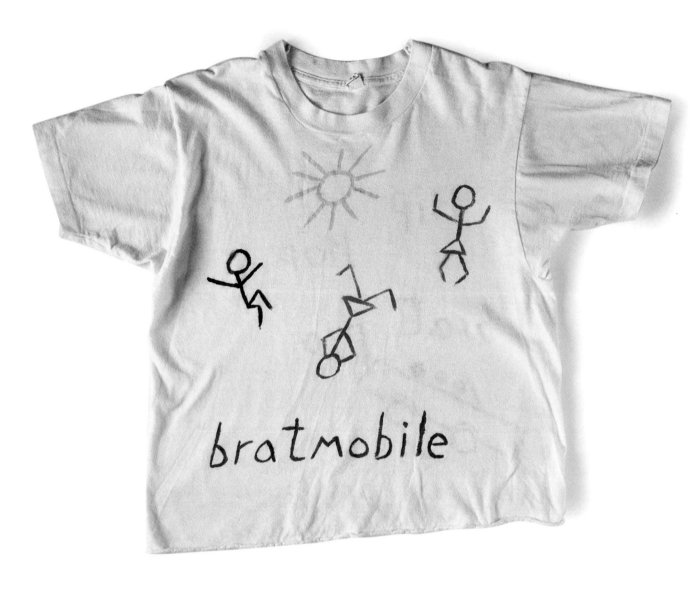

As a closeted teenage skater, Bratmobile's "Cool Schmool" lit the fuse. With the first breath of Allison Wolfe's voice singing "We're so cool, yeah yeah/Yeah we're so cool..." My oversized Dickies were shaking and my Ross "dress for less" striped polo was itching to fly from my body in a homosexual dance frenzy. I was addicted to Bratmobile, along with most of the riot grrrl bands.

In 1999, at the Yo-Yo A Go-Go Festival in Olympia, Washington, I ate acid and saw Bratmobile for the first time. I remember how mesmerized I was by Allison, who was like a god! Molly Neuman's drums seriously stung through me, thrusting me into a euphoric seizure, while Erin Smith's guitars worked my nerves up and down like my blood consisted of a million bouncy balls. There has never been a show that made me dance so hard since that night, and I doubt another one will.

So when I was in Portland a while back and I found this handmade Bratmobile shirt (obviously from the early days), I screamed in the store, loud. My boyfriend was with me and couldn't share my excitement, so I had to walk around aimlessly with a stupid smile on my face without anyone knowing why. A while later I was at a Queers Beers 'n' Rears in New York and Allison's new band Partyline was playing. I had met her a couple times, so I walked up to her and told her about the shirt. Her response was, "I know exactly who got rid of that shirt—it was fucking Corin Tucker from Sleater-Kinney!"

Mat Côté

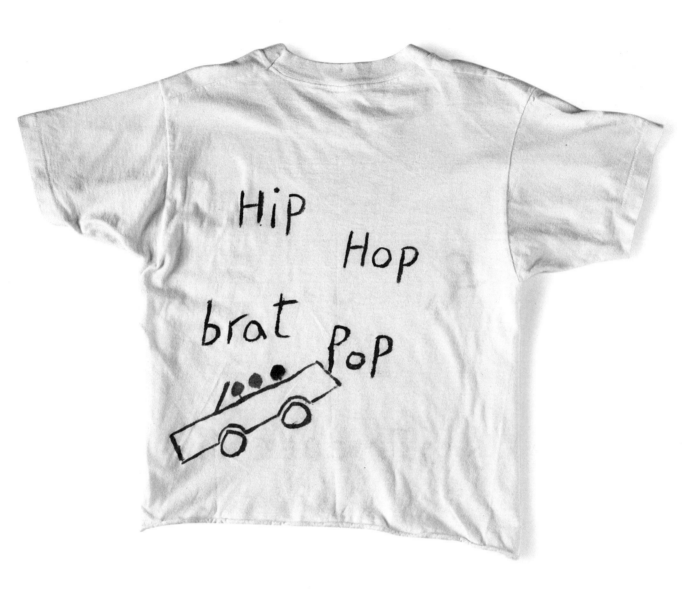

At first, Bratmobile was just a band-in-theory that Molly Neuman and I cooked up while bored at college in Eugene, Oregon. We were pretty much all talk until one day Calvin Johnson called us up and asked us to play a show in Olympia, opening for Bikini Kill and Some Velvet Sidewalk on Valentine's Day, 1991. At first we were like, "What? We can't play!" But Calvin insisted, "Well you guys keep bragging that you¹re a band!" So we went to our elder punk-rock friend Robert Christie's house and asked him what to do about it. He loaned us his band's equipment and practice space and told us to study some Ramones records. To this day I don't own a Ramones record, because I was afraid we'd end up sounding like a rip-off of them and wanted us to be "different."

Molly had a guitar and knew a few chords and bought a cheap old Galaxy 500 to get us to our first show. We made a fanzine, Girl Germs, and hand-painted about five T-shirts to give away to our friends at our first show. A few years later, I saw one of those shirts in the free box at the Martin Apartments in Olympia and took it back! Thanks a lot, pals! Although the stick-figure drawing style is very me, it looks like Molly painted the one Mat Côte found, pictured here.

Allison Wolfe

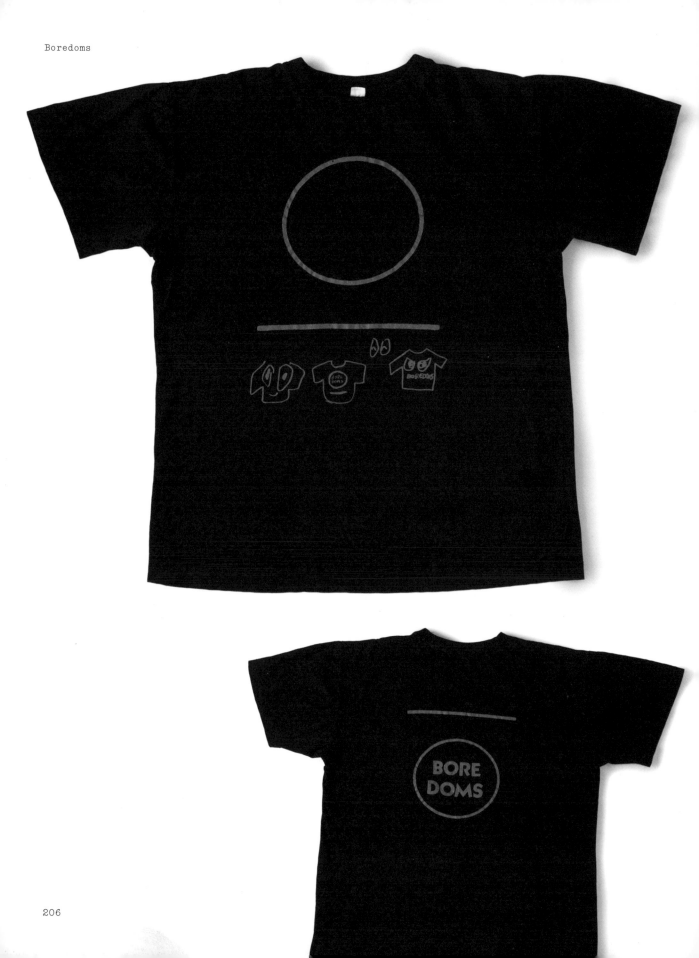

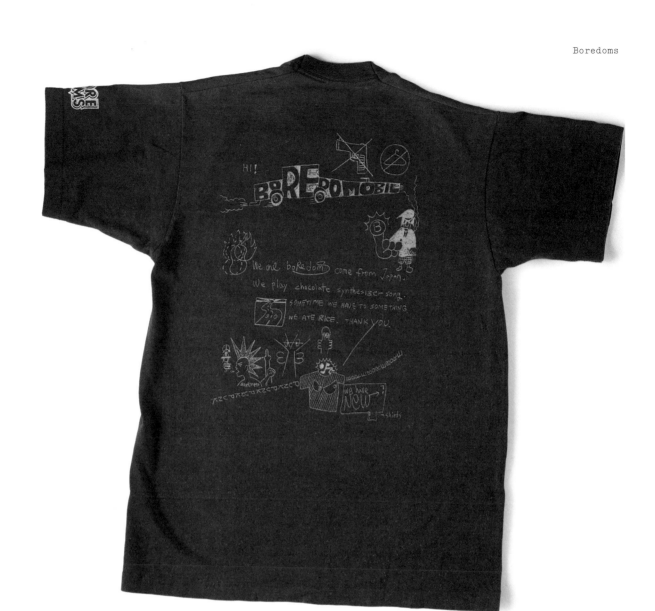

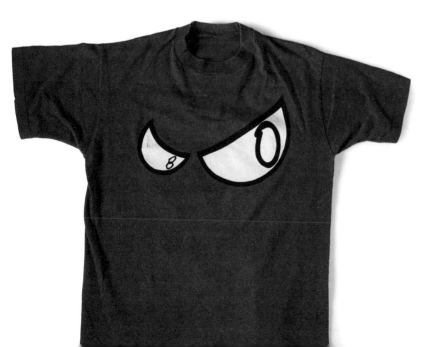

You could be rolling stoned through checkerboard linoleum aisles in Kentucky, surrounded by toothless monsters, sights set on a Dolly Parton ringer T from seventy-two feet... Or maybe you're still drunk at five in the morning, and it's cold and dark at the Rose Bowl Flea Market in LA, and your fingers are racing violently through shirt racks while Japanese vintage dealers move in on both sides, their fingers moving faster and their $300 spelunking headlamps blinding you as the skinny one swipes in on the perfect handmade Wipers shirt. What if you're in New York? It's the Manhattan Vintage Show and the booth where, last year, you found a stained but passable Gary Numan shirt being scavenged by a movie star, a famous fashion designer's muse, and a seven-foot-tall, über-French, hella vintage dealer from Paris named Anoushka!

I've trolled thrift stores since the zits on my face were flunking Spanish 2. It takes a while to happily endure the stench of old clothes—sometimes an alien scent of baby powder and octogenarian farts—but once you've acquired the taste, you almost want it. The hunt can yield days or weeks of happiness just by falling upon some vintage Banger T-shirt, or even a musty leather jockstrap, with an old gay bar's name stenciled on the front. You know you've struck gold.

The flea market scene can be brutal. Crazy weather can render you useless and cranky, asshole dealers might yell at you, "Of course it's old! Do your homework! Come here, I bend you over and fuck you right here! Here in my booth!" Or the McMuffin and crap coffee can strike you down, cramping, looking for the nasty-ass porta-potty. Here again, with the right find, God could rain your own diarrhea on you and it seems that invisibility comes with that '78 Patti Smith concert T in your hand.

Mat Côté

Karen Black